Valeri

Valerie Mendes was born in Buckinghamshire
just after the Second World War began. She arrived
too late to put a stop to it.

Educated at North London Collegiate School
(which she loved) and the University of Reading
(which she loathed) she was first published in her
school magazine when she was six years old.

It was a defining moment in her life.

During her many years in publishing, Valerie
acquired a variety of nicknames. At Oxford University
Press she was The Ogre Queen because she had
inherited a list of Oxford Graded Readers. In one
smaller and rather disorganised publisher she became
known as Genghis Khan. While running *Wordwise*,
her home-based freelance enterprise for eight years,
everybody called her Eagle Eye.

In her private family life, Valerie is Mum
to Sir Sam Mendes CBE and Granny Val to
her beloved grand children.

Valerie is still a meticulous Editor, but only of her
own work. Her own imprint, VMBooks, has published
her new novels, *Daddy's Girl* and *Beatrice and Alexander*,
as well as *Not Only But Also*.

Flight of the Lark, the long-awaited sequel to Valerie's
best-selling historical novel, *Larkswood*, will be
published by VMBooks in 2022.

www.valeriemendes.com

Also by Valerie Mendes

ADULT NOVELS
Larkswood
Daddy's Girl
Beatrice and Alexander

YOUNG ADULT NOVELS
Girl in the Attic
Coming of Age
Lost and Found
The Drowning
Where Peacocks Scream

PICTURE BOOKS
Tomasina's First Dance
Look at Me, Grandma!

Not Only But Also

Valerie Mendes

For Andrew and the Team —

with enormous gratitude

Valerie Mendes
14 October 2021
Woodstock

VMBooks

First published in Great Britain in 2021
by VMBooks

A CIP catalogue record for this book is available from the
British Library.

ISBN 978-1-8382490-6-9 (paperback)
ISBN 978-1-8382490-7-6 (ebook)

www.valeriemendes.com

For Sam Mendes, Andrew Chapman
and Antonia Keaney
with gratitude and love

If I Had Known

If I had known why you had come
I would have curled my hair
Put on the skirt you liked so much
And taken special care
To tell you that above all else
I tried to do my best
Although you never listened –
And the rest.

If I had known why you had come
I should have said "Don't go!
"Let others man those battlements
"They have far stronger throw.
"They whip their horses, sharpen knives,
"Drink in their tents, ignore their wives:
"They lead completely different lives –
"Why go?"

If I had only known. But now
Our time for words, long gone
Lies drowned within a sea of hate
That muffles every song.
"Goodbye" is now the only word
That echoes in my heart:
Goodbye, sleep well, sweet dreams my love:
We part.

Contents

A Necklace of Beads

In the early spring of 2014 Orion published my first adult novel.

Larkswood had taken me seven years to write, and it was a genuine solid handsome-looking hardback. I threw an extravagant launch party in The Orangery at Blenheim Palace and lots of people came to celebrate. The February weather was unexpectedly kind. The Palace had been newly cleaned and polished. It glittered seductively in the gentle light. The novel was expensive and looked rather forbidding. My specially commissioned, luscious blood-dripping graphics for the front cover had been replaced with spindly ones which made it look dull and rather forbidding. But there we were, eating and drinking and book-launching, saying all the right things.

"Congratulations, Valerie ... You must be very proud."

I certainly was.

As often happens after such an event, there was a long silence like the calm after a storm.

I buried my head in the sand of the second book in my

Orion deal, *Daddy's Girl*, at which I was picking and sticking in the most infuriating way. I could hardly bear to glance at *Larkswood* because I knew it off by heart. It already seemed to lie in my past, doomed to failure, never to earn its advance or be read and loved by anyone who really mattered either to me or to the literary world.

Then Orion drew me back into it.

"We want you to write something extra for the paperback edition," they told me. "We'll be publishing it in November for the Christmas market. A short story or an article or perhaps even a poem."

I jumped in feet first. "Could we also do something jazzy to the front cover?" I asked. "Put a bit of oomph into it. Something red and enticing … The hardback looks so aloof."

A cold silence greeted my suggestion. Mendes was being difficult. She wasn't selling, she wasn't producing, and now she had the nerve to emerge from her lair to criticise.

I decided to do my bit for my distinguished Publisher. I did love them really. I opened my two wooden filing cabinets and started to dig.

Over the next six weeks, I sent Orion short stories, features, articles and two collections of poems.

I waited for a decision. Although *Daddy's Girl* sprang suddenly into much improved life, slivers of my past now fluttered all over my desk, getting in the way.

Then the decision arrived. "We don't want any of this stuff for *Larkswood*. None of it is right."

After I'd burst into tears of frustration, Orion added sympathetically, "The poems are lovely. You could always publish them on your website."

I stomped into the garden room and kicked the logs in

the fireplace. I raged around the well-cut lawn and thrashed my way through the field behind it. A particularly hungry spider took a large bite out of my right thigh. I sobbed myself to sleep, my swollen leg throbbing with pain. I decided to become a bus driver.

The following day, a Saturday, I took the bus to Witney and hobbled around feeling ridiculously sorry for myself. I ate a tasteless sandwich, thinking of nothing and nobody. I decided to move to Brighton, where I was sure there'd be people more conducive to life on a writer's wave. I turned on the television and sat down to watch an afternoon of Wimbledon.

But only for five minutes. Suddenly, like a bolt from the tennis blue, I knew exactly what to write. I dashed upstairs to my computer. Twenty minutes later I'd written the short essay on *Writing Larkswood* that I republish here, and that so many of my readers have identified with and loved.

I sent it in an email to Orion.

Back came Juliet Ewers' immediate Saturday-afternoon reply.

"It's perfect," she wrote. "Thank you."

My spider bite and I hopped into the garden and danced for joy. I shall always love you, Juliet.

The November 2014 paperback of *Larkswood* with its sparky cover and extra feature began to sell like hot cakes. Waitrose made it their Book of the Month and kept on ordering more copies. Orion reprinted the eleventh edition in 2020. It looks fresh as a spring daisy.

I did not become a bus driver or move to Brighton.

Instead I moved back to Woodstock to publish *Daddy's Girl* – but sadly without Orion whose heavy-handed editing and new title, *The Hideaway*, stripped the story of its original

intentions – and my fifth novel for teenagers, *Where Peacocks Scream*. I also resumed and completed work on a third historical novel for the adult marketplace, *Beatrice and Alexander*.

But something new had crept on to my horizon. Those riveting gems I'd dug out of my filing cabinets enjoyed the change of air. They began to gather together like clusters of autumn leaves; then to dance before my eyes. New shoots appeared, green and yellow, uncurling in the warmth of the sun. I wrote to Malcolm Edwards at Orion in an informal capacity, sending him a couple of opening chapters of a project I then called *Essays in Publishing*. To my astonishment and delight, Malcolm said he'd be happy to read it when I'd reached the end.

But instead of driving on to the creative motorway, I turned into a cul de sac and climbed out of the car. This memoir of mine, I argued to myself: it would be too difficult, too dangerous, full of pitfalls, who wants to go there, what a boring title, get on with something else.

I snapped the file shut and plonked it on a shelf.

The back burner of the mind is a fabulously useful endowment. While you are doing something completely different – like the washing up, or gardening, or watching a film – it will sort things out and then present you with a *fait accompli* that arrives like a magical surprise.

Fast forward to 12 July 2018, to the evening when, during his visit to the UK, President Donald J. Trump was dining at Blenheim Palace. I fought my way through a line of ambulances and weary policemen parading outside the Palace gates to my waiting limousine. It whizzed me into London's National Theatre and a preview of *The Lehman Trilogy* by Stefano Massini, adapted by Ben Power and directed by my son, Sam Mendes.

I sat there enchanted. By the end of the long evening I knew without a shadow of doubt it was the best theatrical production Sam had directed in his thirty years of show business. Sharp, detailed and confident, it tells the enormous story of the rise and fall of American money, as well as describing the tiny fragments that make up and map out the lives of the extraordinary Lehman family.

I was driven back to Woodstock. I drank a bowl of midnight soup and went to bed. At 5.00 a.m. the next morning I was at my desk, writing my first poem for many months. I never plan my poems. They always wake me from sleep with a first line, an unmistakable rhythm, an inbuilt melody, a sense of purpose that pushes everything else I have to do out of the way until I've written it. This particular poem sprang directly from watching Simon Russell Beale, Adam Godley and Ben Miles weave their story together with consummate skill and flair. They made it look so easy – which is of course the mark of the true professional.

The evening became the trigger that finally opened the door I could no longer close to *Not Only But Also*. Henry Lehman is the man behind this sensational financial story. If it hadn't been for his courage in leaving his country for the big wide world, nothing would ever have happened.

My grandfather, Barnett Buganski, in his own small way, did exactly the same. A devout Jew, he left Poland with his wife at the turn of the century to escape to the East End of London and start an entirely new life in a foreign land. He earned his modest, contented living as a tailor, making immaculate clothes from his home for the local marketplace. He read only Hebrew. He thought in Polish. He talked in halting English. He spoke to my heart.

But it wasn't until I saw Simon Russell Beale standing

with his battered suitcase on the stage of the National Theatre that particular night that I was able to write this poem.

Here it is, then. It is dedicated to Simon himself: one of the very greatest actors of his and indeed any generation. In a career that already stretches round the block and back again, I've seen his Ariel and his Prospero; his Lear and his Iago; his Falstaff and his Malvolio; his Konstantin and his Uncle Vanya, to name only a few. His partnership with Sam is legendary, and it was never more successful than in this enormously difficult and deeply inspiring role.

Let's take the giant, life-changing leap, then, with Henry Lehman.

Choosing to Leave

For Simon Russell Beale

Bavaria, Bavaria, my home through thick and thin
The sweat, the coughs, beginners' call,
the shameful and the grim
The hope that rose so steadily whenever time allowed
Bavaria, I miss your standing proud.

Bavaria, Bavaria, I know your every stone
Ingrained within my eyeballs, the marrow in my bone.
That guilt at playing traitor I could no longer hide
My longing for a freedom, for skies both rich and wide.

Bavaria, Bavaria, come follow as I roam
On every wave a parting: we swell the froth and foam.
Those seas at last divide us with every breath I take –
Bavaria, goodbye then: my name I do forsake.

Bavaria, Bavaria, a new world beckoning
My stomach clenched anxiety,
my knees knocked hairy thin.
I step upon dry land at last. Hot salty tears I taste –
The sense of space fair dazzles me.
There's not an hour to waste.

Bavaria, Bavaria, home grown, home gone, black hole
Familiar items lie within the suitcase of my soul.
One step, then two, then three – then more.
God guide me on my way
As Henry Lehman. Who man? Let us pray.

So here it is: my necklace of beads, covering a span of more than eighty years.

This is not your traditional plodding cradle-to-grave record.

It's not littered with faded ancient photos of my extended family.

It's definitely not a misery memoir. Quite the opposite.

I make no apology for leaving out the nasty bits. Who on earth needs to know about them? They are strictly private, locked within hell holes of misery that I've survived and have no wish to share.

I should like to thank my beloved family and friends, my neighbours and professional colleagues whom I have known and loved throughout my eighty-one years.

The brilliant children's author, Steve Cole, who edited my first four teenage novels for me while he was an Editor at Simon & Schuster UK, stepped in with his unique red pen to read my Memoir's first draft. Without him by my editorial side, I should never have had the courage to publish it at all.

Paul Downes of GDAssociates and Darren Millward of JDP Solutions, my marvellous designer and printer, have worked with me for the past seven years. I am particularly grateful to Paul for creating the image for this cover, with a photo taken by Chris Challis Photography.

In the final chapter of this Memoir, The Eye of the Beholder, I explain the reasons behind this second edition, and acknowledge and thank the team who have made it possible.

My undying love and gratitude go to you all.

Valerie Mendes
September 2021
Woodstock, Oxfordshire

Imperial Leather Daddy

Although I cannot actually remember writing my first poem, it always just came naturally. What I most loved about it was that an idea for one would simmer in my mind like a secret joy. Then a first line would emerge, and the rest came fast but never furious. That first line established the shape of everything else. Three verses: no problem. Rhyming couplets: no problem. In fact there never was a problem at all.

Quite the opposite.

The poems were my creative lifeline between my father, Reuben Barnett, and me. They were our little secret. At the end of my school day, I'd produce a piece of paper with lots of black ink on it. I'd hold it under his nose as he was shaving at the ugly bathroom mirror.

"Look, Daddy! What do you think of this?"

He'd suspend a shaving brush in mid-air, along with the scent of Imperial Leather. His curly eyelashes, which he fed every night with Vaseline, would flutter and then calm down. He'd read my latest poem as I watched his face in the mirror and held my breath.

"That is very good indeed," he'd splutter through the foam, although I cannot remember what he actually sounded like. "I particularly love the bit about the bee foraging at the heart of the rose."

My happiness complete, I'd dance the thirty-six inches to my very small bedroom which overlooked Hale Lane in Edgware, and close the door.

North London Collegiate School played a crucial role in everything I wrote. The bees never droned and the roses never wildly bloomed beside our house in the silent, terrifying suburbs. But they certainly hummed and blossomed in the spacious gardens of my school.

My official family may have owned a rose bed, a patch of lawn, a garden shed, a washing line, a small cluster of coxes apple trees and a hideous patch of cement that had once supported an air-raid shelter. But NLCS had a proper round rose garden, an enormous rhododendron bush into which small girls could crawl, a magnificent cedar tree standing on countless beds of needles, a lime avenue that stretched into the distance, a scruffy pond complete with wiggly tadpoles and gungy slime, and a gym wall against which I could thrash a tennis ball. Once through the iron gate of the private grounds, I entered paradise.

And the freedom to be myself.

The school magazine sometimes published one of my poems. Waiting for their behind-closed-doors decision was a nail-biting time that seemed to go on for ever. Then, if that particular poem shimmered before my eyes in dazzling print, I danced all the way to the tuck shop at the bottom of Canons Drive.

My best friend, Pamela Sutcliffe, never bought anything.

I always emerged with a select bundle of sherbet in bright yellow packets with dib-dab liquorice straws that exploded in my face, purple aniseed balls that changed colour as I sucked, or barley-sugar sticks. It's hardly surprising I had spots galore. But I couldn't face Hale Lane without the sugary treats.

Pamela, on the other hand, caught the train at Edgware station. She lived in an elegant house in Hampstead Garden Suburb with a mature garden, a mother who read a novel all afternoon without first clearing away the teacups, and a solicitor as a father. How I envied her.

And then I discovered I had hatched, sweets and all, into the world of adults. The Poetry Society's magazine, *The Voice of Youth*, published one of my poems and asked me to read it to a chosen London gathering. Strangely, I remember nothing about the event, not even what I wore. But I'm sure that Imperial Leather Daddy – plumper, in his fifties, his hair speckled with grey, but still undeniably handsome – was not in the audience. By then he'd abandoned our shaving-cream moments for other, less fatherly, pursuits.

Being on your own as an amateur poet is a different ball game. It certainly isn't tennis. It's plough-your-lonely-furrow time, with the odd foray into showing your work to a colleague who doesn't really read anything but women's magazines.

I never belonged to the public-house set who lolled about congratulating themselves on their beery and usually masculine brilliance. The University of Reading was hardly conducive either to happy poems or joy of any kind. Indeed, it probably didn't even recognise the word, it being only three letters and not really philosophical. Giving birth to Sam was an incredibly joyful moment in my life, but you

can't really ask a busy midwife for pen and paper.

Later, though, I did write a letter to my in-laws who lived in Trinidad about the extraordinary moment of giving birth; of seeing Sam open his blue eyes for the first time and look straight into mine; and of my complete enchantment and devotion to him from that moment on.

Becoming a mother can be a tiring and lumpy process, particularly in hot weather.

Being a mother can be the most joyful experience in the world.

The Wrong Place at the Right Time

At North London Collegiate School I was awarded a State Scholarship in English and History. My superb Headmistress, Dame Katherine Anderson, solemnly discussed my future beside her fireplace in her house off Canons Drive.

"I have to be in bed by ten-thirty," she told me. "Otherwise there will be mayhem tomorrow … Why don't you go to Cambridge University to read History? You're obviously an historian to your fingertips."

My English teacher had been constantly articulate and encouraging. The history graduate hauled in to teach us Sixth Formers had been neither, barely able to translate her recently acquired college notes to a class who were almost asleep with boredom. She had some knowledge of English history, but none whatsoever of European. In desperation, I did my own research and invented an exam paper with five questions. To my utter astonishment when I sat down in the examination hall, every single one of my five questions shone like beacons from the paper in front of me.

Silently, I thanked my lucky stars and wrote five essays that probably all earned full marks.

I tried to hide my bitten nails from Dame Kitty.

"But I want to read English," I murmured. "I don't just want to churn out stuff about other people's lives. I want to do *original* work."

But ten-thirty, twanging impatiently from the grandfather clock, ended my muted protest. In those days, university degrees in creative writing had not yet been invented. They arrived from America ten years later and gradually swept the UK in a stifling blanket of false hopes and fading dreams.

I arrived for the Cambridge interview wearing a modern outfit my meticulous tailor of a grandfather had made for this special occasion. If successful, I'd be the first in the family to get educated to such-a-much level. A bit of a surprise even to me, I wore an extremely bright blue-and-green-check tweed suit with a short jacket, full-length sleeves and a short tight skirt.

The Cambridge don conducting the interview, hunched behind her desk like a panther ready to strike for every complaint in the history of toiling academia, had greasy grey hair and an acid snarl to her voice.

"Good afternoon, Miss Barnett. Please take a seat."

She looked up from her pile of identical documents. Her eyes were the colour of pickled walnuts. One of her hairpins jangled to the tiled floor.

I waded in with my usual blunt technique: tell it like it is, chum, we'd both prefer to be punting on the river.

"I don't like Jane Austen," I told the creature from the walnut-infested lagoon.

Silence petrified on my bright check shoulders.

"I think George Eliot is a much greater novelist than Austen. Eliot has a breadth of vision, enormous vitality and

real daring. She constantly challenges the status quo."

As I warmed to my theme, my short skirt began its climb up my thighs.

"I mean, do you really yearn to read about yet another blooming ponced-up ballroom in Bath?" Bashfully, I cleared my throat. "But in *Silas Marner*, to take but one absolutely brilliant example—"

The walnut closed her eyes, probably longing for her gin and tonic. She extended a wizened claw to tinkle a tiny bell, like Alice in Wonderland summoning the Cheshire Cat to his mid-morning fishcakes.

"Thanks, Tomkins ... Could you show Miss Barnett the way out?"

The University of Reading told me in writing I could read for a Double Honours Degree in English and Italian. The Whiteknights Campus interview, conducted by both Professor Donald Gordon and Professor Philip Brockbank, was a doddle. No jungle swamps lay across my determined path.

The two distinguished mentors had just been to see, as had I, as had the entire literary and theatrical world, a new play by John Osborne, *Look Back in Anger*. Donald and Philip sat on facing sofas, squealing with well-fed laughter. Donald looked immaculate in a well-cut suit. Philip, altogether sexier, looked crumpled, raffish, lithe. I warmed instantly to them both, and began to breathe properly for the first time in several weeks.

"Squirrels," hooted Donald, bending double over his neat paunch.

"Yes, I know ..." Philip sobbed with laughter, fat tears greasing his cheeks.

I pretended to giggle hilariously to attract their attention.

Two sets of eyes glanced across at me.

"Miss er Barnett?" Donald asked, consulting his diary.

"Yes, sir!" I stood to rapt attention. My new shoes, made of shiny clover-coloured plastic, cut across my toes. I almost joined the squealing brigade.

"That's me, through and through ... Is there anything else you'd like to know?"

"Not really ... Sign on the dotted line, and show in the next candidate."

It was not until I actually arrived at the start of the new term that I discovered nobody spoke Italian within a 500-mile radius of Reading University. Instead, my degree would have to be English and Philosophy. This in spite of the fact that, as I describe later, I'd studied Italian at the University of Perugia in devoted preparation, and loathed Kant and all his wretchedly boring crew.

Once formally admitted to Mansfield Hall, I also discovered that the entire value of my State Scholarship needed to be paid in full to the University. Imperial Leather Daddy appeared not to be as rich as he had made out to the educational authorities earlier in the year. I became dependent on monthly cheques from my mother, which arrived like soiled sanitary towels in dirty envelopes. But at least they rescued me from poverty. To pretend I had as much grant money as my new best chum from Liverpool, who was rolling in dosh, I puffed at the odd Gauloises cigarette, filling my dingy room with a sophisticated aroma and quiet coughing.

At the start of my second term, I collapsed with glandular fever. The virus struck me in the front garden of deadly Edgware. By the time I arrived back in my Mansfield room with my battered suitcase, I felt all of a quiver.

My sharp decline meant I took my first-year examinations in the Sanatorium. I sat up in bed, covered in red spots, waving a spoon at Matron.

"Please tell those builders I cannot write a single word unless they stop work for three hours," I said through a mouthful of egg. "The noise they are making is entirely unacceptable."

Matron trotted off: trim, tidy, efficient. Five minutes later, everything went silent. My fevered brain ticked into examination mode.

The only thing I took away with me after three dull years trapped in Mansfield Hall was a passionate love for the poetry of William Butler Yeats. And a longing to be out in the reality of the adult world.

Halfway through my second year at Reading I decided I'd had enough of the dreary beer-drinking, mostly homosexual set who dominated the English department. I got on a train to London and went to talk for an hour to an analyst friend of my family, Sonny Davidson. We'd known each other for years when our families met on Sunday afternoons. He was always interested in my progress through school and immediately understood any problems I was dealing with. He was the closest to a father I then had.

"I can't bear my life a minute longer," I told him. "I've read all the English stuff and the Philosophy is dull as ditch water. The good-looking men are farmers but I don't want to be a farmer's wife. I want to be like you: an analyst. I want to sit and listen to real people with real problems. To write about them. I'm wasting the best years of my life in a beer-sodden dump."

Sonny was sympathetic but firm.

"You may be bored to tears, but go back and finish your

course. Find things you enjoy doing that have got nothing to do with your curriculum. Walk, swim, play tennis, go to the cinema. Sit the exams and get a degree. Just grit your teeth and bear it. Then do whatever you want. Nobody respects a drop-out and, more importantly, you will never respect yourself."

I knew Sonny was right. On the train back to Reading I threw Kant out of the window, but I went on reading Yeats.

When, soon afterwards, during the vacation and back in Edgware, Sonny was discovered dead – I was told he'd drowned himself while at a conference in Scotland – my grief for a time knew no bounds. Rumour spread he'd been in love with Melanie Klein.

Melanie Who?

I went to the library and looked her up. It seemed that psychoanalysts were divided into warring camps. Anna Freud versus Melanie Klein … I didn't want to know. Sonny had got himself trapped in a lovesick mire when he should have known better. I walked the streets, tears pouring down my cheeks, feeling that I'd been to blame for his suicide. I'd given him another burden he didn't need.

I shall always love him. "Put aside all that self-pity. Finish what you've started. Life is never perfect. Get on with the job in hand."

I've always tried to follow his advice which became all the more poignant when he failed to follow it himself – and I'll forever remember him for giving me a pathway to follow.

For Professor Donald Gordon

Reading University 1959–1962

Talking of Yeats, you flew. Around the room
Ashes, consumed, sputtered. The Sunday light
Fell on to pen and paper, then in bloom
As I took down your words, if wrong put right.

I watched you struggle with an English prose
Whose labyrinths you polished. Ireland, Maud,
The beauty and the power of men Yeats chose
To love, his country – bloody, gored –
All these your wisdom understood, admired,
Placed in their essence.

Yet where was your voice?
Who fired your spirit in reality
Until imagination found its choice?

"I sought a theme and sought for it in vain."
You spoke his verse, melodious and proud.
I could not help but hear. You voiced our pain,
You trod Yeats' anger as you read aloud.

I listened, learned. My eyes reflected awe –
Yours for the poet. It was then I knew
The anguish that in solitude you wore.
I understood. Talking of Yeats, you flew.

The Cat's Whiskers

I've always loved cats. Tiny little kittens, fat hairy moggies, sleek groovy stalkers and everything in between. Apocryphal within my so-called family is this story: when I was six years old, I informed anyone who happened to be listening that if I didn't have a kitten, I might as well be dead.

This traumatic moment in my life must have woken deep rivers of guilt among those responsible for my upbringing. Dark mutterings bloated the lounge, a room only used when a major sacrifice needed urgent action, or I was reading a book.

It had the desired effect. My scream for help, that is. A kitten duly arrived the following day. Whiskers was waiting for me when I got home from school, mewing piteously because nobody had bothered to let him out of his basket.

Performing this most magic of ceremonies, the sound of a real voice in Edgware came as music to my ears. Whiskers' little body, light, furry and entirely mine to care for, became the central character in the daily dramas, shouting, banging – Daddy's wife used to bash her clenched fist against the staircase, telling the street she needed to have

her head examined (but nobody ever came forward) – feuds and, from Imperial Leather Daddy, silent sulks that lasted for days on end.

But as my suburban nightmare continued unabated, Whiskers became my domestic companion and beloved comforter. One day I got home from school, longing to see him and tell him about my day. Three months old at the time, he'd done a poo on some expensive carpet in the dining room. Daddy's wife took her revenge. She held my kitten's head down and pushed his face into the silt-coloured shit until I managed to pull him out of the mire.

"That should teach him," muttered the witch. "He won't do *that* again in a hurry!"

My loathing for Daddy's wife scalded itself into my heart for good and for ever. She was none of mine.

Over almost eighty years, I've either owned a cat, was recovering from the death of a cat, or celebrating a new relationship with one. In Wolvercote, north Oxford, where I lived in a tiny but beautiful cottage for almost twenty years, one particular cat literally saved my professional life.

I'd been working as a freelance editor. I'd complete enormous commissions and often not get paid for three months. One Christmas, my three major clients owed me close to £8,000. I could only just afford to pay my mortgage. At the beginning of January, after three weeks of living on baked beans on toast, I decided I'd had enough. I tossed a coin. Heads I'd sell the house and retire to Cornwall. Tails I'd acquire a cat, and soldier on.

My heart in my mouth, I spun the coin. Tails it was. I collected Top Cat from a Blue Cross Centre and took him home in a taxi. He vanished underneath my bed for twenty-four hours. He only emerged when I began to talk to him.

We became friends for life – until he was given a dose of medication which caused him to have an epileptic fit. I watched him swallow a large and unexpectedly early supper, gulping down the stuff as if he hadn't eaten for a week.

Then, sitting beside me on the sofa, he started to shiver, shake and spit. I rang the vet, whose line was busy. I returned to the sofa. For ten days I watched over Top Cat, unable to take my eyes off him in case he had another fit. Then, exhausted by lack of sleep, with publishers clamouring for new work, I knew this was the end of Top Cat and me. A taxi driver took me and a miserable him back to the Blue Cross Centre. I sobbed for another ten days, snuffling around my cottage and constantly falling over a cat toy or a bowl or a ball which kept the grief returning in waves.

Sam kindly offered me the use of his magical cottage retreat, an almshouse in the Cotswolds, for a fortnight. It did the trick. I slept, walked, explored a new landscape and gardened. I wept a further sixty buckets of tears, spring-cleaned every inch of the cottage without being asked – Sam was absolutely furious – left a pile of bin-bags for the heroic refuse collectors, and returned home to my desk, refreshed.

On my arrival in Woodstock, Oxfordshire, second time around, my gardener and I were sorting out the front garden together in Hensington Road. Into my life walked another cat, skinny as a wet sheet, feral as a tiger, and entirely black except for a slash of white along one leg, like the casual stroke of a painter's brush.

"I say, David!"

My gardener tipped his cowboy hat over one ear and grinned. "What?"

"That's just the kind of cat I've been looking for!"

"Okey, dokey … Give it a whirl."

I gave a whoop of joy. The cat looked startled but continued to wait for a new source of breakfast, his eyes watchful yellow slits.

"I shall call him Sloop."

Two months later, our friendship had developed into love. I took Sloop to the vet. No, he had not been chipped. I ordered immediate action, gathering the snarling bundle into my arms.

He's still a majestically loyal animal: less feral, much more of a gentleman, and a cat who knows a goody from a baddy without my spelling it out. I once employed a set of cleaners to help with the housework after I was recovering from a hip replacement. Sloop hated them at first sight. He knew when they were coming and recognised the sound of their car pulling into my drive. He'd make an immediate bolt for the garden and hide there in all weathers until they drove away.

They proved to be as evil as they come.

Luckily for me – and for the cat – they went.

For Sloop

My Miraculous Black Cat

If I am mine and Thou art thine we've not a jot to fear.
You're on the prowl for all that's foul,
while I clean plump and near.
I can't think where you panther to –
I'm not allowed to know –
For I am mine and Thou art thine
Let's go.

If I am mine and Thou art thine between us we're a pair.
You slumber sweet, I'm on the beat a-sniffing our rank air.
I've got a lot to do because we must protect our shore
For I am mine and Thou art thine
It's war.

Now I am mine and Thou art thine
we must be on our toes.
I'll sing and dance and take a chance
there's nobody below.
We'll play together on the grass
Whenever His feet come to pass
We'll watch and wait and man that gate
In case our Postman's mail is late.
You play with mice – not very nice! –
I'll tap an hundredth word.
You lap your milk, I'll wear some silk
To make sure we are heard.

So! I am mine and Thou art thine: we make a proper pair.
I'll hum and think, you'll make a stink
when enemies you dare.
I've just guessed where you panther to,
so now I'll always know –
For I am mine and Thou art thine
Just so.

Beneath an Angry Cloud

In my Edgware bedroom stood an enormous sepia photograph of my young Daddy, with sparkling eyes, dark hair and a vivacious energy and confidence that must have been the wow factor incarnate. He was in black-tie evening dress, posing for the camera alongside a slim, sleek snake of the woman he married. She wore a long frock spattered with a design of crudely drawn flowers. She was smiling with closed lips to hide her already rotting teeth. Her childhood diet must have been appalling, but I no longer felt any sympathy.

I assume this photograph marked their engagement. I never saw the actual frock, although I was allowed to dress up in the one that marked their marriage, which was made of exquisite pale turquoise organdie. I also still have another photo of the two of them in cycling gear, taken in some forest near London. They are nestled together as if this kind of activity was an everyday affair. But it wasn't. It was a most ridiculous pose: a sham both of them desperately wished were the truth.

Both made a valiant attempt to escape the poverty, grime,

racism and filth of the East End of London before the Second World War. But it was in their blood.

They managed financially to climb across the city to the edges of seeming success. And for a time it worked. They'd fought for peace and, in their small way, helped to bring it about. Their Jewish friends from Hampstead, Golders Green, Highgate, Mill Hill and Burnt Oak gathered together on Saturday nights to talk over sandwiches and tea, never alcohol. There was always serious political discussion: long, heated debates about the issues of the day.

There were no single women or men at these gatherings. You had to be a couple or you didn't exist. You had to drive a car. Your clothes had to be new or almost new. On Saturday mornings most of them went to synagogue, and only then were they forced to walk. They paraded the streets in their Saturday best, looking elegant but supremely self-conscious and uncomfortable, like something out of *Vogue*.

But the daily, including the Saturday morning, problem for my family was this: Imperial Leather Daddy drove back across London to the East End every day to work.

He crossed the divide as early as he could each morning, never participated in any local community event, and couldn't have given a snow shovel's handle about his neighbours. They didn't exist. The people who mattered most to him still lived in the land of salt-beef sandwiches where his parents had first established their sparsely furnished home, with their family Bible, strict Hebrew rituals and quiet, holy ways.

My father had two identities. One lay in his work, where his posse of mistresses called him Mr B, manicured his nails every Saturday morning, and cavorted with him in heaven only knows how many beds of iniquity. His other identity

of suburban affluence became less and less the centre of his life.

He'd open the front door on his return to Edgware and make a furtive dash to the lavatory next to it, in order to repair the ravages of whatever he'd been up to late that afternoon. Then he'd face the music of Hale Lane. He'd eat supper in the ugly kitchen, relentlessly talking crazy Communist politics. His wife ate almost nothing, saying she'd been nibbling all day.

His daughter sat looking at this monstrous pretence for a life, wishing she could be in her own room with her books, her cat, her fountain pen, her poems and her English essay on John Keats.

There were lots of things that made me angry when I was a child – but the problem was, I had to swallow them all, even though they stuck, first in my throat like giant gob-stoppers, then in my stomach like cannonballs.

Ever tried to swallow a cannonball?

Try these for size and flavour.

Try being shoved into the school gym for Jewish prayers every morning when you were not a Jew but nobody had ever bothered to ask you what you really believed.

Try holding your tongue in your mouth so that it feels like a dead snake when, standing outside on the school terrace, a girl in your class tells you her mother, who runs a famous publishing company in London, had given her strict instructions she must never, ever, talk to Jewish girls under any circumstances because Jews were filthy, smelly and corrupt.

Try getting home early from school one afternoon because you were feeling sick to find your mother in riotous bed with the permanent, live-in, blonde, tanned, athletic-looking Swiss *au pair*.

27

Try learning by rote an entire chapter on the history of Holland, churning it out, word for word, in the examination hall, and being told that you'd gained an excellent A Plus. The teacher had however spotted one single fact that you'd deliberately omitted, in order to test how ridiculous the whole process of examinations was. What on earth is the point of being a spoon-fed parrot?

Try having periods so heavy that the blood seeped everywhere like a dark river set to drown my entire life. Along with the blood went the agony of period pains. Even at Reading University everybody knew about it when I crumpled up in a ball again on somebody's dusty floor.

And then the sore throats arrived. Those eventually were the final straw. The moment I was twenty-one and could make my own decisions, I raced off to Harley Street.

My consultant gasped.

"Great Scot," he said. "I've been looking down throats all my working life, and those are the nastiest pair of tonsils I've ever encountered … Why on earth didn't your mother—"

"She refused to let me have them out," I said. "In case I got TB."

Booba

One of my most treasured possessions is an old
photograph of my father as a young lad standing for
the cameraman with his younger brother, Barney. They are
frozen to the spot, dressed in their best dark suits, looking
as if they've been beaten into a terrified solemnity. Maybe
they'd never seen a camera before. They certainly didn't
smile for this one. My father is holding on to the edge of a
bare table, probably because he would have collapsed
beneath the strain of his new clothes and shining fringe of
hair if he'd only had his legs to support him.

He had an older sister called Lilly, but although she was
certainly the love of his life, I have no photo of them together.

Nor – markedly – do I have any photograph of my most
beloved Booba, my mother's mother, who was also one of
the most extraordinary role models of my childhood: a
woman who maintained a fierce silent spirit beneath a cloak
of rheumatic pain, who had immaculate manners, excellent
spoken English, and who never said a single grumpy word
of complaint to anyone about anything.

The story is that Booba married a man who bullied her

something rotten, who gave her three daughters and a son, and who accidentally killed himself one night by falling down the wooden stairs of their East End home in a drunken rage. She took in everybody's dirty washing to make ends meet. Her four children shared a single bed.

I can only imagine the life of toil, poverty, endless soap suds and damp walls she must have endured and survived. She was only rescued from the worst of it when my father began to give her cash, discreetly bundled into weekly envelopes, that kept the hungry wolf from the door. By the time I got to know her, she was riddled with arthritis, walked slowly with a mahogany stick, and lived alone in a tiny ground floor apartment on the Keir Hardie Estate in Clapton. She'd survived the Second World War from a first-floor room in Stoke Newington, only just avoiding the bombs and increasing devastation surrounding her. Keir Hardie, by comparison, was heaven.

We'd visit my Booba regularly on Sunday afternoons, driving across from our comfortable plush suburban house to the part of London where my parents had lived as children. I loved the journey there and dreaded the one back. I loathed leaving my Booba on her own to face the week alone. She always greeted us with a table piled with delicate chunks of food: sardines mashed with lemon juice on soft white buns. Freshly brewed Indian tea. A spotless table cloth. Neatly cut slices of sponge cake you could swallow in two chews that left you feeling hungrier than ever.

The kitchen was spotless, with no signs of any other food. You could have eaten off the shiny tiled floors. She wrapped every shred of rubbish in newspaper, and never opened a window in case a fly had the audacity to crash into her little paradise.

My father adored and respected her. The cash-filled envelope was always balanced on the mantelpiece and she always said, "Thank you, Reuben," with a look of devoted gratitude. She'd listen fascinated to our tales of the week and the great big world beyond Keir Hardie, but rarely had any of her own. I never saw her with a friend or any of her other children. One of them had disappeared to Brighton. But the other two continued to be East Enders, ignoring her existence. She had her Hebrew Bible which she read from cover to cover. No other books. I once helped her into bed when she was wearing her nightgown. I had a glimpse of her bare legs. They were white as chalk, as if they belonged to a plastic doll.

In the Edgware suburbs, round the corner from our house, were a string of well-built bungalows with pretty front gardens and shiny front doors. I wanted my father to buy one for my Booba. Then I could have seen her every afternoon, taken my cat to show her in a basket, and brought her an iced bun for her tea. I would have had the time and space to ask her about her past. Years later I discovered that when she gave birth to my mother in 1911, she was living in Liverpool. I can only assume she'd intended to leave on an ocean liner for America and a beckoning new world. Presumably her bully of a husband changed his mind – or perhaps she decided to return to the East End she knew and maybe loved.

I shall never know. The last time I saw her, she was sitting miserably in a hospital bed refusing to eat the disgusting food on offer. I was driven home and spent an entirely sleepless night nursing an entirely broken heart.

Decades later I used that scene as a prelude to my third novel for teenagers, *Lost and Found*.

⚭

Daniel stood by the side of the hospital bed.

He looked down at her.

At the frail, wizened hand trying to hold the spoon.

At the mouth trying to pull the grey mince on to its tongue.

Into the dark-ringed eyes which said: "I am sorry. I can no longer eat."

He reached towards her.

He took the spoon from her hand, inch by inch, and put it on the tray.

Metal clinked against metal.

A gust of wind punched through the curtains.

Daniel took a breath of it.

Then he said, "Goodbye, Gran," and turned away.

The words filled his mouth and tasted of mince.

Jump forward some years later. I was living in Woodstock in Hobbit Cottage that I'd transformed from being a draughty shack into an elegant Edwardian dwelling. I'd spent the week spring-cleaning – one of my obsessive annual rituals – and I'd reached the final half hour.

At the back of the last drawer I found a very small stone box engraved with a delicate flower. I'd forgotten its existence. I opened the lid.

Inside it was a small metal thimble. It had belonged to my Booba, who wore it on her busy finger as she sewed. Today, I work with it on my table so that her independent spirit watches over me. She used needle and thread. I use a green felt-tip pen or black ink.

Danger's Claw

"Watch out for those prisoners of war," Daddy told me in 1945 when I was six years old. "They are highly dangerous spies. They look as if they're mending the road. But they can use their shovels to bash your little head in."

I'd wander through Edgware in my smart blue-tweed coat, duly looking for spies and writing down everything I saw in an immaculate notebook. I hid this in my desk until Daddy's wife raided it and stole the key. Then I found a loose piece of carpet under my bed where my Spy Diary flourished undisturbed. Daddy's wife only stole things she could reach without straining her corsets.

Because I was ever watchful and always suspicious, growing eyes in the back of my head became useful assets as I grew up. I learned how to spot the baddies. HAFS I would write with my newly sharpened pencil: Hate At First Sight. Today, they are probably not mending potholes but there are still a lot of them around. The spies and the potholes.

The extraordinary thing about the 1940s and early 1950s was that although we'd survived and seemingly won the

most traumatic of world wars, we lived in an obstinately innocent state. Dire warnings of bacteriological warfare were too horrendous to contemplate – so we pretended it didn't exist. Acid rain? What acid rain! Fog so dense you couldn't see your own nose? Of course it wasn't really poisonous! Having problems breathing? Swallow an aspirin and have an early night.

One morning at school assembly Dame Katherine issued a unique instruction: a man had been seen lurking around the public lavatory in the field outside the school grounds leading to Stanmore station. He spelled danger to everyone. If any of us spotted him, we were to report his whereabouts immediately.

Although it was not my usual route, I deliberately went that way home with a friend who lived in Stanmore. I spotted the shadow of a man outside the lavatory but was much too frightened to confront him or to say anything to anybody. A week later the police arrested him.

"All is well," we were told.

But we'd been given no further details and we were not convinced. The lavatory remained a concrete eyesore in the middle of that field. Heaven only knows what happened in it or why it had been built there. Our minds boggled. That's never a pretty sight if you are teaching maths or history. There's all the difference in the world between girls with active imaginations and those with boggling minds.

Growing into an attractive teenager had its problems. Walking home alone from school one dark winter's afternoon, a car pulled up beside me. A man wound down the window. Stupidly I stopped to answer his question. Would I like to show him the way to Burnt Oak? A ghastly stale-blood stench belched into the street. A hand reached across and almost grabbed my arm.

I pulled away and started to run. The car zoomed off in a puff of angry fumes. When I got home to a gloriously empty house, I told my cat what had almost happened. Listening to every word, he promised me faithfully he'd never talk to strangers.

During my final summer at Reading University a friend hired a battered green van and asked me to go on a picnic, claiming he'd made some superlative cucumber sandwiches. The isolated field into which he drove, without asking me first, contained a filthy-looking thug who was wildly brandishing a machete.

Luckily, my friend spotted him in the driving mirror, cranked the gears and lurched rapidly away. I crouched on the floor of the van, paralysed with fright. My heart beat like a wild bird for hours afterwards. The van was returned to the garage, but memories linger even when they are no picnic whatsoever. I cannot remember what happened to the sandwiches.

Running away from danger is sometimes impossible. Taking my almost one-year-old baby on board a ship sailing for Trinidad in July 1966 was a case in point. I was twenty-seven, slim in my white jeans and blue shirt, a devoted mother with eyes only for her child: a tigress defending her cub for whom I'd have laid down my life.

My parents-in-law, who paid for us to join them in the Caribbean because they'd never met their grandson, had given us a cabin deep in the hold. It was dark and airless. Before I'd even unpacked our suitcases, I noticed a heavily built man with a square head and a ruthless crew-cut lurking in the corridor. As I left the cabin with Sam in my arms, he squeezed past us and stood watching. When I returned, he

had his face pressed against the keyhole of our door. Every time I saw him, he seemed to slink silently away. He was never carrying anything or doing anything other than watching us.

Two anxious days and sleepless nights later, I could bear it no longer. I asked to see the ship's Captain. Shaking with rage and fear, I reported the lurker's behaviour.

"Every time I leave our cabin, he's waiting for us. It's ghastly. I haven't slept a wink since we boarded."

The French Captain, resplendent in his snow-white uniform, bowed over my hand, his hair coiffed, his skin tanned, his eyes navy blue.

"We already know about him, Madame. He has been in this kind of trouble before. We gave him a second chance. But now … Would you be good enough to identify him for me? If you could walk outside my room at two o'clock this afternoon we will arrange for the man also to cross your path … All I need is a nod and – how you say – a wink … He will have no idea you are responsible for his change of duties."

"Of course." I felt slightly less shabby and ridiculous.

"Thank you, Madame. I hope you will accept one of our best suites as compensation. Your luggage, it will be moved there at once. You will have a bottle of our best champagne, a wonderful balcony and a view of the sea." He smiled, his teeth glittering. "And very good sleep from now on."

That afternoon I stood as instructed in the shadows of the corridor while the suspect marched past me, carefully controlled by a colleague. I nodded briefly to the Captain. He went back to his room and I walked the ship in freedom for the first time without the dread of being watched.

The rest of the voyage felt completely different, full of sunlight and sea air, with far fewer stairs to climb. Except I often woke in the night, worrying. When we got back to

Manchester, would I be haunted by the square-headed, crew-cut thug? Might he find me out and exact revenge?

On Tuesday 5 October 1999 I left my cottage in Wolvercote to catch an early train to London. Halfway down the road to the bus stop I realised I'd forgotten to switch on my answerphone. I hesitated in my tracks, decided I might miss some crucial commissioning phone calls, and turned back.

I'd left in a hurry and the cottage looked dusty and untidy. Papers scattered the living room. The thin carpet needed hoovering.

A voice in my head said, "Stay home and do some housework. Don't go anywhere."

I overrode it. I leaped upstairs to my study, turned on the answerphone and ran for the early bus. As I reached the end of the road, the bus trundled past me.

I caught the next bus and therefore a later train.

Here is my diary for the following hour:

Four horse's legs, brown, knobbly, stand on Port Meadow. The rest of him is wrapped in a white ribbon of mist which hangs motionless over the grass. It is 6.45 a.m. I am off to London to attend Elizabeth Hawkins' class on *Writing for Children* at the City Lit University. The sun nibbles at the mist, thins it, drinks it away. The horse emerges from his white-cloud world into a translucent sky, startled, as if he'd forgotten how powerful the rays of the sun can be.

I board the 7.22 a.m. Oxford train. It is clean, empty, its seats a confident blue. I sit by the window, wrapped in *The Mayor of Casterbridge*. I see nothing but the words on the page, hear only Thomas Hardy's voices. I'm transported into his world.

Very slowly I know I'm not reading any longer. There's a

long moment where I'm partly frozen. I'm in Hardy's world – but I'm out of it. I'm on the train – but I cannot remember why I'm travelling. I'm suspended between my imaginative land – and the reality of a field somewhere in the middle of nowhere. In this frozen puddle of time, something frantic calls to me.

Wake up!

The train has stopped. It's now packed with people. There's a deathly silence, broken only by a nervous cough. Someone blows their nose, embarrassed by how the snuffling sounds in the quiet.

Five minutes go by. I cannot read. I cannot think. We're all waiting.

"There seems to be a bit of a problem with the train ahead of us," says the Tannoy.

A minute restlessness waves through the standing passengers. Someone turns a page of their newspaper as if he's just read something absurd. A low murmuring begins at the end of the carriage. The girl sitting opposite me loses her casual cool. She dials a number.

"Maureen? I'm stuck on the train. We've passed Slough but God knows where we are. I'm supposed to be chairing the training meeting at nine and another one at ten. You'd better get Tim to cover for me … Well, tell him to get on with it. He hasn't got a choice." Her pale face flushes.

For half an hour we sit in the middle of a field. A hundred mobiles begin to ring. Snatches of news, picked up and reported by the jigsaw-puzzle voices, run up and down the carriage.

"A fire … Ladbroke Grove … Two trains ran into each other … They were both standing … What do you mean … How could they have collided if they were … How big a fire? … Nothing to worry about? But it must be serious … We're stuck here … We've ground to a halt."

Alarm begins to spark from face to face.

An inspector bolts through the carriage, pushing his way through the bodies blocking his path as if someone had set fire to his head. The train hums into life. It starts to reverse. Exasperated laughs rise and fade. We reach Hayes station.

The Tannoy says, "Those passengers who wish to leave the train may now disembark."

The doors open. I climb out on to the platform, the sky dazzling, the autumn leaves turning to gold, the air cool, crisp, rejoicing. I am free. Into my head come words: clear, distinct, single.

There but for the grace of God …

I don't remember how I eventually got into London, but I do remember opening the door to the class that was in full swing at City Lit. I was so late it was ridiculous. I muttered an apology and sat down. The people around me suddenly blurred. Tears of relief ran down my face. Had I caught my intended train, I should have been killed. I always travelled first class and sat in the carriage at the front so I could read or write. I'd been saved from certain death by an answerphone. Thirty-one people had died at Ladbroke Grove. Many more were injured and traumatised.

When I got home that afternoon my answerphone had stored six messages, all from friends desperate to know whether I'd survived. I rang them each in turn, managing to make light of what could have been the last day of my life. Then I went downstairs to heat some tomato soup.

Tears don't mix well with tomatoes … I picked up the cat instead for a long and very tired cuddle.

∽

The birth of my first grandchild in December 2003 when I was sixty-four was a momentous landmark in my life. Sam was living in New York and I'd trained myself not to worry about him. But as a parent you never stop fearing disaster, praying it will never happen, shutting off your mind and forcing yourself to think of other things.

We planned the trip so that I'd be in New York immediately after the birth and able to see my new family for a week. As luck would have it, Joe, my beloved grandson, took his time. He arrived late, but healthy and blooming. Because they'd both become celebrities, his parents had to manage their lives under a complicated cloak of secrecy, booking themselves into a nearby hospital under false names to avoid being surrounded by the paparazzi.

I was summoned to the bedside and for a glorious half an hour I held Joe in my arms. Sam snapped his camera, Joe jumped in response. Nothing wrong with his hearing, then! I was finally a grandmother: delighted, triumphant, filled with incredible joy.

My family planned to go back to their brownstone house that evening. I got up to leave, putting Joe into his cot, kissing his cheek, pulling on my coat. Outside loomed the December afternoon and its setting sun. Sam turned towards me and gave me a large official-looking portmanteau.

"The midwife forgot to take this with her," he told me. "We have *such* a lot of luggage. Could you take this for us? We'll meet up later for supper. You can bring it to the house when you come."

We stood together in the hospital lift, Sam babbling with happiness. He waved wildly at me from the front door and vanished before somebody recognised him and spread the word.

I walked towards the road carrying two heavy bags. One belonged to the midwife. I had no idea what was in it. The other was my handbag. I was perching for the week in a shabby first-floor flat. Shady-looking characters littered the corridor. The doorman changed identities every time I came and went. I repeatedly asked for a plug for the bath. None arrived. Could I have some heat in the radiators? Heads were shaken. I crammed my clothes into a suitcase each time I left the flat – but I made sure my handbag contained everything else: keys to the New York flat and my Oxford cottage, passport, airline tickets, wallet with dollars and sterling, sunglasses, reading glasses.

I was still dancing on cloud nine. Joe had arrived in the world. Sam was a father as well as a stepfather. The cloudless New York sky shone down on me, gradually losing its light. As I looked up at it, I suddenly realised I had no idea where I was. I'd taken a yellow cab to reach the hospital. Now, when I tried to find its replacement, there wasn't a taxi in sight.

For half an hour I walked steadily on, in the right direction, but unable to fling out an arm to hail anything. My luggage started to feel heavy. My euphoria sank a couple of notches and then another three. It was almost dark.

And a sneering man's voice behind me said, "What have you got in those bags, lady?"

A massive hand thudded on to my right shoulder.

Fear thrashed through me like a bolt of lightning. I knew if I turned my head to look at the owner of the voice, I wouldn't stand a chance. Instead I started to run as best I could. The midwife's portmanteau bumped against my thigh. Nobody would have believed me if I'd told them I had absolutely no idea what it contained.

I hurtled across a narrow road, not looking, cars honking at me. I ran on. My lungs felt as if they were pumping out of my body. I started to pray for a cab. And miraculously, just as I was about to cross another road, one drew up beside me. I yelled instructions at the driver, opened the door and flung myself into it, crouching over the wretched bags as the cab zoomed me away.

"You OK?" the driver asked.

I managed to nod. "I've just become a grandmother," I told him, blood flooding my cheeks. "But then someone started to chase me round the block."

The driver grinned. "Me get you away," he said proudly.

My breath seeped back into my body. I remembered holding Joe in my arms for that miraculous but all too brief half hour. Thank God I'd live to see him again.

"Thank you," I said. "You've just saved my life."

But it almost came to a halt over the next few weeks. My life, that is.

I left New York for London the following morning. A series of near-disasters occurred. The taxi booked to collect me from the ghastly flat had been given the wrong address. I had to pound the streets with a suitcase for three blocks before I found it waiting.

The driver I had booked to collect me at Heathrow failed to turn up altogether.

And as I got off the plane I realised I was seriously ill. I was dripping with sweat, a high fever, a sore throat and a cracking headache. For ten days back in Wolvercote I lay, coughing and sweating, my bed a puddle, my head a muddle, while my Cat sat on the end of the bed listening to me trying to clear my lungs. There were two long nights when I was sure I'd never see the dawn.

Eleven days later I rang for a taxi to take me to Sainsbury's. I faced starvation and the Cat needed food. I climbed out of the car in Sainsbury's car park, half-paralysed with whatever Covid-1, 2 or 3 had done to me. I could hardly walk. I'd lost masses of weight. I clung on to my driver, a cheerful man who suggested I put one foot in front of the other, one at a time, and could he take my bag?

That was eighteen years ago. I decided air travel was no longer for me, and I haven't flown since.

For My Grandson

22 December 2020

Now you are eighteen and I am eighty-one
We'd make the perfect couple could we frolic in the sun
But fields lie between us. The floods swell up. The rain
Descends upon its puddles while pandemic spells its pain.

Now you are eighteen and I am eighty-one
Those numbers are but nothing in the many still to come …
Congratulations darling boy. Your manhood, beckoning
May health and joy attend it as my birthday wishes sing

To you and all around you in happy bubbles, blown
Across our Cotswold fields where the seeds of spring are sown.
Now you are eighteen and I am eighty-one
We shall make the perfect couple in twenty twenty one.

with all my love
Granny Val
21.12.20

44

Early Days in Oxford

After I'd graduated in 1962 my father assumed I'd return to Edgware and get a job in London. I had no intention not only of living in the suburbs, but of staying with my parents whose lives together were strained and miserable. I applied for a job with Blackwell's in Oxford and was immediately accepted.

I packed a small suitcase and carried it down to the hall. My father began to rant and rage. He told me I'd never survive on my own, that the world was a cruel place, that he had his eye on a suitable admirer in Golders Green who was wealthy and would make me a wonderful husband. I told him I was perfectly able to make my own friends and had no wish to get married. I marched out of the house and walked through Edgware to the station and freedom.

Ten days later my father sent me a brief apologetic letter and a cheque for £25. I wrote to thank him but my heart wasn't in it. I knew he'd washed his hands of me and wasn't the least bit interested in knowing what I wanted to achieve.

In Oxford, I rented a single cold room in Beaumont Street for a week. Then a landlady who had connections with

Blackwell's offered me an attic flat in a house she owned in Little Clarendon Street. At the top of four sets of stairs, my own two rooms had a living room with a narrow divan bed and a window overlooking the road. Behind it sat a rough kitchen with an ancient cooker, a wooden table and two wonky chairs. Its chimney breast had been sealed off. One summer afternoon a year later I heard a bird trapped behind the wall flutter up and down it until the heart-breaking sound died away. On the hall table by the front door sat our rent book where every week the house's occupants put their small piles of cash and signed their names.

The bathroom was in the basement, off a communal kitchen I never used. But every morning I'd go flying downstairs while the three other occupants of the house were still asleep, to run a deep bath by putting three pennies in a gas boiler and watching the hot water steam out of the rusty tap.

The house's only lavatory sat on its own at the end of the ground floor. During my first winter there the Big Freeze held the whole of Oxford under rigid layers of snow and ice. After weeks of peeing into bottles I made a brave attempt to de-freeze the lavatory by flinging various chemical concoctions into the pan – and almost choked to death inhaling the fumes.

Many years later I used my memories of this house in my second adult novel *Daddy's Girl*. It's the one Walter rents as a young artist, and where he manages to persuade Moira to live with him.

Working for Blackwell's on the Cowley Road was the most brilliant introduction to the world of books anyone could have had. I was employed as a super-sleuth to solve the hundreds of problems in the bundles of letters that arrived

every day from all over the world. I'd set to work finding the solution, patiently digging around in the paper files, writing careful letters of explanation and apology.

Gradually as I grew more experienced I began to recognise the patterns that emerged: those areas of the world where books never arrived, or only half the order had survived, or the money had vanished in transit. Or all three and more. The permutations were endless. It's hard these days to remember that most of the world to which Blackwell's was then sending its wares didn't even have a telephone; that letters could take weeks to arrive at their destination; and when they did, the wrong people often opened them.

I always felt a thrill of delight when I read about the passion with which people even in the most remote corners of the world wanted to improve their minds by owning and opening a book. Every now and then a letter of thanks would arrive, gratitude streaming out of its beautiful handwriting and excellent grammatical English. They made the hours of headaches and apology worthwhile.

I had more sleuthing to do when I joined the Taylor Institution as a librarian. I had vague plans to qualify properly in London and wanted to experience life in one of the oldest libraries in Oxford. The enormous leather-bound files crackled with labels and meticulous details written in black ink, but the office of the Head Librarian was an untidy nightmare bordering on chaos. I remember one afternoon spending three hours trying to track down a book for a desperate reader who needed it for an imminent exam. When eventually I emerged with it, both of us covered in cobwebs, the reader broke down in tears of gratitude.

Other vivid memories sharpen my early life in Oxford. On

47

the afternoon of 22 November 1963 I arrived home to hear on the radio the news that President Kennedy had been assassinated. My legs buckled beneath me. I crashed down at the top of my flight of stairs, appalled at the details as they emerged, hardly able to believe what had happened out of the blue to such devastating effect. Only a year before I'd listened rapt as Kennedy navigated the Cuban missile crisis, so his voice was familiar – and now it no longer existed at all.

On another occasion I received an invitation from Robert Maxwell to attend a businessman's meeting he was chairing from Headington Hill Hall. I've no idea why I'd been invited, but I duly set out from my flat after work, and in a hurry.

It had been snowing, the path to my house was slippery and over I went, flat on my face. I arrived at the meeting wearing a green pixie hat that fell over one eye, damp trousers and snow-bound boots. Maxwell made a point of welcoming "the only woman in the room" at which point I turned bright red, wishing the earth would swallow me up.

Around that time, Maxwell opened a new bookshop in St Clements called Maxwell's of Oxford. Blackwell's were terrified that his shop would become a serious rival. They needn't have worried. Maxwell was told that many of the shop's expensive academic books were vanishing without being paid for. He installed himself behind a shelf to watch what was happening, and collared a student intent on making his escape with stolen books. The student told Maxwell he could afford to give away a few books and ran off with them. Maxwell closed his new venture overnight. As far as I know, he never tried to be a bookseller again.

Other remarkable memories include cycling round Cowley Place's roundabout and falling off in the middle of heavy traffic. Luckily, everyone swerved to give me the space

to get up and hobble away. And finding one evening after a bath that I'd locked myself out of my flat. Wearing a blue-felt dressing gown with a high embroidered Chinese collar over my naked body, I dashed out to find my landlady who lived with her boyfriend in a house on Wellington Square. I pounded on her door. The moment she opened it, I apologised and asked for a replacement key. Luckily again, the streets were empty. My landlady didn't seem to mind being disturbed by one of her tenants, albeit half-dressed and fluffy-slippered.

I always felt there was something very special about Oxford even though I had no idea at the time that I'd return to live in Woodstock with a twelve-year-old Sam. A post with Oxford University Press and an invitation to work for them again meant that Sam was automatically offered a place at Magdalen College School. Oxford doubly became the centre of our universe.

The city hadn't changed a single inch in the intervening years. The University Parks still blossomed, the bell of Tom Tower tolled, the university undergraduates hurried along the streets, their black gowns billowing. The covered market – now sadly much depleted and greatly mourned – sold everything from cat baskets to exquisite jewellery, expensive leather boots and lamb chops. The Bodleian was still the Bodley, and the well-manicured grass still lay a perfect green in every quad.

Sam and I used to share a joke: Two Oxford academics are cycling down the High Street in their black gowns. One of them is saying to the other, "And eighthly …"

Even now, so many years later, it makes me laugh.

Finding My Voice

After our trip to Trinidad and Tobago to celebrate Sam's first birthday in 1966 we returned to our flat in Manchester. The bedroom floor lay exactly as we'd left it: scattered with discarded clothes and toys. Sam picked up his teddy bear. It roared its teddy welcome at him. After a long and what must have been a bewildering journey home, Sam burst into tears of shock and exhaustion. I cradled him in my arms, gave him supper, a lovely bath – and as always sang him to sleep.

I hadn't written anything during our two-month trip, and now eagerly opened my desk and began an article describing our adventures. The liners that took us there and back across the oceans which were warm enough to swim in. The outdoor lives of the Trinidadians. The lack of a long twilight and instead the sudden draining of day into night. The way neighbours would appear uninvited on to verandas for an evening rum and Coca-Cola, and then vanish back to their own homes. The surprisingly harsh seas in Tobago whose waves had knocked me flying. The sudden warning of an imminent hurricane. The baking hot sun. The airless heat of the indoor cinema in Trinidad. The beaches where white people swam in the morning, black people in the

afternoon. And everywhere the racial tension that hung in the air, palpable and threatening.

My in-laws invited us to stay permanently.

"You'll have servants for everything," they told me. "You won't have to lift a finger … You could teach English, both of you. Who wants to go back to rainy old England?"

I did, very much indeed. And the first thing I decided to do when I got home was to send my article on the Caribbean to the pioneer radio producer Olive Shapley at the BBC in Manchester.

As a child I had been an avid radio listener. I vividly remember the first time I heard the fabulous Paul Robeson sing his spirituals with an incomparable bass-baritone that has stayed with me for my entire life. I'd rush home to listen to *Children's Hour*, to its thrilling and often terrifying dramas, masterclasses in storytelling for children, and to many of the programmes for which the famous Uncle Mac and often Olive Shapley herself had been responsible. Now moving towards the end of her long and extraordinary career, she still had a great deal of power and charisma – and years of uniquely varied experience behind her.

Her prompt reply invited me to meet her in her studio. I was so excited I rushed around for three days trying on different outfits, buying a new lipstick and having my hair cut.

Olive held out a welcoming hand.

"Delighted to meet you … Do sit down." She rustled my article at me. "I like this a lot. It's original and it's gripping. You cover a great deal of ground. Your descriptions of your son are revealing and honest. You certainly bring the Caribbean to life."

She paused.

I said, "I hear a but coming."

"Yes." Olive smiled. "But you are still writing academic prose." She leaned forward in her chair. "*Why don't you write as you speak?*"

"You mean – "

"I mean stop preening and polishing everything. Shorten your sentences. Pretend you are *talking* to people in their own homes. Relax. Let the air in. Sparkle and enchant me."

I gasped. "You make it sound so easy."

"It isn't, of course, but I think you could do it really well." Olive glanced at some schedules on her desk. "We have several different slots at the moment that would suit you down to the ground. You have a lovely speaking voice. Send me a couple of new features about anything you like. Your life at home. Your baby, your domestic problems. Anything our listeners can relate to, identify with. Make them think. Write the articles and then read them out loud. Time them to the last second. We'd like you to broadcast them yourself, and each time we can allow you a minute and a half."

Olive stood up to shake my hand. "Be brief, be succinct, be brilliant."

Tears of gratitude stung my eyes. "Thank you so much, Olive. I'll do my very best."

I caught the bus back to Didsbury, ideas for new features buzzing in my head. Back home, I gathered Sam into my arms to do a joyful jig with him in the living room.

I had had a difficult time getting used to living in the north of England, which to me felt hostile and alien. My husband had been offered a job teaching English at Manchester University and I had no choice but to follow him. For the first time in my life I longed to live in London. I bought the *New Statesman* every week to see what was showing at the

Everyman Hampstead cinema. I hadn't made any new friends for a whole year. That didn't matter because bringing up Sam had been an engrossing full-time job.

But now I had something to do as well as raising him. I'd write for Olive Shapley and the BBC. She had faith in me and that was all I needed.

The most important thing about my commission was that Olive hadn't been prescriptive, she'd simply been encouraging. Her job was to recognise talent, not dictate to it. And because she gave me freedom, I quickly found that I had opinions about practically everything.

In 1967 alone I wrote and broadcast short features for *Spectrum*, *Roundabout* and *Woman's Hour*: wherever the BBC thought was most suitable and whoever needed a ninety-seconds filler. Brevity is a marvellous discipline. Instead of rambling on in dull, pompous, academic prose, I could use my own voice and tell it like it was. I had nothing to prove. I had everywhere and anywhere to go.

Reading everything aloud is also a great discipline. I could immediately hear the obvious repetitions and knock them on their heads like weeds. I got into the habit of asking myself: Is this word absolutely necessary? If it isn't, delete it and watch your garden bloom with a healthier and sweeter-smelling rose. To use a domestic comparison, it's like opening an untidy drawer full of underwear, tipping out the contents and putting back only what you need and like. In five minutes the look and feel of the drawer is transformed from ancient muddle into freshness and order. I was also a regular listener to Alastair Cooke's *Letter from America* on Sunday mornings, which I always thought an outstanding example of brevity and informative wit.

All I needed to do was follow the master.

Here are three examples of the features I broadcast:

For Roundabout on 29 April 1967:
a talk called RADIO TRINIDAD

To my rainy English mind, the word "tropics" meant sunshine, health and a natural vitality that didn't have to be dosed from bottles. So the prospect of having a summer vacation in Trinidad, in the West Indies, was an obsessively exciting one.

When the French liner docked at Port of Spain under charcoal skies and blankets of rain I simply could not believe that we hadn't sailed north to Finland by mistake. The tropical humidity, which is like standing in an oven full of wet washing, made its point with a heavy hand.

No, Trinidad isn't always like that. July, August and September, as we discovered to our cost, are known as the rainy season. But the Trinidadian radio system doesn't function in seasons: it retains the incredible gloom of the skies that greeted us.

A constant and obscene pessimism emanates from the American-inspired advertisements which crash into music and conversation alike. But instead of sweets or shampoo, it's drugs you are asked to buy, of every varied and dangerous nature. Go to work not on an egg but an aspirin. Come home not to baked beans on toast but fruit salts. Make sure your child takes his daily cold-preventive medicine – not forgetting his nightly sedatives and anti-worm juice. As a mid-morning break, you'll be able to hear a list of all the people who've had the misfortune to die the night before. Then, if you can, try bravely not to become a hypochondriac.

So when you're told yet again that the calypso is the expression of the West Indian's "natural exuberance", have the courage to disagree. Much more than that, it's a beautiful and successful method they've evolved for cheering themselves up.

For Roundabout on 25 April 1967:
a talk called TALKING BABIES

Some stories begin with a conversation overheard on a bus. Mine begins with one I failed to hear. A mother with two children, aged around four, travelled in front of me this morning for twenty-five minutes without saying a single word. A few jokes took place, but all in what was obviously a private – and obviously silent – mime language of their own.

Is talking going out of fashion to that extent, I wondered. Lots of fuss is made about teaching children to read, but can they, do they talk? Only if they're spoken to, surely. I have "talked to" our baby son ever since he was born – not in baby jargon, but ordinary language without undue emphasis on any single word. Now he's nineteen months old and beginning to form his own sentences.

But the looks I've had, and the snide remarks.

"Oh, you talk to it, do you?" as if "it" has to be all of three foot four and playing football before language is permitted.

You don't teach a child to talk by yelling "doll", "cup", "carpet" at him at odd times of the day. You explain, comment, or chat to a companion – and he'll listen. For our children are [or should be] constant companions until they're off to school, so why not treat them as such?

The only disadvantage of course is that he'll swear too. Our child has an extensive vocabulary of long, short and mildly forbidden words. But are my feelings of guilt for my swearing, or the fact that his friends will hear him?

I'm a hypocrite, I decide firmly – but at least I'll talk about it.

For Spectrum on 2 July 1967:
a talk called LISTENING TO MUSIC

One of the most embarrassing evenings I've ever spent took place in London's Festival Hall some years ago. My escort was a young, ambitious businessman who, to my astonishment, as soon as the first Beethoven notes sounded, produced a large sketchbook and thick black pen, and proceeded to draw what he could see. The pen gave a faint squeal, like a lizard squirming between damp leaves. By the end of ten minutes I was a quivering mass of nerves, anger and resentment that he'd been allowed inside a concert hall, and that I'd been stupid enough to accompany him.

What I'm going to argue for now would make that kind of behaviour impossible. I realise that my escort was a trifle odd. Not everyone attends concerts armed with pen and pencil – or indeed anything at all that makes a noise in addition to the one advertised for the evening's entertainment. But in a theatre or cinema we see only the stage or the screen. So why do all those disturbing and irritating lights remain on in the concert hall?

Oh, yes: you've brought your own music sheets and want to be able to read them. This problem could be easily overcome by retaining a small proportion of the seats specially for music readers. These would have discreet but adequate lighting, and a proper place to balance the sheets. But the layman would sit, please, in beautiful darkness to look not at a fidgeting audience or horrible hat, but at the orchestra, soloist or singer.

Am I particularly self-conscious or do other people hate to be looked at while they're listening to music? Listening isn't just a passive art. It's difficult and requires a sustained concentration capable of shutting off mundane worries and plans for a considerable length of time. "Real" listening

means hearing the corners of music, not just the well-known themes. It means feeling the constant surprise and admiration at the expert planning of sound, the continual rediscovery of familiar territory, or the satisfaction on finding a new one.

I can't be unique in finding all this very difficult under bright lights.

For the concert hall has one great advantage over music played at home: once a concert has started, the neighbours may call round, the phone ring, the children howl, the groceries arrive, and the gardener next door can rev up his infernal lawnmower again.

Blissfully, you won't know anything about it.

The concert hall gives us the privilege in this incessant noise-ridden world of listening to a piece of music in its entirety. So let's honour the privilege more often, pay our musicians more respect – and please: turn off the lights.

I cannot remember the date of that concert and I've been to many since. Most of them have been in darkness. Somebody out there, at some time, must have heeded my passionate request to dim those lights.

I relished writing features like these. I enjoyed planning my trips from Didsbury to the centre of Manchester; learning how to use a microphone; feeling albeit briefly a part of the professional broadcasting team. I was treading a new learning curve and loving every minute.

Olive Shapley's original confidence in me gave me back my confidence in myself. I began teaching English at the College of Further Education in Didsbury: only part-time and only in the evening, so I could still look after Sam during his waking hours. The college offered me a full-time post which reluctantly I had to refuse. Instead I flung my energy

into finding us a house in Didsbury. I organised a mortgage and all the removal details, decorated each of the rooms, and designed the back garden so that Sam had the freedom and security to play in it. After the confines of a first-floor apartment, the little house was bliss.

But my "marriage" was falling apart before my eyes. For months I agonised about making the decision to leave. Then two specific events suddenly became major triggers for my departure. On a visit to London to see my parents, I offered my opinion on an outfit my father had designed to several buyers who were in his office at the time.

"Don't listen to her," he told them. "She's only a Manchester housewife." The cruelty and inaccuracy of his description shocked me and crushed my spirit.

And then one morning I returned from the local shops with Sam to find I'd accidentally locked myself out of my house. I went next door to a kind elderly couple and asked for sanctuary. They gave me a cup of coffee and Sam a glass of milk. As we sat talking round their kitchen table, they started gently teasing each other about something that had happened to them the day before. They laughed together, looking into each other's eyes as if they were love-struck teenagers.

I realised that nothing I could ever do in a hundred years would let my husband and I share that crucial life-saving wavelength of laughter and joy.

The following morning I left the life I'd built in Manchester, my jobs in broadcasting and teaching, the house I'd bought and cared for, and the man who made it transparently clear he'd never really wanted me. I had my beloved Sam, my health and strength, and a world of courage and determination burning in my heart.

I never went back.

I hoped I'd faced the truth, made the right decision and that only good would come of it. In Sam's small bag sat his clothes and toys. In my suitcase lay a few clothes, a few books, my own short stories – and my BBC scripts. There weren't very many of them. They weren't the most brilliant talks the world had ever heard. But they were original and they were mine: my chosen opinions, records of my own small world, written and broadcast in my own voice.

They proved to be my passport to a new life as a single mother in London.

Becoming a Journalist

During the summer of 1968, my father died. Although I'd known he was a very sick man, and we no longer liked each other, in Didsbury, remembering my early childhood and how much I'd loved him – and how horribly he'd changed in later life – I mourned him as if my heart would break. With the money he left her, my mother bought a small first-floor apartment close to Primrose Hill. Sam and I moved into it with a few sticks of furniture. My first job as a journalist paid me £100 a month. I gave £60 in cash (to avoid the tax man) to my landlady. Sam and I lived on the rest.

I found a marvellous nursery school for him in St John's Wood, owned by a great teacher and lover of small children, Gitta Wantoch, and run from a large shed at the bottom of her garden. Sam adored being there. Every morning he'd chomp his way through a large breakfast and wait impatiently while I did the washing up. Then we'd race downstairs to his pushchair and march off down the road.

We had special names for our landmarks as we passed them. One was an ancient tree which I christened "Mr Gnarled and Wizened". His vocabulary as a three-year-old

was already formidable. When another child called Sam subsequently joined Gitta's select band, Sam became Big Sam and his companion Little Sam. There seemed to be room for them both.

The wonderful thing about London at the time was that it was still a remarkably safe place to live. I travelled on the Underground without worrying about bombs or fires. I walked over Primrose Hill at night on my own without fear of being accosted. I sat in one of Regent's Park Road's many coffee bars without being chatted up. The great city felt relaxed and at ease with itself. And so did I.

I didn't have much money, but I'd got used to being poor. I wore jeans, polo-neck sweaters or high-necked shirts and long flowing waistcoats summer and winter, with sturdy walking shoes. I carried a bag of washing to the local launderette every week and collected it, washed, dried and folded, on the way home. The only serious piece of new furniture I bought was a long wooden table which I found at Heal's. When it arrived, I managed single-handedly to carry it up two flights of stairs and put it together with its legs. I slid it into my bedroom which doubled as a study, with my Olivetti typewriter and small wooden bureau. My window looked on to the tree-lined Elsworthy Terrace and the borders of Primrose Hill. Cars may have come and gone, but I was never disturbed by the noise of traffic. My happiness at being independent knew no bounds.

All I needed was a job.

I'd lost touch with most of my London friends over the previous few years, but one of them told me about a company called Marshall Cavendish, a group in Soho run by three brilliant men: Norman Marshall, the figurehead

and flair of the organisation, Patrick Cavendish, the brains, and George Amy, their finance director. Between them they'd developed a successful formula for publishing encyclopedias in weekly parts. They'd begun with *Mind Alive* and were just about to launch a second, *Book of Life*. I was told they needed an in-house writer and project editor to join the team.

I rushed back to my apartment and my stalwart Olivetti. I made myself a cup of strong coffee, took a long gulp and a deep breath. I sent Norman Marshall a brief CV, a description of how I'd just spent three years raising a small child, and copies of my BBC scripts. I was asked for an interview by return of post.

Norman seemed to know instinctively that I'd be perfect for the job. He admired the fact that I was a single mother, agreeing without question that I could leave the office at 3.00 p.m. in order to collect Sam from nursery school, and take work home to finish in the evenings.

The only condition he made was that I must never wear trousers to work. At the time I didn't have a dress or a skirt to my name. I lived either in jeans or flared black trousers, so I spent the following day buying two dresses for the office, three skirts, black tights and two pairs of low-heeled shoes. Coats, gloves and accessories had to wait until I'd received my first pay cheque and could afford them.

I shall never forget my first day at work with Marshall Cavendish, standing at the door of their Soho offices filled with excitement and anticipation. We were a small team and each of us had a specific role. We worked as a group cheek-by-jowl in the same open-plan office to a tight weekly schedule, six weeks ahead of our actual publication date. Everything we wrote or commissioned was vetted by our

editor-in-chief – at the time an intelligent, civilised man whose beloved dog lay faithfully under his desk all day without disturbing anyone – and then typed up by a wizard secretary who uncomplainingly worked for us all.

Each weekly magazine was divided into strands, with its own identity. The art director oversaw the front covers, approved all the internal photography and artwork, and designed the look and feel of every magazine. Each week it was a question of getting things right first time around: none of us had even an hour to make mistakes.

Most of the articles for *Book of Life* were written by professional contributors who'd made a name for themselves in their own special fields. The encyclopedias had already gained an excellent reputation not only because they were interesting, accessible reads, but for being accurate and up-to-date. Every now and again I took the plunge and wrote a feature myself. I remember researching and writing an article called *The Roman Child* and thinking it would make a brilliant, accurate basis for a children's novel.

One afternoon Norman burst into our office brandishing some photographs. Tall, silver-haired, wearing an immaculate pale-linen suit, his eyes glittered with excitement. For the first time ever, we were able to see photos of the foetus, curled in its mother's womb. And what was more, we had obtained permission to publish them. It was a veritable coup.

Book of Life indeed.

By the time I started work on our next project, *Man and Woman*, I'd proved to be a good, reliable and experienced in-house writer. I was given a double-page spread at the centrefold of the magazine. Each week I invented a couple who were tackling specific problems in their lives, describing

their dilemmas and outlining some kind of resolution. It was psychology made popular and instantly understandable.

During my time on *Book of Life* I'd commissioned London's most distinguished psychoanalyst Charles Rycroft to write a series of articles. He did so with extraordinary grace and speed, and the articles were brilliant. We became genuine friends and spent hours discussing the psychological problems of his patients – although of course I never knew who they were. Later, Charles was the one who encouraged me to learn to drive and to enter book publishing proper. Twenty-five years older than me, he needed an enormous amount of attention and the kind of loving care his own aristocratic and rather formidable mother had failed to provide.

One of the things I'm most proud of achieving while I was writing and editing this centrefold was to persuade the Marriage Guidance Council to talk about their work. Up until then, it had remained extremely protective about what it did. I admired their aims, and told them that if they were prepared to describe their methods and working practices, more couples and individuals would have the courage to ask for help. Of course, names had to be protected and private conversations needed to remain exactly that. But their previous secrecy did nobody any good: indeed it had worked *against* the Council, often making couples with problems feel guilty about asking for help. As if they were criminals rather than human beings who for a host of different reasons had hit the buffers of the most important relationship in their lives.

They listened to my arguments – and eventually agreed. They renamed the organisation *Relate* which sounds and is a much more accessible and couple-friendly name. Long may it last.

I'd worked for Marshall Cavendish for almost five years when I heard the news that the company had decided to change tack and publish magazines on home economics and knitting. I wasn't the least bit interested in going down-market with women's magazines. One morning I received a phone call from a furious man who accused me of spying on his family. Quite by chance I'd published a fictional article about a couple who'd moved from Australia to London and encountered problems along the way. I'd hit a raw nerve and told the man's own story.

This incident became the trigger for me to leave Marshall Cavendish. One evening in 1972 I wrote to twelve London publishers, sending them my now longer CV and telling them I wanted to move into book publishing.

Oxford University Press replied, saying I didn't have the right experience. The following day they wrote to me again. Somewhere in the space of a few hours they'd changed their minds. I'm sure the person behind their revised decision was OUP's Publisher, John Brown (he was knighted in 1974), or Bruno as he was always known to his friends.

I was asked to join them in Ely House in Dover Street as a member of Tutorial Books, soon to be renamed the English Language Teaching Division. I was thirty-three years old. I desperately wanted to make the move from ephemeral magazines to the solid, more permanent world of book publishing. And I liked the idea of managing OUP's list of "readers" for children living overseas.

I had no idea what lay ahead of me, but I could hardly wait to start.

Sixteen years later, in October 1988, as Publishing Field Chair at Oxford Polytechnic, I published the first of what

were intended to be a series of small magazines called *Publishing at Oxford Polytechnic.* In its introductory article, *Making Sense of Teaching Publishing,* I wrote:

"When I began my publishing career proper in 1968 it was as a journalist for Marshall Cavendish in the heyday of their part-work publishing. I offered them a sharp eye, an organised mind, an excellent memory, a highly trained pen and unlimited dedication.

"I owe Norman Marshall a great deal, for he gave me both freedom and responsibility without once questioning what I would do with either. It was not until I eventually stepped into book publishing five years later that I began to realise just how valuable that apprenticeship had been. After the pace, the clear definitions, the clarity and the confidence of the world of weekly magazines, book publishing seemed to me to be slow, stuffy, ponderous, often ugly and irrelevant, hidebound by out-of-date traditions, and sunk into self-analysis."

Of course, it wasn't always as bad as that.

There were some wonderful moments too – and a great deal to learn about a global network and one of the greatest publishing companies in the world.

Behind the Wheel

"All aboard!" Imperial Leather Daddy opened the door to his pride and joy.

As always, he'd spent that Sunday morning washing, polishing and admiring his Armstrong Siddeley which now basked, gleaming and immaculate, in the early afternoon sun.

It was 1946 and I was seven years old.

I adored my darling Daddy in those halcyon days. The only time I had him to myself was when we drove together, just him and me, to see his parents who lived in Hampstead Garden Suburb. They hated the woman he'd married and she loathed them.

"Hop in then, Valerie."

Ecstatically, I hopped. I wore a green silk dress embroidered with red poppies my beloved grandfather had made for me. The fabric brushed against my thighs as I sat down. It felt cool and I felt beautiful.

I asked as I always did, "Will you tell me another story about King Kong?"

"But of course." The enormous car swung down Hale

Lane towards Burnt Oak beneath the hairy hands of its superb driver. "Once upon a time ..."

And we were off. My father was a magnificent storyteller. King Kong was a benevolent despot who ruled over his small kingdom in extraordinary ways. The master of disguise, he'd dress up as a peasant or a farmer and eavesdrop on other people's problems behind a dustcart or from the branches of a tree in order to find out what was going on. He'd then become disastrously involved in solving every solution under the sun, before returning to his throne and pretending he'd been asleep all the time.

My father made everything up on the spur of the moment, often making me laugh so much my tummy ached. He loved being behind the wheel. The sense of going somewhere, but not yet being there, gave him a freedom he never found anywhere else.

My darling Daddy hung on to the Armstrong until it finally fell apart at the seams. Sitting in front with him was my definition of paradise. Relegated to the back seat behind his wife was an entirely different kettle of fish. Immediately, I felt sick. The car was surprisingly cold and draughty, full of places that didn't quite fit together. But my father never sat in the back, so he had no idea.

On one occasion we'd driven to France for a brief summer holiday. By accident I dropped my riveting book down the Armstrong's gangly side. Its cliffhanger ending remained forever unresolved: try as I might, I was unable to wheedle the book from its hidey hole.

While my father's driving instincts would have rivalled Lewis Hamilton's – although he was never interested in speed – my mother was without a doubt the worst driver the world has ever endured. In those pre-war days she didn't need a

formal driving licence and would not have obeyed any of the rules if she'd ever taken a driving test. She simply made things up as she drove. We're not talking stories here, we're experiencing lunacy. Besides, her driving instructor would never have survived the ordeal.

Once, collecting me from Reading University at the end of term in her fashionable white Mini, she drove head-on into another car as she was coming out of the car park. I was in the back, doing battle with three old suitcases, books and bundles of files. Blithely she stood in the middle of the road for an hour, claiming it was all the other driver's fault. Fed up and humiliated, I left her to it. I caught the train to London, and the tube to Edgware.

The next day, unpacking the battered Mini which my mother had somehow managed to drive home, I discovered that during the very public argument some clever clogs had stolen the best of my suitcases containing most of my clothes, and ransacked another. All my Charles Trenet records had vanished.

In her later years, as her driving disintegrated from grasshopper to slow-worm, my mother terrified the residents of her block of flats in St John's Wood. She clunked and stalled her way out of the communal car park every morning on her way to coffee with friends. Her long-suffering neighbours took one look and postponed their plans, pretending to be frightfully busy with something else.

One morning, just after I'd bought an apartment in West Hampstead – I was in my early forties – I'd been to see her and my beloved stepfather, Donald Veall. She offered to drive me home. I was incredibly busy at the time, trying to settle in, so reluctantly I accepted her offer. Halfway up the Finchley Road I asked her to stop the car. She screeched it to a halt.

"You're driving like a lunatic," I told her. "You change lanes without a signal and you almost mowed down that cyclist."

She yelled with laughter.

"This isn't a joke. You're extremely lucky to be alive … Now let me out. Try to get home without killing anyone along the way."

I never sat in a car with her again. She continued to massacre the St John's Wood roads in what she called "my lifeline" until she was ninety. Only once did she condescend to climb on to a London bus. She disliked the experience so much she got off one stop later and hailed a cab.

My best friend at school, Pamela Sutcliffe, sat behind the wheel the very day she came of driving age. Her parents immediately gave her a car. We were all terrifically impressed as we watched her purring into the school car park.

At least, we pretended to be.

I didn't much like the idea of driving on my own. I adored walking everywhere. Edgware had a brilliant Underground station and I liked hopping on and off its regular trains. Most Saturday nights I'd take the tube to Golders Green and its theatre, where I sat in the gods to watch anything and everything. My most glamorous boyfriends had cars of their own, although my father – whom I no longer liked, let alone loved – turned green with jealousy if theirs were more expensive than his.

But then I grew up and had Sam. I began to have a regular nightmare. I was in a house full of children, one of whom was taken ill. I'd hold the child in my arms and run out to take them to hospital … only to discover as I climbed into the car that I had no idea how to make it move.

One evening in London I went to supper with a friend.

He drank a great deal of red wine and then climbed into his car to take me home. Within minutes the police flagged us down. They took him away and put me in the hands of one of their own sober drivers. The moment I got home they rang to warn me about getting into a car with a drunkard. They removed his licence for a year.

I'd been handed the final straw. The following morning I made an appointment with a top-notch driving instructor.

I took to the whole thing with relief, anticipation and joy. My brilliant instructor was a thin, eager man with a Spanish accent and the face of a belligerent parrot.

"Make a decision," he'd tell me. "And then make it happen. Not tomorrow or the next day but NOW." He punched the air. *"Mirror, signal, manoeuvre … NOW."*

His words echoed in my head as I bounced triumphantly back to my apartment. Within two months of weekly lessons and no practice sessions, I'd passed my driving test. I went to meet Charles Rycroft in Harley Street for a celebratory lunch.

"So!" Charles pumped my hand up and down. "Congratulations, Valerie … Absolutely marvellous … Now you have a licence to kill."

My mother decided to buy herself a new car and gave me her ancient blue-green Triumph. My heart in my mouth, sweating with fear, I drove it to the local garage to be checked. Everything was faulty: the brakes, the gears, the tyres, the lot.

The garage mechanic peered at me and frowned.

"This isn't a car," he told me. "This is a lethal rust bucket … Where the hell's bells did you get it? … *Your mother?*" He doubled up with laughter. "Are you kidding?"

I persuaded him to patch it up, and paid him a king's ransom to do so. But I knew it was a short-term and potentially dangerous solution. And it certainly wasn't plain sailing. By that time I was working for Penguin Books and sometimes needed to attend meetings in Harmondsworth. Driving to Penguin's headquarters in Grosvenor Gardens was difficult enough. Getting myself to Harmondsworth was positively exhausting.

One afternoon I almost disappeared beneath the wheels of a huge lorry that bullied me along for several miles before it overtook me at ferocious speed. The driver's companion spat at me through the window. I shook with a mixture of anger and terror for hours afterwards, and then forced myself to make the journey home in time to collect Sam.

The following year, one of my best ever friends took one look at the Triumph and, horrified at what I was tottering around in, gave me a surprise birthday gift. It was a brand new silver Ford Escort that completely changed my life. It sat outside my door on Primrose Hill, my pride and joy. When Oxford University Press asked me to move to Oxford to take up my former post with them, I could give them an immediate, "Yes."

As well as good walking legs, I now had decent wheels. Without them my life would have been completely impossible.

I became a chauffeur as well as a mother, a publisher, a teacher, a gardener, a cleaner, a washerwoman, a housekeeper, a writer and, I hoped, a friend. The Ford was an automatic: I never learned to control her on snow or icy roads. But in every other way, she allowed me a fabulous freedom and independence, even though I couldn't afford to go anywhere but to and from Woodstock to Magdalen College School and Oxford.

By the time Sam had won a place at Peterhouse College, Cambridge, I'd chosen to leave Oxford for a while to revisit London's publishing life. I took one look at the big city's traffic and sold my beloved Ford. I decided to manage once again without wheels.

It's a decision I've never regretted. Today I can travel with my free bus pass (or I could before Covid-19 struck us) and hire a chauffeur-driven limousine when I need to. I'm doing my bit to improve the so-called quality of the toxic air we all have to breathe. I never worry about the price of diesel or where to park. And if there are days when I desperately miss my silver Ford – well, I take a walk around the gardens of Blenheim instead.

Luckily, thanks to a new titanium hip, I can and do still walk.

As for telling a good story, I've found all I need for one of those is a centrally-heated room of my own, excellent health, a circle of friends, a functional computer, stamina, determination, a good night's sleep and scrambled eggs for breakfast.

Tell that to Daddy for me when you next raise a glass to Old King Kong.

Oxford University Press

When I walked up the steps of Ely House to join OUP that first morning in 1972 I had a sense of destiny. It felt a bit like Buckingham Palace without the flunkies. The Press used to say prayers every morning before work began, so Ely House was also chapel and church and had a saintly feel to it. Dark-suited men floated silently up and down the elegant stairs carrying documents, as if they were members of the secret service. They probably were. The great children's book publisher, Mabel George, was one of the few women who worked there. I remember seeing her waft in the front door wearing a dark green cloak. She was always alone and never seemed to speak to anyone, but she had a formidable reputation and an outstanding list to match.

The Press had a name for being a great training ground for staff who quickly tired of their complicated rules and regulations and disappeared elsewhere. But OUP's tentacles stretched far and wide, not only in the UK but also in their many branches overseas.

That first morning I wore a white muslin shirt with long billowing sleeves, a black woollen waistcoat and a knee-

length black skirt patterned with white polka dots. It was as formal an outfit as I could manage. I had straight dark hair cut into a bob, with a heavy fringe. Somewhere along the line I turned the bob into a fashionable frizz. It was a big mistake. The following day I went to collect Sam who by then was a pupil at Primrose Hill Primary School. One of his friends stared at me, then did a double-take.

"Blimey," he said. "New hairdo." He grinned at me. "Same old face, though."

Luckily my hair soon grew straight again. The face, however, undoubtedly gathered several more lines and furrows.

My immediate boss ran Tutorial Books, and his office was always filled with pipe smoke. I shared a large square room with two other colleagues and lovely windows overlooking Dover Street. We had pens, notebooks and a telephone – and that was it. No computers, no mobile phones, no emails. They hadn't been invented. We endured a weary, sharp-tongued secretary who was very good at telling us what we were *not* allowed to do. Nothing could be formally commissioned without a ton of paperwork and a great many signatures from people who called themselves The Delegates. They were certainly a secret service in their own right. Their decision, when it arrived, was final and seemed to come from God. The whole process took months.

I was responsible for OUP's list of "readers": books that children of all ages overseas could read in addition to the formal English courses they were studying. The dilemma I was passionately concerned with was not that children *could* read but that they *did* read, after they'd conquered the English alphabet and a smattering of basic vocabulary.

I liked some of OUP's readers, which were simple, straight-

forward reproductions of the great old stories. Many others should have drowned with Noah and his ark. I particularly disliked a series called Oxford Graded Readers. I thought their language was stilted and their full-colour illustrations crude and ugly. Known as OGRs, however, they immediately became part of my inheritance. I was dubbed "The Ogre Queen". The nickname stuck to my forehead like a second-class postage stamp. It certainly wasn't a penny black.

When we received an order from Australia for 25,000 copies of each title, everyone was absolutely stunned. The impoverished lady of the English Language Teaching department had suddenly made the Press a lot of money. Unfortunately I felt no sense of pride in the achievement. I was just terribly sorry for the children in Australia who'd have to put up with such second-rate material. I desperately hoped it wouldn't put them off reading for life ...

The contrast between the work I now did and the job I'd done as a journalist could not have been more stark. At Marshall Cavendish we commissioned material, accepted it, paid for it and published it two months later so that it was as up-to-date as possible. There were five short days to our working week and every minute counted.

When I started to read the files that OUP housed in its basement, I began delving into a global past dating back to the 1930s. The files made fascinating and unique reading. They came from all OUP's overseas branches: long intricate letters arguing for or against new projects across the globe. But all too often, not a book to show for it ever actually emerged at the end of the trail.

Whenever Sam spent the weekend with his father, I took the opportunity to spend long afternoons and early evenings ploughing through first one file, then another. I knew I was being given an opportunity to learn about a world in which

the Press had built its famous empire. It was a tremendous and privileged learning curve.

My passion for encouraging children to read really began in those complicated early days. I taught Sam to read, and always read to him at bedtime. At Marshall Cavendish I'd been allowed to commission photography as well as artwork, so inventing an idea for a front cover for a "reader" came naturally.

I still have a precious copy of my first reader, a 48-page paperback called *Jason Whyte, Jamaican: A True Story* by Terry Parris and published by OUP in London in 1973. It contains some beautiful black and white illustrations by Trevor Stubley. I wrote to the art department telling them that on the front cover I wanted a naked child standing in a small boat shouting for help, and on the back cover the massive liner that rescued him. And that was exactly what I got. The book includes sets of questions for each of its ten chapters, an intelligent and useful glossary – and a list of OUP's branches. Glasgow, New York, Toronto, Melbourne, Wellington, Cape Town, Ibadan, Nairobi, Dar Es Salaam, Lusaka, Addis Ababa, Delhi, Bombay, Calcutta, Madras, Karachi, Lahore, Dacca, Kuala Lumpur, Singapore, Hong Kong and Tokyo: a global reach indeed.

I cannot remember how long I spent in the room I shared, but I was soon moved into one of my own at the end of a corridor. To get to it I had to walk past Philip Chester's office. As Deputy Publisher, Philip was in daily communication with OUP's offices in Oxford. He took a fatherly interest in my career and began to give me proposals to read that had come from the Education Division there.

I read and commented on everything, enjoying the variety of the projects on offer, and assuming my reports were for his eyes only. One afternoon I rejected a project called *Mister Men*. I'd stand by my decision today, but I don't suppose it made me very popular in Oxford.

One morning in 1974, Philip came into my room and asked me whether I'd consider travelling to India to run OUP's branch in Delhi. My heart flipped over with surprise.

"Are you serious?"

"But of course. You're an excellent administrator, you've learned the ways of the Press extremely fast, I'd like you to do the job."

I stood up from behind my desk. A pair of white doves, who lived among the Ely House eaves, cooed at me from the window.

I said, "But I couldn't take Sam with me. He'd never see his father, and I can't break up their relationship. I've never stood between them and I can't start now. Sam would never forgive me."

"Put him into a good boarding school." Philip stared at me. "That wouldn't be a problem, would it?"

"Yes, Philip, it would …" I gripped the edge of the desk. I knew I was turning down the opportunity of a lifetime. "I don't approve of boarding schools. I want to look after Sam, to see him through until he goes to university." My eyes were burning. "Anyway, I couldn't live without him. However good your offer – and I take it as the most enormous compliment, I'm incredibly grateful and all that – my answer is no."

Philip's eyes blazed with anger. Without another word, he turned and clicked the door behind him. I'm sure nobody had ever before turned down the offer to run one of OUP's branches overseas.

I've always disliked office gossip and politics, but it became difficult to ignore the fact that everyone in Ely House had begun to talk about OUP's planned move to Oxford. At the time I was only interested in keeping Sam at his current school and giving him the continuity he needed. So when a letter arrived from Penguin Books asking me whether I might be interested in working for them, I jumped at the chance.

Penguin had decided to close its Education Division which functioned from Harmondsworth, but they wanted an editor and project manager to keep alive Geoffrey Broughton's innovative ELT course *Success with English* and to publish new material to be sold along with it. I joined them from 1974 to 1976 and then returned to OUP, but this time in Oxford.

My decision was dominated by two factors. The first was that my stepfather had arrived at my apartment on Primrose Hill one Saturday morning asking me to move out as soon as possible because he and my mother needed to sell the place. The second was that the feeling of living in a safe city had drained away. The IRA were beginning to bomb London. I couldn't face a future at an office desk worrying all day and every day about Sam's safety while he travelled on the precarious Underground and lived in a more than potentially dangerous city.

For the first time I played office politics. A small academic publisher advertised for an editor. I applied for the job, knowing they'd ask OUP for a reference. When they did, OUP telephoned to ask me to return to my former post – but in Oxford. They'd never found my replacement and the job was still mine if I wanted it.

I did. I accepted the offer immediately.

I rang Magdalen College School in Oxford and spoke to The Master, William Cook. He offered Sam a place on the spot, inviting us to meet him the following Saturday morning at MCS. I bought Sam a new pair of jeans for the interview. Sam cut holes in the knees to look fashionable. I sewed them up while he was asleep. Sam woke up and cut through the stitches, by which time it was too late to do anything but race for the train.

We sat together in The Master's elegant room, with its sensational view over the school gardens, looking like gypsies: Sam's knees gleaming through his jeans, my hair falling to my shoulders. But somehow or other, we managed to impress William Cook. Sam made him laugh. I asked him a question he thought staggeringly brilliant. He failed to find an answer. I cannot now remember what on earth I said. But as we shook hands, The Master told me he was looking forward to having Sam as one of his students. And I'm absolutely sure he meant it.

OUP in Oxford felt very different. The company was being torn apart by ASTMS' union squabbles over the different sets of hours staff had worked in London. I thought the Press was bending over backwards to help its staff, and that those who complained should put up and shut up – or leave.

If I'd been frustrated first time around with OUP's lack of pace and dynamism, I was now doubly irritated. I fought tooth and claw to launch a new series of readers, *Alpha Books from Oxford*, asking some well-known children's writers whether we could adapt their stories into simplified language. I also tried hard to forge links with the children's division and Mabel George's distinguished list.

But Mabel herself had left her post, without a successor, and I found myself spending all my time trying to heal the

rifts in the Press's office politics. My heart wasn't in it. Raymond Brammah, who'd returned to lead our team in the UK from a dynamic career with OUP overseas, was full of sprightly energy. He'd come bouncing into my office every morning, with a "Morning! Anything?" which was a wonderful way of being able to put him in my publishing picture at the flick of a switch. But because he'd lived abroad for so long, he seemed ill at ease with us, with his new posting – and indeed with the UK – as if at any moment he'd decide to take flight once again.

Instead, I took flight myself.

There was only one person at OUP I was sorry to leave: Ron Heapy who worked for the Press throughout his entire career and was among the first people to welcome me to Ely House. Ron's abundant cheerfulness and dogged good will, his love of amateur theatricals and his ability to see the funny side of office politics, warmed hundreds of OUP hearts.

Many years after I'd left, I was struggling to sell my first children's novel, *Girl in the Attic*. On the verge of throwing the umpteenth draft into the Thames and myself with it, I sent a copy to Ron together with a cheque. Ron, bless his valiant heart, who protested that nobody had ever paid him before to read something and enjoy himself, read it and sent me a detailed and marvellously useful report. It ended with the words: "Stick with it, Valerie. It should do well."

When Simon & Schuster UK published the much amended and edited novel two years later, thanks in large part to my new and enthusiastic Editor, Steve Cole, for several weeks it shot to the top of their entire list. Sometimes a little encouragement from the right person at the right time can go a very long way.

Munch Munch Luncheon

The first proper formal lunch I remember eating was in 1946 at North London Collegiate School. Staff and students alike, we were recovering from the long-lasting effects of the Second World War. Miss Turpin, who ran the spotless kitchens with arms of experienced steel, stood majestically at the top of the dining hall, facing the rows of wooden tables and lines of expectant eyes.

"You may begin," she boomed.

Ravenous, we duly did.

Pale pink pigs' livers, perfectly cooked, nestled against crisp curly bacon. Sharp green lettuce leaves floated in a delicate handmade mayonnaise. Bread and butter puddings vanished in five minutes flat. And among the swiftly cleared plates clanked our mugs of water, made of battered wartime iron. They bounced as we put them down. The metal gave the liquid the scent of war, a reminder of the men who'd fought for our young lives – but did not return to eat anything at all.

It took several years before we drank from thick, weather-proof glass. I've often wondered what happened to the

mugs. Are they buried in a secret hoard in the rose gardens of my old school? Were they melted down in an angry furnace of fire to make truncheons or guns?

At the University of Perugia, where I spent three summer months pre-university learning Italian and fighting off seductively beautiful Italian men, there was one special restaurant that served for lunch two eggs cooked in a heaven-sent oil which we ate with fresh white bread. No eggs I've eaten since have come anywhere near such perfection.

At the University of Reading the food served in the main restaurant of Mansfield Hall was so profoundly revolting that I often abandoned formal mealtimes altogether and instead snacked alone in my shabby room. Lunch was always one fried egg and an orange. The egg, cooked in semi-rancid butter (my room lacked a fridge though it did have a much-trodden windowsill above a communal fire-escape ladder where the butter sat before it fell on some climber's head) spat at me from my tiny frying pan, trying to be Perugian but always falling well short of the mark. The perfume from the orange peel refreshed my studies throughout the afternoon.

At the beginning of my second year I returned to Reading with some new clothes. Chief among them was a gloriously large cardigan made of deep purple mohair. Its sleeves sprouted spindly fingers of wool that waved in the breeze like tentacles. One lunchtime as I crouched over my gas burner with a pan of tomato soup, determined to make something different, my right sleeve began to flicker with fire.

Within the space of sixty seconds the entire garment, with me in it, could have gone up in smoke. I tore the cardigan off and stamped on it. The smell of singed mohair quite

put me off my soup. I raced across the grass to the dining room and grabbed a plate of macaroni cheese. It was burnt on top, cold in the middle and tasted of soap.

When I began working as a journalist for Marshall Cavendish, lunches on a Friday, when our weekly magazine had been safely delivered, were sometimes boozy affairs that took longer than an hour but never two.

As an editor for Oxford University Press in Ely House, I was allowed to eat in the small dining room. Free alcohol was supplied and consumed in vast quantities, before the accountants moved into the Press and closed down this smugglers' den of drunken vice, sloppy afternoon mistakes and angry telephone calls that couldn't even be recalled the morning after.

I avoided alcohol altogether. Being stone cold sober was a crucial necessity when collecting an intelligent and energetic small boy from his beloved nursery and then primary school every afternoon and giving him my undivided attention until bedtime.

During Prime Minister Edward Heath's desperately imposed Three Day Week, we were treated to a special lunch with the arrival of OUP's new Chief Executive. The dining room was lit by three thin and swiftly diminishing candles. Somebody handed me a plate of salad. Too busy talking to an interesting guest, by mistake I swallowed a whole walnut. Minutes later I found myself squirming on the floor, struck down by my allergy.

The Deputy Publisher, Philip Chester, was kind enough to summon a car. I was immediately sent home. My skin crawled with what felt like a host of flies buzzing beneath it. I scratched every inch to no avail and the taxi-driver's open-mouthed astonishment.

Back in my apartment I telephoned my doctor.

"I'm dying," I told him. I thought it best to get straight to the point. "Somebody in Ely House gave me a walnut for lunch. We were eating by candlelight. I wasn't looking. I thought it was a small tomato." My body continued its race towards certain death. "And I swallowed it." Sweat broke through the scurrying flies. It lurched down my back. Heroically I continued to sit in a puddle on the floor. "This is the end. Could you please come to help me as quickly as you can?"

"No, I can't," my doctor said. "I'm extremely busy with my mother. She has influenza. She'll be ninety-four next Tuesday, if she's lucky … Make yourself a cup of tea and lie down. You'll feel better in the morning."

I did, but it was one hell of a night. I never forgave my doctor's mother – and I never saw him again. I'm sure he failed to notice I'd vanished, together with my ill-digested walnut, into the breezy, invigorating air of Primrose Hill.

Then austerity struck its blow for abstinence and the pendulum swung the other way. Long lunches in professional London became a distant memory. Sandwiches, stale, fresh, boring or delightful, sprang up among the new computers like wheat in Theresa May's field. Because nobody ever switched off their screens, the pre-packed food was swallowed at the rate of knots in front of them, while half-eaten apples turned brown among the dusty files and lumps of mouldy cheese stank to the ceiling.

As BUPA's Publications Manager I was allowed to trundle down to the basement of their offices on London's Embankment and for half the normal price eat an enormous three-course lunch. I needed it. Commuting from north Oxford's Wolvercote meant I got up at 4.30 a.m. to

catch an early Oxford train and be at my desk by 7.30. Without a decent lunch I would have faded into a starved shadow every afternoon.

Sick to death of waiting for the train home from Paddington, where Iris Murdoch in her long greasy mackintosh was a frequent sight for sore eyes, and bored to tears with writing health-insurance documents, I set up *Wordwise*, my own editorial consultancy in Wolvercote. Now I had nobody to cook me anything. Lunch became an apple and a large chunk of feta cheese. Delicious and all I needed in the middle of my own working-from-home day. I always make scrambled eggs for breakfast and have never written anything worth reading after a heavy meal.

I could not afford alcohol, but regular cups of Indian and Earl Grey tea kept the proverbial wolf from the door. When publishers large and small failed to pay me on time, hungry and with nothing in the cupboard, I reassured myself by reading wartime diaries, where rationing dominated everyone's life and even eggs became a luxury. But every night I'd go to sleep dreaming of fillet steak and spinach.

One of the most interesting things about growing old is that your eating patterns need to change. The famous journalist Malcolm Muggeridge admitted in his old age that in order to stay fit, he lived mostly on yoghurt. In the biography *The Fabulous Bouvier Sisters: The Tragic and Glamorous Lives of Jackie and Lee* by Sam Kashner and Nancy Schoenberger, a "desperately sad book about women who were defined by men", we learn that "the only thing the sisters had in common was their resolute thinness; neither had anything more for lunch than a bowl of clear soup" (Daisy Goodwin, *The Sunday Times*). Although Edward, Prince of Wales and briefly future King and ruler of the

Empire, drank himself off the planet every evening, lunch was always a solitary apple.

Today's fashionable diet books focus on fasting, not eating. The truth behind John Yudkin's pioneering and brilliant anti-sugar book, *Pure, White and Deadly*, is only now beginning to be recognised. As the world becomes less healthy and ever more obese, perhaps it's time we all ate less of everything.

I shall always eat a large breakfast and a small evening meal. But into my eighties and hopefully beyond, I plan to survive on a couple of nutritious protein-heavy snacks during my working day – and give up lunch for good.

I wrote all that two years ago, before the pandemic made sure we needed to make enormous changes to our social lives. Eating outside the home was both forbidden and impossible. Now – September 2021 – the gradual easing of lockdown has made a rare lunch out even more of a treat.

My very special thanks go to Lucio, who owns and runs La Galleria in Woodstock, and his team. It has always been my favourite place to take my friends to lunch. Like all good restaurants, it has patiently survived the storm and returned to welcome its guests with open arms, delicious food, sensible prices, a pristine interior, a continental atmosphere – and toilets large enough to get in and out of in one piece. It even has a small courtyard for supper under the stars on balmy summer evenings.

What more could anyone ask?

Bringing Up Baby

Bringing up baby was relentlessly hard work. It was also the most extraordinary fun. Children who are happy and well fed bring an essential ingredient into one's life: laughter. A sense of the ridiculous and the absurd. They have their own vision of the world, a fresh and always surprising one.

Sam was no exception. It's impossible to be depressed or miserable if your child is chattering to you about what happened at school. You have to enter his world and learn about it. You need to listen, to unplug yourself from the successes and disasters of your own working day and become a child again. Not the child you were when you were young, but the child who's living in the world as it is now, and as it will be tomorrow.

Looking back, I think the mistake I made was in trying to be too much of a friend and not enough of an "I know better than you because I am older and wiser" parent. I made all the important decisions about Sam's life: where we lived, what we ate, how we dressed, what schools he went to and which books he read. His father took over some of the holidays: he had the fun bit. I did the hard

work, so in Sam's eyes I was always much less popular.

After our first trip to the Caribbean, I never returned there. Sand and sea became something I left to other people to enjoy. Indeed, the summer break was always a nightmare. That was when I saved up for Sam's school uniform and everything he needed for the coming autumn term. One summer in Woodstock I was so poor I wore the sweaters Sam had grown out of. I never told him I went without supper for three months in order to pay his school fees.

Living in a small flat in London with a growing child is not always easy. Luckily we perched on the borders of Primrose Hill, which became our back garden. In the space of three minutes we could be kicking a football on the hill, jumping around with a space hopper, walking towards the Regent's Park zoo or the shops on Regent's Park Road.

Sam moved from the nursery school he loved to Primrose Hill Primary School where he settled in equally well. The school had a well-earned reputation for being modern, free-spirited and excellent. Its community of families were mostly professionals who revelled in a cultured London life. We talked politics and theatrical hits at the school gates, played musical instruments, painted huge portraits, created collages, sang in choirs and went to the cinema. One of my best friends, Sarah Morton, whose husband, Alistair, later made the Channel Tunnel a reality, opened a shop opposite the school. *Party Mad* was years ahead of its time and sold crazily wonderful things every child was desperate to have.

Like all parents I had some scary moments. After long discussions I allowed Sam to walk to school on his own for a couple of mornings until a neighbour telephoned to tell me he'd almost been run over by a car. Without further ado, I went on taking him to school myself.

On another occasion I was at my Marshall Cavendish desk when the head master rang to say that Sam and a friend had gone missing. I raced out of the building in Soho and flung myself into the nearest taxi. It had ground to a halt in the traffic and was already occupied.

The driver and its occupant were instantly sympathetic and roared me to Primrose Hill, where I discovered that Sam had returned, wondering what all the fuss was about. He never told me where he'd vanished to, what he and his chum had done in the lost few hours – or indeed why they'd decided to escape.

"As long as you're safe," I told him, scrunching him in an enormous hug. I should probably have been much less forgiving, putting him on a Victorian punishment diet of bread and water for a week. That was never my style. I remember one of my friends threatened to "thrash" Sam for something impertinent he'd said. The friend was instantly taken downstairs and shown the door.

A great character who enlivened our Primrose Hill days was our cat, Giggles. He arrived via Peter as a black and white kitten who immediately stole my heart. From his first day with us, he was the best-tempered moggie I've ever owned. He adored playing games. Sam would hop him around our apartment on his hind legs and Giggles smiled. He sat contentedly on Peter's back while he played "I'm coming to get you bears" with any child who happened to be around.

In fact, the madder the so-called adult, the wider grew Giggles' grin. He never minded being carried downstairs to roam Primrose Hill if we were out for a day and an evening, and always waited patiently on our doorstep for our return. He used his skilful charms to great effect on a doting neighbour and often devoured huge platefuls of her food as

well as mine without putting on an ounce of weight.

He also eventually travelled to Woodstock with us, where he irritated our fastidious neighbours with a newly cultivated and horrendously loud miaow. One evening I returned to our cottage to hear him howling on an even more desperate note. One of my exasperated neighbours had locked him in her garage. I managed to trace the noise and insisted on his instant liberation.

Giggles had one serious handicap, however. He was not a dog. In trying to persuade Sam that our move to "the country" rather than staying in "dirty old London" would be an excellent idea and of course would be accompanied by a bouncing puppy, I made him a promise I intended but failed to keep.

Sam held it against me for years. In the middle of filming *Skyfall,* the first of his two James Bond movies, he emailed me to say he'd just bought a Jack Russell terrier called Myrtle. He said he'd realised that when all his children were teenagers and none of them wanted to see him any more, the one creature to welcome him home would be his dog.

Moving to Woodstock in the summer drought of August 1976 was a big step. I hadn't realised how liberal the world of Primrose Hill had been until I encountered the conservative atmosphere of Oxford, and indeed, at the time, of Magdalen College School. A general election in 1979 meant the Tory campaign-bus circled Woodstock, its droning voice assuming everyone would vote for Margaret Thatcher.

The first parents' meeting I attended at Magdalen College School was a miserable experience. I was the only single parent there. Everybody else was part of a couple. One of the teachers I approached, a scrawny, sour-faced man who obviously wanted to be some place else, told me

Sam had a dismal record, he was thick as two short planks and would never be a success at anything.

I was absolutely furious. Had I been accompanied by a shiny-booted husband with thick grey hair, a flashy tie and a lucrative job in the City, the teacher would never have dared to be so rude. There are civilised ways of telling a parent their child is not developing as well as they should. Being told he is a total write-off certainly isn't one of them.

I had a flashback to being at school myself as a teenager. It was the last day of the summer term and the long holiday stretched ahead of us. Through a ground-floor window I spotted our biology teacher dancing for joy on the path leading to the gym. In all the time she taught us she'd never given us even half a smile. I realised how much she loathed teaching and looked forward to a summer of freedom. And how the best teachers are always the ones who love what they do.

Although I adored living in Woodstock it was mostly because every Sunday morning, come rain or shine, I could walk in Blenheim. The anger and frustration of the week burned itself away as I walked round the marvellous lake and then beyond it, over the bridge, past the garden centre (which has long since disappeared) and back to Hensington Gate.

When I first took Sam to Blenheim he stood looking out over the extraordinary landscape with its breath-taking bridge. He turned to me and said, "If I'd been born here, I'd have been Winston Churchill too."

But I don't remember him ever walking with me. His great game was cricket. He captained the Magdalen College School team for two consecutive years, and claims that is where he first learned to be a director: a natural leader of a hand-picked, well-knit team. He's probably right.

☙

The geographical space between Woodstock and the centre of Oxford seemed to grow larger the longer we lived there. The traffic certainly increased, and my life as a chauffeur became more of a burden. One morning Sam told me bluntly he was sick of being driven around. He needed his independence and intended to buy a motorbike.

Without giving it a second thought, I put our cottage on the market. With the help of my stepfather, who generously and speedily acted as my Solicitor, I sold it within two months. We moved to the first house I could find: an ugly but functional 1930s semi-detached in Wolvercote. It had three bedrooms, one of which became Sam's study. Because it was close to Port Meadow and a relatively easy ride to Magdalen College School, I bought Sam a top-of-the-range bicycle that took him independently to school.

But I promised myself I'd return to Woodstock and Blenheim one day if I possibly could.

Living in Wolvercote had some wonderful advantages. Being close to Wytham Woods meant I could walk there every weekend. Port Meadow, with its horses, cows and river life, also made a great stomping ground. Or I could slip beneath the bridge and walk along the towpath directly into Oxford, shop or go to the library, and return the same way.

Getting to know the canal eventually became fertile ground for my third teenage novel, *Lost and Found*. And it was bliss not having to face the journey to and from Woodstock twice a day. Wolvercote itself, meanwhile, still boasted at that time a small but useful supermarket, a post office that also sold groceries, a newsagent and a tiny hardware store.

A single-decker bus stopped outside our door, and in my neighbour's garden a cherry tree blossomed every spring. Our cat regularly caught birds and left them as offerings in

the garden. It was Sam's job to bury them wherever he found a decent space. And Sam's social life began to include girls.

His school life was punctuated by end-of-term reports that continued to worry me. One of them caused a Friday evening rumpus. It told me that Sam was not particularly good at science. Not only that, he continually disrupted the class so that none of the other boys could concentrate on being good at science either. At the time I was project managing an enormous art encyclopedia. I'd had a long and tiring week and this report was the final straw. I hit the roof. I told Sam if I ever received another report like it, I'd remove him from Magdalen College School overnight.

I stomped up to my bedroom and slammed the door. Unfortunately, the door decided to remain closed. When I tried to open it, ten fuming minutes later, the handle fell off in my hand. Sam was unable to open it from the landing. He had to ring the police to ask for help.

Half an hour later, a burly copper arrived and asked me to, "Stand back, please, madam!" He heaved the door off its hinges, grinned, checked that I was still in one piece and clattered noisily down the stairs.

From then on, Sam's end-of-term reports marginally improved.

During our Wolvercote years I led the team that published *The Encyclopedia of Visual Art*. When I needed to take time off to have a major operation in October 1981, the staff at Magdalen College School rallied round. Several of the masters came to see me while I was recuperating in hospital to tell me what a wonderful job I was doing, bringing up Sam. How he was always on time for the start of the school day, always looked clean and tidy, was doing some good work and I should be proud of him. I was enormously

grateful for their approval and that they'd taken the time to visit me. The underlying message was they knew he could be a bit of a handful for everyone concerned.

Interestingly, Sam's class was the last one at Magdalen College School *not* to have computers on every desk. Now the machines have filtered into every corner of a child's life, a fact that never ceases to alarm me and fill me with dread.

I watch young teenagers walking to school, staring at the tablet in their hand. I notice young mothers with children tugging at their sleeves, needing attention, while the mothers themselves are chattering to someone else down the line. I once saw a family of six eating Sunday fish and chips in St Ives. None of them said a word to one another. As soon as the food had been eaten, out came their devices and the voices started jabbering. I wondered whether they ever spoke to one another during a normal day ...

The moment Sam had taken his final exams, I started applying for various new jobs.

One advertisement that caught my eye was for a senior management position in a publishing house in Newton Abbot. I was curious to see how the company worked and what the town was like. During my visit, as well as being interviewed, I contacted an estate agent who showed me round three potential cottages.

I sat on the train home feeling incredibly depressed. I'd been told the job was mine, with more money than I'd ever earned before, and lots of holidays and benefits. On paper the package made perfect sense. In reality it was far from what I wanted.

I reached Oxford at twilight, got into my car and drove slowly home in the rush hour up the Woodstock Road towards Wolvercote. And then I realised why I felt so miserable. Every house I passed in Oxford had their lights on. Their living

rooms revealed shelves groaning with books. The three houses I'd been shown that afternoon were littered with television sets and modern machines of every kind. But none of them had displayed a single book. I knew that if I moved there, I'd feel like a fish out of water to the end of my days.

The second job I applied for was as a journalist again, big time. John Anstey appointed me Features Editor of the *Telegraph Sunday Magazine*. I knew this would mean a swift move to London but I felt ready for the fresh challenges the post would entail. The semi-detached in Wolvercote had fulfilled its function and I was glad to leave it although I still loved Oxford. But I needed to update my knowledge of London publishing by gaining first-hand experience.

My determination and persistence with Sam paid off. While I was at the *Telegraph* some good news reached me. I have a copy of the letter I wrote to William Cook, The Master at Magdalen College School:

From the Features Editor, Telegraph Sunday Magazine
August 18 1983

Dear Mr Cook

We were all overjoyed this morning when Sam told us of his excellent A-level results.

I send you and all your staff, with this letter, my most grateful thanks for everything you have done to make his achievement possible. I cannot write to you all, so please take this brief note as to each of you.

I hope Sam will now go on to wider achievements. And I know that he will continue to be, always, a part of Magdalen life.

Yours ever
Valerie Mendes

Walking with Donald

My stepfather, Donald Veall, was a scholar, a Solicitor and a gentleman. One lonely evening as a widower in Esher who couldn't face cooking his own supper yet again, he decided he needed a wife to make it for him. He placed an advertisement in the *New Statesman* and my mother answered it.

Their personalities could not have been more different. He was a lovely quiet man with his own intense, private inner world who could go for hours without saying a word to anyone, but when he did it was always relevant, clever and original. When my mother's hectic social life forced him for a few hours to sit among the chattering classes who bored him rigid, he'd pretend to be deaf. He made his own wine, had led an extraordinary life in India, and not only practised as a distinguished lawyer but found time in the evenings and at weekends to write about the things he knew and loved.

When he came unexpectedly into my life he was a practising Solicitor for the Supreme Court. Before we met he'd published *The Popular Movement for Law Reform 1640–*

1660 with Oxford at The Clarendon Press in 1970; and in 1979 a 64-page but equally erudite footpath guide to walking, complete with detailed maps, published as a Spurbooks Venture Guide, and called *Afoot in Hertfordshire*.

In its Introduction Donald says: "E. M. Forster in *Howard's End*, written in 1910, described Hertfordshire as 'England at its quietest with little emphasis of river and hill; it is England meditative'. The county has a wide variety of scenery: the parkland, the bottoms, downlands, gentle hill slopes, woods, canals and river valleys. There is much for the photographer; some fine spots for the painter to return to and spend a sunny day; much for the bird watcher; plenty in the right season for the blackberry picker; something for those interested in history and buildings; and more than enough pubs for the thirsty walker. The going is generally easy, although occasionally part of a walk, particularly in the green lanes covered by trees or near farms, may be muddy, and stout shoes are advisable."

This is a rare example of Donald's private voice: clear, concise, well-ordered, practical and experienced. In many crucial ways, Donald himself was "England meditative". He thought about things, he pondered on them, he never jumped to swift conclusions, he was a brilliant listener and a good judge of character. Any advice he offered came from his educated mind and stout heart.

We liked each other immediately. I found him easy to talk to and when he offered to take me on some of his all-day-Sunday walks, I immediately and gratefully accepted. These expeditions were a great deal more than a quick flick over Primrose Hill. Donald would spend Saturday afternoons preparing his walking equipment, cleaning his boots, making his packed lunch, getting out his maps and compass, filling his car with petrol and double-checking everything.

In spite of the fact that he worked in London, where most people looked pale-faced and sickly, Donald always had a healthy tan and shining eyes. The Sunday walks kept him slim, fit and sane. And his offer to share his best hobby with me was the greatest compliment.

He'd collect me in his sports car and off we'd roar. When I first emerged wearing a pair of tennis shoes and a flimsy linen jacket, he insisted I bought proper walking boots, a light but waterproof mackintosh and a hat to match. He showed me how to make a lunch that was light to carry but packed with protein and vegetables, with a thermos of strong sweet coffee. I never asked where we were going but every Sunday he found a different route – and he knew them all.

We often walked together in companionable silence for hours on end, but I always knew he'd listen carefully if I had a problem I needed to share. He rarely spoke about his concerns, mostly because he was dealing with clients whose lives he always kept confidential. I knew he'd suffered terrible domestic problems with his children, but he never mentioned them. Out of loyalty, he also never discussed my mother, although it became increasingly obvious he found her a strain to be with.

It was only towards the end of his life that one day I noticed he was driving badly, seemed unusually tired and listless, took a sharp right turn, only just avoiding another car which would have killed us both on impact and then, even with his compass, lost his way in the middle of a field. It took us hours to get home. He started to mutter grumpily to himself, something he'd never done before. Instead of feeling refreshed at the end of our journey, we were both exhausted.

I waved him goodbye, climbed the steps to my Primrose Hill apartment and flung myself on my bed. I knew that

Sundays with my beloved Donald had reached their natural end. I felt utterly bereft – and I still miss him to this day.

But he taught me how to walk. And every time I do, I think of him.

I'd always been a walker, setting off to North London Collegiate School every day as a child to tramp through Edgware to Canons Drive and then on through the wonders of the school gardens. Walking up the hill from Mansfield Hall in Reading to the university campus at Whiteknights. Endlessly trundling Sam around the parks in Didsbury, playing racing games with him in the summer, pushing him in his buggy in the snow.

But proper walking alone for several hours in a landscape that allows you to think, brood, dream and plan, to sift and sort the problems of the week or, as a working novelist, to imagine the next chapter, clarify a piece of dialogue, change your mind about a twist of plot or the depth of a character's depravity: that's altogether different. We're talking proper slabs of time here that need to be planned as regular slots in a working day. Without them I find it impossible to write with the ease, coherence and clarity my work demands.

After Donald died and I set off on my own, there were several major open spaces that really mattered to me and became crucially important parts of my life. The first were the extraordinary landscaped yet wild gardens of Blenheim Palace. The second was Port Meadow and Wytham Woods because I lived close to them. And the third was the National Trust land surrounding Grayshott Hall in Surrey, the setting for my first adult novel, *Larkswood*.

Although I cannot remember the first time I walked in Blenheim, it must have been during my early days in

Oxford. When OUP asked me to return to work for them in 1976 and an estate agent offered me a three-bedroomed, flat-roofed cottage on a corner of Woodstock's Hensington Gate Estate, I already knew the small town. I felt overjoyed that I'd be able to walk in Blenheim whenever time allowed.

The greatest thing about the famous Palace is not the size, shape and beauty of its building, or its connections with Winston Churchill and his family, but the way it's set with such dignity and splendour in its gardens. Carefully landscaped by Capability Brown specifically to be seen on horseback, the grounds are a magnificent combination of controlled design and deliberately wild reach.

I've known them in all seasons and every possible weather. I've loved every tree and every angle from sunrise to sunset. I've written poems about its lake, its pine trees, the ravens who nest in them and the rabbits and squirrels who bounce, scuttle and run. Sheep and their lambs munch in the fields, geese and their goslings grace the lake and wander along its shoreline. There are always hungry ducks to feed, swans to admire, seagulls that scatter the sky. In the autumn Canada geese rise through the clouds in their immaculate formations, warning of the winter to come. I've walked round the lake thousands of times and taken longer routes whenever I had the energy. Over the past forty years – half my entire life – Blenheim has been there for me.

Recovering from major surgery in 2007, I made myself walk round the lake seven days after the operation. It took me two hours instead of one and I only just managed it. Once out of Admiralty Arch, I stumbled into the nearest tearoom and collapsed beside their wood-burning fire. Sweat streamed down my back and poured off my face. I drank several pots of tea, strength slowly returning to my body. I knew that somehow I'd find the determination to

101

recover. It took me all of eighteen months and walking in Blenheim played a major part.

When I decided to set my second adult novel, *Daddy's Girl*, in Woodstock, it was partly because Blenheim could become one of its settings. Several important scenes take place in Fishery Cottage, one of many properties owned by Blenheim and set within its gardens as permanent homes for its privileged staff.

On the evening of 8 November 2016, when Donald Trump was elected President of the United States, Fishery Cottage caught fire and burned to the ground, killing its two elderly occupants and their dog. Devastated at hearing the news, I walked around the sealed-off site, unable to believe my eyes. Nobody had seen it happen. It wasn't until early the following morning that staff spotted smoke rising from the trees in that dip in the path leading around the cottage.

It took me months before I could bear to look at the remains of Fishery Cottage again. *Daddy's Girl* was published in May 2017 (as *The Choice*). The scenes set in the cottage seemed all the more poignant, especially as I'd intended to give its occupants a copy of the book, together with a letter of thanks. My website displays a photograph of Fishery Cottage as it was, and as my photographer, Chris Challis, saw it the day we were given permission by the Palace to capture its unique beauty, nestled as it used to be within its circle of protective trees.

I was given a pass to walk in Wytham Woods in 1976 when I moved back to Oxford to rejoin OUP. The small green card, handed to me by a colleague at the Press after several members of staff told me I'd never be given one – that even to ask would be ridiculous – swiftly became a prized possession.

There was – there still is – something magical about the village of Wytham, its Abbey and its Woods. Mostly owned by Oxford University, although the Abbey is now in private hands, it retains a sense of privacy and mystery, as if it holds secrets about its past that nobody will ever discover. In the late 1970s the Woods were more protective than they are today about the secret research that's their prime focus. Today, along with the precious pass, come a beautifully drawn map as well as the rules and regulations of the privileged walk.

It's by no means an easy ride. Walking up Wytham's hill into the centre of the Woods is a steep climb, although the puffing and panting are worth the effort once the pathway levels off. I've always instinctively then turned left to complete the circle by walking towards the farm, its various caged beasts, and down to the borders of the village. During a short stay in the Abbey, I wanted to leave my mark of gratitude. A wooden bench where three people at one time can rest their weary limbs still graces the orchard at the edge the Woods.

When I lived in the adjoining village of Wolvercote I used to cycle to Wytham every Sunday morning, prop my bike against a wall near the magical All Saints' Church, walk in and through the Woods, collect my bike and cycle home. One morning while I was in the Woods, my bike was cruelly vandalised: its back wheel bent double, the handlebars wrenched apart and the tyres slashed. I managed to carry the bundle of metal back to Wolvercote, but I never had the heart to replace it.

My walking, however, continued, although the road between the villages can be dangerous for those on foot. There's no proper pavement the entire way and traffic can be vicious, heavy and fast. The Wytham villagers call it The

Rat Run. This may be unkind to frantic commuters, but when facing it on foot that's exactly how it feels and sounds. Shades of *Watership Down* echo in my head.

There's a single sacred hour, very early on Sundays, when the traffic may ease or even slow, but there are no guarantees. One of my great friends, Lady Anne Piper, who lived at Overford Farm in Wytham for many years, told me she'd only once walked between Wytham and Wolvercote in all that time – and immediately decided that driving was a much safer option.

Once, while I was walking in Wytham in the middle of a weekday afternoon while taking rare time off from an enormous art project, an elderly gentleman popped out at me from the roadside hedge. We shook hands and became immediate friends. Rex lived in one of the apartments in Wytham Abbey, then still owned by Oxford University. He invited me to tea. As we drank it, we looked out at the gentle rolling fields and secretive woods of one of the most beautiful of English villages. When he eventually made plans to move to sheltered housing, Rex asked me to take over his apartment.

I would have loved to have done so, but the University decided the Abbey needed restoration and sold it off. Although I was bitterly disappointed, with hindsight it's probably just as well. Enormous sums of money were needed to bring the building up to modern scratch. The moral of the story is: you don't have to live in a wood to enjoy walking within its boundaries.

Yesterday, Sunday 20 September 2020, I spent a few hours walking in Wytham Woods, under the azure skies and dazzling light of our Indian summer. Because of the Covid-19 restrictions, I hadn't travelled out of Woodstock for six

months. The trees stood tall and magnificent as ever. The fields beyond the Woods stretched, peaceful as ever. Tears of gratitude poured down my face. In spite of the pandemic, the natural beauty of England survives to tell its magical, haunting tale.

But the Woods do not simply take care of themselves. They are managed down to the last detail by a professional team, led by Nigel Fisher. Appointed in 2000, Nigel remains their first Conservator, a man who has dedicated his life to protecting and developing this unique inheritance.

Here is one of many poems I've written about Wytham Woods:

In Wytham Woods

New Year's Day 1989

I walk as woodlander in Spring.
Gingerbread leaf beneath me bring
Tone to exquisite fern and ring colour at colour.
Listen! Sing yesterday's naked tune, its sting
Healed as woodlander I spring.

I walk as woodlander to hear crab-appled squirrel
Plashing weir, scruffle on bark, the plaint of near
Moss dove in flight. See! Fallow deer suddenly flow
Eyes right, then steer singular fleeting course, their tier
Swiftly apart from Wytham's ear.

I walk as woodlander to see utterly silent bole, that Tree
Pointed and raising, curled and free,
watching and waiting.
Come with me! Tracking fresh path I'll coin three
Wishes. In health for thine and thee
Grace upon Grace, prosperity,
Joy with her counterpoints may He
Beckon and orchestrate.

So be walking as woodlander. I find
Twig-snapping way whose branches twined
Comfort the shoulders, light the blind
Foliaged omens. Call! I've timed
Midday to midnight sky on rind
Tasting of wood smoke sent to bind,
Scented, our New Year's open mind.

Port Meadow is literally a water meadow, and there were several winters when I lived close to its boundaries that I feared we'd all be trapped beneath the slurp. Villagers today still speak of the winter of 1962 when the season's heavy snow suddenly melted and everyone found themselves under water.

Walking through the meadow to the cows down at the river's edge is always an extraordinary delight. Boats skim the water with their energetic rowers. Small craft lie moored to its banks, their windows heavily curtained. And the sight of Oxford's skyline, with its dreaming spires, gradually appearing out of an early-morning mist inspires, soothes and enhances every walker's day.

When I finally abandoned commuting to Paddington and a regular income in favour of a much more precarious life as a freelance editor, I'd put down my pen, switch off my computer, and race out to Port Meadow at 5.00 p.m. every afternoon. I'd dance down to the river to celebrate the fact that I didn't have to jostle, exhausted and impatient, for the next appropriate train.

I cannot remember when I first visited Grayshott Hall in Surrey. I only know that from the very beginning the place felt like home. The house is spacious without being an overbearing mansion; friendly without being cosy; and it still has private corners when you want to be alone.

It has also retained an exclusive reputation. Actors and actresses whose faces are too well-known to be anonymous can stay there to recuperate after making a film or having a facelift, wean themselves off alcohol, lose a couple of stone, recover from the end of a love affair, or even begin a new one, without the cameras flicking at their privacy.

I went there to sleep when my workload as a freelance

editor and project manager became too heavy to bear. On one occasion I arrived still wearing bedroom slippers. I was so tired that I fell asleep while talking to a qualified nurse who used to greet all guests on their arrival. She was taking my blood pressure. She woke me up and we decided to try again the following afternoon.

The Victorian manor house was once a holiday home for the Poet Laureate, Lord Alfred Tennyson. With 47 acres of its own gardens, it is set in 700 acres of National Trust land: for me its chief attraction.

After sleeping like the proverbial log, and jumping into the indoor swimming pool the moment it opened at 6.00 a.m., I'd spend every morning walking on my own in a great circular route that took me across sandy pathways, through dense woodland, over a tiny bridge and back through yellow-headed gorse bushes and purple heather under wonderfully open skies. Dog-walkers and horse-riders grace the land at regular intervals.

I once travelled to Grayshott on Sunday 31 August 1997: the morning when we woke to the tragic news of the death of Diana, Princess of Wales. People talked of nothing else all week. The heath was littered with clusters of dog-walkers discussing it, while their pets champed to move on and the horses ignored everyone's distress and galloped by.

I only once got lost. I'd been walking for several hours, unusually for me in the afternoon, thinking about the plot for my current novel. The cry of a bird startled me from my thoughts. I looked up to realise I didn't recognise a single bush, tree or pathway. I couldn't hear voices or traffic. There wasn't a cottage in sight.

I'd lost that most crucial of walkers' attributes: my sense of direction.

I wandered on for another half an hour. When an elderly

walker bobbed up from behind a tree I practically fell over him in relief. He waved his stick, grinning at my despair and pointed me in the right direction. It took me two hours to get back to Grayshott Hall.

To this day I have absolutely no idea where I'd ended up. Had my beloved Donald been with me, I'm sure he would have known.

On 22 November 2020, Grayshott Spa, as it was known, succumbed to the second lockdown. It suddenly and permanently closed. I was devastated. For me, it was more than just a retreat or a spa: it became a central character in my first adult novel, *Larkswood*. It continues to live and thrive in its sequel, *Flight of the Lark*. I cannot believe it will never open again.

Kaye Webb and Puffin Post

The first thing I noticed about Kaye Webb when I met her was the pain she was suffering. Her arthritic limbs were stiff with it. Her eyes glittered with it. When she moved around her home, she would grab any piece of furniture she could find to support her body. I wanted to take her in my arms, soothe the aches and pains, and tell her everything was going to be just fine. But I knew it wouldn't be. There was nothing I could do to help except keep talking to her of other things.

She'd invited me to her London home to ask me to curate an exhibition she was mounting to promote Puffin Books. They were central to her life and her passionate enthusiasm for children and the books they read. But the brief she gave me for the exhibition was singularly vague. She'd put nothing in writing. I was sure she knew people who could do a much better job. She didn't seem to be listening. The following day I wrote telling her of my decision. Although I never received an answer, I'm sure the exhibition was a great success.

After our meeting, we took her chauffeur-driven car into

town. During the journey Kaye asked me whether I was a writer. When I said yes, it was my passion, she asked me to write for her.

"I'm always on the look-out for fresh talent," she said. "A novel, I love a good novel. Do you have children? … Sam … That's a great name. Write a novel for him. Put him in it with his friends. Disguise them, of course. Let them have some magnificent adventures. I'll read it overnight. I read all the time, as long as the pain lets me."

Ideas for my first children's novel crowded into my mind, but putting food on the table took precedence, together with looking after Sam, a hectic daily domestic routine, my full-time job and the fact that in the evenings I was also writing romantic stories for several women's magazines. I needed a regular income. I also knew that writing a novel would require months of patience and commitment that at the time I simply didn't have.

Several years later in 1974 I joined Penguin Books at their new offices in Grosvenor Gardens to become managing editor of their English Language Teaching list. The Penguin Education division in Harmondsworth had been closed and their staff made redundant, but they wanted Geoffrey Broughton's course *Success with English* to remain in print and be expanded with new linked material.

The National Union of Journalists were furious I'd agreed to take over the new role and promptly sacked me from their ranks. I knew that going it alone would be difficult but I've always preferred to be a lone voice in the wilderness rather than the member of a group. So I took the job.

Kaye Webb and her small, devoted publishing team had a corner office on the same floor. Enormous black and white

photographs of Allen Lane looked down on us from several freshly-painted walls. This time Kaye specifically suggested I write some stories for *Puffin Post*.

"Make them seasonal," she told me. "Short, relevant, sparky." She handed me the most recent copy of her best-selling magazine. "If you've never written for children before, this is a great opportunity."

In her own unique way, Kaye Webb became as important to me as Olive Shapley. It was through Kaye that I met other children's writers for the first time: Leon Garfield, Jane Gardam and Russell Hoban chief among them. I'd met Geraldine Kaye and Nicholas Fisk at Oxford University Press. During my time with the Penguin English Language Teaching list, I invented and published a new series of magazines called *Password*. I packed it with stories, plays, puzzles, crosswords, talks with English people and features on places in London. I'd learned a great deal from reading Kaye's inspirational magazine.

Here are two stories of mine that Kaye published in *Puffin Post*. Sam was ten years old at the time.

The Best Guy on Albert Street: a Story for Guy Fawkes Night

It was November the first and very cold. Jimmy woke up to the sound of the wind. He lifted the curtain by his bed and pressed his nose carefully against the window pane. Outside, Albert Street was still soot dark.

Jimmy let the curtain drop and put on his lamp. Then he reached under his pillow and drew out a green felt purse with large red stitches round its sides. The coins inside were already making the purse bulge with their weight.

Saving up, he thought, wasn't all that easy. The coins seemed to be shouting to be let out. He'd been putting them in the purse ever since he'd finished making it at school, three weeks ago. But in only four more days it would be November the fifth and then he'd be buying sparklers.

Not even Joe, who managed to find most of the secret things in his room, knew about his purse. Joe was eleven and big while Jimmy was only eight and, everybody said, looked more like six.

Jimmy buried the purse between the mattress and the bed-springs and remembered his plan for the morning. It was half-term Friday. He was going to sweep the front-patch leaves into a sack and earn 10p.

Doing it took him until lunchtime, what with the wind biting at his ears and leaves crouching in surprise corners. By that time, Bob, Joe's best friend, had come for lunch and at first Jimmy's ears felt so cold that he could hardly listen properly.

"Where's our list?" Joe said. "Let's tick off the things we've got."

Bob took a crumpled piece of paper from his sleeve.

"Hat – yes, scarf – yes, mask, from your last party – yes, old red socks – no, two long thick pieces of string – yes, sack for body – no, my dad's old trousers – yes," Bob said.

"Why do you need all that?" asked Jimmy.

"We need gloves too," said Joe. "Put down gloves."

"What are they for?" asked Jimmy.

"And a jacket for the body," said Bob.

"Whose body?" Jimmy asked.

"Jimmy, will you please eat up." His mother put some ice cream on the table. "I've got to go to the office. I'll be back soon after six."

Jimmy said quickly, "Can I have my 10p, Mum? All the leaves are done."

"10p, eh?" Joe looked across the table at Bob. "I reckon we should earn at least a pound this afternoon. What d'you think, Bob?"

Upstairs, Jimmy put the 10p carefully in his purse, hid it again and wondered what to do next. From his window he could see Joe and Bob in the street. They were tying his sack of leaves together and Bob was wearing a red mask with a thick black mouth.

So that's what they were doing. Making a guy. If only he'd thought of it. He found himself belting down the stairs and out the front.

"That's my sack," he gasped at Joe. "Those leaves took me all morning."

"No, it isn't. Mum paid you 10p and she said we could use it. Anyway, what do you want it for?"

Jimmy kicked at the gatepost.

"Tell you what," Bob said thickly through the mask. "If you want to be useful you can run and get my go-cart."

Jimmy zoomed past the three houses down to Bob's patch. The go-cart was a prize possession and had taken Bob's dad three weekends to make.

When he got back, Joe had finished tying the sack and Bob was holding an odd pair of socks, one blue, one green, and some mittens with holes in them. He began to fill the mittens with gutter-leaves, crouching down over the pavement. He said the mask was sweaty and it lay by the road.

"Look, we still haven't got a jacket," Joe said crossly. "You were going to ask your dad."

"Well, I forgot, didn't I?" Bob's back ached from bending. "My dad this, my dad that, it's always my dad. Just because yours is ..." he stopped.

"Yes," said Joe. "Mine's dead, so I can hardly ask him, can I?"

Bob hurriedly stuffed more leaves into a mitten. "Sorry, Joe, I didn't mean anything. It's just that it isn't looking like a very good guy, is it?"

Jimmy felt his heart beginning to thump. He stared miserably down at the pile of old clothes, at the mask lying by the road, at his own thin legs spread straight along the go-cart. And an idea flew into his head.

"Well, I could be the guy, couldn't I? If I wore Joe's blazer, it'd look very big on me. And I could try to kind of sag, like a real guy, better than leaves."

Bob looked at Joe. "It might work," he said. Then he looked at Jimmy. "Can you be as still as frozen fish fingers?"

"Stiller," said Jimmy. "Try me and see."

First they put the trousers on and tied them round Jimmy's waist. They covered his legs and a lot of pavement too and Bob nearly choked laughing. Then Joe fetched his blazer and the arms dangled and flopped over Jimmy's hands. Then they sat him down on the go-cart again and tied on the stuffed mittens, which scratched, and the socks which felt warm and heavy.

"Now," Joe said, "the mask and the hat and then we'll tie him on to the cart. Jim, flop your head a little. No, not so much. Right! That's great!"

Being inside the mask was like being in a strange, stuffy underground. Jimmy could see out of the eyes as long as the mask didn't slip. So they tied that on too, and wound the scarf round to hide his neck. Breathing was hot work.

By four o'clock they were ready.

"Where are we going?" Jimmy muffled, steaming up the little air he had.

"To the station, of course," Bob said. "All the best guys hang around outside the Tube. Come on, Joe, you push first. Jimmy, no more talking. You're supposed to be a dummy."

At first Jimmy enjoyed it. It felt good to be pushed along

and to be a part of Joe's and Bob's plans, and he knew he looked real. Then Bob said, "Here's a good spot," and the go-cart stopped.

The next hour grew steadily more awful. "Penny for the guy ... penny for the guy," he heard Bob and Joe saying, and he felt the coins dropping into his lap, but he was so uncomfortable. His legs ached and he couldn't breathe and once he nearly sneezed and his nose tickled and then he wanted to go to the lavatory. But he didn't dare to move or say a word. He shut his eyes because it was too much effort to go on trying to see, and then he began to feel the wind biting at his legs and hands.

He wanted to go home. Hang November the fifth. Who on earth had invented it anyway?

At last he heard Joe say, "We've got one pound and twenty pence, Bob. Let's go back. We'll get some sweets," and the go-cart began to move.

Jimmy opened his eyes, wriggled his toes and breathed a sigh more of relief than air. Through the tiny eye slits he saw it was already getting dark. They crossed the road opposite the station and turned up a side street. Joe danced ahead of the go-cart backwards.

"How's the great guy?" he sang, but didn't listen for an answer.

They got to the corner of Albert Street and Bob bent down to speak into Jimmy's mask. "Just going for some sweets," he said. "Won't be long."

Jimmy suddenly felt fed up. They hadn't asked him if he wanted anything to eat or any of the money and it had been his idea, his dressing up and his sitting there that had earned it. The footsteps and voices faded into the silence.

Jimmy's misery hardened into anger. He'd clear off – what was the point of sitting like a dummy for nothing? He wrenched one leg free of the string.

Then he heard the noise of a van. It stopped on the corner, right beside him. At once Jimmy froze, only this time to listen to the two voices talking in loud whispers.

"Hurry up," one of them said. "I'll keep watch. If anyone comes I'll sound the horn twice. You've got five, eight minutes. Right?"

"Keep your hair on," a second voice grumbled. "Nothing'll go wrong." Feet tramped past Jimmy, round the stringy hedge and crunched across the small patch of grass. There was a faint squeak of a window being heaved upwards, echoed and then drowned by the first man's uneasy whistling. Then the whistling stopped and Jimmy heard a match strike. Sour cigarette smell drifted through his mask and for a terrible moment Jimmy was sure he would cough. He swallowed instead, feeling sick.

The thin trail of smoke suddenly stopped. Voices floated from the shop and the van's horn sounded twice. Footsteps pounded from the house.

"OK?" the voice was grim.

"OK. More than OK. Don't worry. A bag full. Here, take it."

The van doors slammed. But Jimmy was ready. He bent his head to his knees to shove his mask away. DXA 492B he read as the engine blurted into life and the van stuttered off into the darkness. DXA 492B. DXA 492B.

Then Jimmy wriggled out of everything – trousers, blazer, gloves – kicked the go-cart aside, and ran the block to his house. The front door was open, the telephone was on the shelf. 999. Jimmy's hands shook with cold and excitement. "DXA 492B" he said loudly. "It's a van. They've just stolen a bag full."

Half an hour later Jimmy's mother returned to find a police car outside the house. A pale and exhausted Jimmy was telling a patient policeman an impossible story about guys and sweets and trying to keep still.

Two hours later Jimmy had become the hero of Albert Street. His disguise grew more elaborate, the sweets sweeter, his achievement more remarkable. Everyone believed every word. Even the police took him seriously and found the van, and the bag. The men remained a mystery.

On November the fifth a huge box arrived for Jimmy. Fireworks of every kind: crackers and bangers and sparklers and showers, some which fizzed and some which sprayed and popped, pink and white and silver and orange and green, some which rose into the sky for ever and others which were a mistake and never got off the ground. They drank the night air and painted the night sky and those who saw them never forgot. They were, as Joe so rightly said, for "the best guy on Albert Street".

And the good thing was, his purse was still full.

That story is very much an adventure, full of real but nevertheless straightforward, predictable characters whose storyline is pinned to a straightforward, predictable public celebration. I was aware of the fact that I dealt with a "missing" father by killing him off altogether; that the mother is pushed for time, works away from home and has no idea what her sons and their friend get up to when her back is turned during the half-term break.

Woven skilfully into the story is a child who is small for his age. Sam was obsessed with his lack of height. I knew he'd be as tall as the rest of them eventually because he always had big feet. But try telling your offspring that it's quality that counts, not quantity, when his peer group are not only towering over him, but also bossing him about.

This second story is considerably deeper and more complicated. Once again, my confidence as a writer had blossomed with the encouragement of a consummate

professional. Here I approach a subject very few children's writers at the time had dared to confront, although the problem was only too real for thousands of children up and down the UK.

What happens to you when your dad is sent to prison? How does it feel? How does it change the relationship you may have had with him? Can something good come of it – and if so, how?

New Year Cat

The thing about my father was that you never knew what he was up to. He was hardly ever at home and even when he was, he could have been somewhere else. He talked to you if you talked to him but more often than not I couldn't be bothered. I mean he never really answered questions properly, so although I was curious about him it never got me anywhere. It was as if he was sitting behind a brick wall. However high you jumped, all you could see was his hat.

The bowler was always part of his leaving-the-house uniform, but when or where he took it off remained a mystery. My sister didn't know and I don't think my mother did either, though she always pretended she was simply too busy to tell us.

And in a way that was true. She was always making something: rugs and pots and toys and jewellery and clothes and raffia mats; you name it, she'd made one. And sold it. Because the other thing about my father was that the bowler hat never seemed to make us any money. At breakfast when the bills arrived he'd have that hat on and be out of the door quicker than you could say cornflakes. But my mother would leave the house with a dozen assorted ashtrays and come back with a week's groceries, cheerful as a robin. I've never seen her really sad.

119

Well, only once. We were giving my sister her twelfth birthday party – my father wasn't there, of course: he was "somewhere in the City", according to Julia. In the middle of it all the telephone rang and my mother stood talking in the hall for half an hour. When she came back to the kitchen she looked all white and old. That evening she didn't make anything. She just sat on the edge of her bed staring at the floor. It appeared that the bowler hat routine had gone a little wrong and Father had been sent to prison. For two years.

Julia and I didn't actually know that for months. First we were told that Father was abroad on business; then that he was having a holiday; then when Julia asked and asked, Mother looked up from the knitting machine and said we were all going to see him – behind bars. So once a fortnight we began to have family outings which I rather enjoyed because afterwards we went to the cinema and ate fish and chips. Which we needed. Seeing Father in that grey uniform was really weird.

And it didn't make talking to him any easier. He hadn't changed at all – he still looked a bit remote and superior, like one of those men who read the news on TV. And he went on looking like that, every fortnight, for about a year.

Then one visit he looked different. We'd hardly got there before he started the conversation – something he never did – with, "Look, chaps, I've something to tell you."

That something, it appeared, was the prison cat. Jenny was her name and she'd been living in the prison for six months. Or, according to Father, existing – indeed, barely surviving. The other prisoners, whom Father referred to as The Thugs, had taken up a new hobby: they tortured Jenny wherever and whenever they got the chance.

When we asked how, Father just shook his head.

"I can't bear to look," he said, "let alone describe it. And

the irony is that the cat is supposed to give The Thugs 'an interest'! … It's done *that* all right."

He paused. Then he said, "How'd you like to try your hand at smuggling?"

Mother went very red. "Isn't it enough that you've got to spend another year in here?" she said. "Or do you want us all in with you for life?"

Father looked across at her. "Don't be ridiculous, my dear," he said.

There was a terrible silence and then suddenly she smiled and we all laughed. Father had actually laid a plan which involved us all and for the first time we had a great deal to discuss. It was the end of November. Our plan was to give Jenny her freedom on New Year's Day.

We bought a wicker picnic basket, removed the plastic cups and forks and put some newspaper inside instead. After weeks of persuasion Father had enlisted the help of one of the prison warders who kept a great many cats himself back home.

We arranged to meet Father in the prison garden. When he arrived, late, we were nearly frozen. Father's face was scratched and his hands were bleeding – but there was something bulging beneath his jacket. The bulge was transferred to the basket in a flash of black and white fur, and mewing enough to wake the dead. We abandoned the cinema and bought an extra portion of fish. The basket howled all the way home. By the time Jenny reached our kitchen floor she was not so much mewing as croaking.

We opened the lid. Mother picked Jenny out and put her on the table. She was the thinnest, scrawniest thing I'd ever seen. Her fur hung off her in lumps and one ear had an edge like a corrugated fence. *And she couldn't stand up.* Whatever The Thugs had been doing to her, they'd sure done a good job. Her legs were bent in a perpetual crouch, ready for take-

off. Julia's face crumpled up. Mother opened the fridge door and shouted "*Savages*" as if they were a new kind of sausage. I sat down quickly in the nearest chair and Jenny leaped for the corner. She stayed there for three days.

It was weeks before you could get your hands anywhere near to stroke her and weeks more before she learned to stand and walk without bolting for it. We had to buy her a lead when we first took her out in the garden, and she ate everything – baked beans, scrambled eggs, even apple pie, though she did leave a piece of it. The only time she stopped eating was when Julia got out the picnic basket for a school expedition. Jenny disappeared – all that day and that night. We never discovered her hiding place, and we gave the basket away.

But the best thing about Jenny was my father's face when we talked about her.

"How's New Year Cat, chaps?" he'd ask, his other-world look completely gone. And we'd say that she was fine and getting fatter every week and had caught her first mouse or her fifth and had been in a fight or had cat flu. And Father would say, "Oh, *dearie!*" or "Jolly good show" or "Topping news, chaps" and "The Thugs think Jenny just escaped and they want to know where she dug her tunnel" – and so on. Jenny had broken our sound barrier. The visits that in the bad old days had felt endless and uneasy, like being in a hospital, now flew past in a trice.

Father began to talk about himself when he was a kid. He'd had lots of cats and remembered them all. Then he began to tell us about his days at college and his friends; then a little about his first job, although his eyes did cloud over a bit and he grew vaguer and cleared his throat a great deal. I'm sure that some of the things he told us were new to Mother too: I used to watch her face closely on the bus going home, mulling it over.

When the two years were nearly up, I began to feel quite sure that Father not only wanted to get out of prison, but he really wanted to come home to us.

We had a surprise for him, and we'd worked very hard for ages trying not to let the cat out of the bag. We didn't really know when the surprise was going to happen or what exactly it would be, so all we could do was pray that the timing would fit.

Miraculously, it did.

Father was still on the doorstep when he asked, "Where's New Year Cat then, chaps?" and Mother said, "Oh, bother the cat. Can't you kiss me first?"

So he did.

Then Jenny appeared, curling herself round the edge of the hall door, shy and curious and very faintly aloof. She looked at Father and he looked at her. Then he walked towards her and bent to touch her permanently chewed ear, the only prison scar which showed.

"I can't very well leave home again, can I?" he said. "Not with you lot and New Year Cat to look after."

Then he straightened his back and looked across the living room. A large open basket lay beside the fire and in it curled three assorted bundles of wild fur.

A vast and delighted grin washed Father's face.

"I see," he said. "And New Year's Cats as well."

Dawn Chorus

In August 2006 I moved into a small terraced house in Woodstock that I named Hobbit Cottage.

It looked like the shack that Doris Day inhabits in that marvellous film *Calamity Jane*, starring Howard Keel as Wild Bill Hickok. Whenever I'm stuck on a new chapter, I sing *The Black Hills of Dakota*, and instantly feel a whole lot better. *Once I Had A Secret Love*, also from the film, can help, too, but I have to be in the mood. I often sang it to my cat, who'd always listen spellbound.

My Hobbit Cottage shack soon settled down into something more civilised. I filled the enormous cracks in the floorboards for a start. I made sure the stairs actually reached the landing. I tracked down a gas leak coming from the smallest mouse hole in the world. It stank to the heavens and beyond, but nobody had noticed it before. Even the man from the gas board couldn't smell it. Luckily, his smellometer did. We sealed it up. I went to bed happy in the knowledge that I'd indeed wake in the morning, ready for poetic and novelistic action – and that my gas bills would turn out to be roughly half the original estimate.

I love moving into a blank canvas and seeing it blossom before my eyes: creating something that will last, from very little to start with. My first small self-published collection of poems, *Dawn Chorus,* was a direct result of feeling refreshed. Its theme is birds: watching them, listening to them, imagining where they've been and how they live. The collection is intended for children, although of course it can be enjoyed by people of all ages. All you need is a vivid imagination.

Imagine being a bird ...

Here are twelve of the best:

Gulls

In St Ives, Cornwall

Who knows where the gulls have been?
Can you tell what they have seen?
Wind rakes under the fretful sky,
Gulls wheel, shrieking. Hear their cry!
Where have I heard it before? That high
Siren tearing my heart from my thigh?

Midnight quails. The gulls race through,
Blood on their wings, in their eyes. They spew
Bosnian Field, Chernobyl Hill,
Frantic from Chechnya, bloated, ill,
High on the wings of the wind they spill
Pellets of vomit from the lands that kill.

Do you know where the gulls have been?
Imagine it. Relive the scene.
Fly on their necks, come, taste the air,
Black with the stench of burning hair.
Mimic their shrieks of scavengers' dare.
Listen to the gulls.
They care.

Guillemot

On a Neglected Coast

All between the water's froth seeps the sickly oil
Lustrous, dark and dangerous, coil after coil
Winding into ebb and flow, watch the slickly oil go
Boil after boil after coil.

All between the water's froth swims the guillemot
Innocence personified, oil she knows not
Winding into ebb and flow, guillemot doth gladly go
Oil she knows not, she knows not.

All between the water's froth of that soiling sea
Lustrous, dark and dangerous glides the oil. See!
Winding into guillemot ebb and flow doth find her spot
Whirling, twirling, tie their knot round the
sinking guillemot.

Throttle guillemot.

First she smells the stench of pitch,
makes her very eyeballs itch
Acrid fumes then seize her brain,
blind her from behind their rain
Breathe she cannot, cannot call: cannot see or feel at all.

Slicks glide with their choke and frown,
seep and soak their blackly brown
Kiss, caress her, claw her down.
Gladly now she wants to drown in the soiling sea.
Gladly now she will be drowned in our soiled sea.

Dawn Chorus

On Port Meadow

Why? caws the Crow from his slice of the hill,
 Shiver my timbers, you give me a thrill –
Inky blue morning. Come, rise! Hip and shine!
 Shiver my timbers, this air tastes like wine.

Who? bellows Owl, puffing stern on his bough
 I am The Pearl Dropper, always know how.
 Wisdom incarnate, the fountain of all
Got you sussed out – where the poop is my shawl?

When? mutters Chicken, just answer me that
 It's perfect for you but her mangy old cat
Comes prowling meeowing, he gives me the quake.
 When may I hennify worms I might rake?

What? hammers Woodpecker, looking ahead,
 Hand me that nail, my dear, making a shed.
 Can't stop to chatter, push on while it's light.
 Haven't had time to think. Muscle? It's might.

How? screams the Raven, swoop-brushing the field,
 Beautiful seedlings so nicely revealed.
 Flying together my husband and I:
 We do the hard work for breakfast in sky.

Dawn tiptoes shivering over the lake
 Horses stare quietly, ever awake.
 Cats carol argument,
 Cows gather grass.
 Dawn will come quivering
 Where His feet pass.

Don't Say Boo to the Goose

On a Cotswold Farm

Don't say boo to the goose, my child,
Be careful where you tread
For the goose has a hiss disguised as a kiss
And aimed right at your head.

The goose may hiss to protect her young
Little gosling, soft as dough,
But the goose with a hiss disguised as a kiss
Shoots venom pure as snow.

Don't say boo to the goose, do you hear?
Never goose-step down the line,
There'll be no golden egg, that's clear,
Just the barren weeping twine.

The serpent boasts a hiss like that:
He thinks it slimy fine
When your skin goosefleshes
And your eyeballs meshes
And your mind seeps thick with wine.

Please, don't say boo to the goose. No fear.
Be careful where you tread.
She's the snake in the corn wherever you're born.
Dance somewhere else instead.

Eagle Who Dares

For Diego

You'll never find my hideaway, not in a thousand years:
My private ledge, my rest, my rock, the fortress for my fears
That I show not. Not me. I am an Eagle of a Bird
I fly for hours on the wing – haven't you heard?

I like the mountains and the sky where I can
stretch and swoop.
I see for miles in the rain, I watch the rivers droop
And rush and dance, the waterfalls that dazzle in the sun:
I am an Eagle of a Bird – why don't you come?

But you will have to dare with me,
your heart will beat as fire.
The nights gloom pitch, the moon spins wild.
Fly higher, ever higher.
And when the Dawning Light appears
and you freeze cold as ice
I'll fly you to my craggy ledge. Won't that be nice?

Folie de Grandeur

In Wolvercote

Percy is my peacock. He sometimes comes to tea
But only in the summer time beside his favourite tree.
Percy is my peacock. He lives beside The Trout
In splendid resignation. He grows his colours stout
Especially when the winter's frost crisps,
and his tree stands bare –
This afternoon I saw him fly to sit on it and glare.

Hee haw he sniffed – he often does,
he's such a puffed-up snob –
But though he likes an audience he hates the jostling mob.

Percy is a proud one. He knows he's handsome is
As handsome does. He's hard won but hardly loyal. His
A pride of royal ages ingrained within his race:
Tiared and beplumed he struts,
My Percy peacock ace.

Gathering

By Blenheim's Lake

High in the fir trees the ravens gather
Bending the bough, bending their ear
On the horizon the branches darken
To hear

First zooms the first and promptly one other
Bend me the bough, bend me your ear
Flap in the fir trees, their branches harken –
It's near

Gather the ravens for watching and waiting,
Storming and calling their Voice from the Sea.
First dips the one and then floats another
Then, out of nowhere, come three ...

Soon, by commandment, flock hundred on hundred
Filling the sky with battalions of wings.
Swiftly they gather their hundred on hundred. It brings

News of the climate beyond the horizon
Ominous warnings of wind, wave and tide
Screeching and flapping –
Then suddenly silence gapes wide.

Into the stillness, a pearly white thrill bless,
Each bird sits frozen in time and in space
Motionless, clinging to branches in silence –
Their place.

Nightingale

For Joe

Sing for me, sing for me, over the hill,
Sing when the corn is ripe, golden and still,
Sing for the apple tree's blossom and then
Sing for me over and over again.

Now is the time for you, most blessed bird,
Sing for we need you, I give you the word,
I make intercession, I listen and then
Ask: sing for me over and over again.

Sing when the nights are long, high on the moon,
Sing when our troubles come only too soon.
Sing for our purity, celebrate calm,
Stand for integrity, pour on its balm.

Sing in our dawning and through into dusk,
Watch as the perfumes of night drench their musk,
Sing for remembrance, be proud of our past
But as we look forward, we also stand fast.

Sing for me, sing for me, over the hill,
Sing when the corn is ripe, golden and still,
Sing for the apple tree's blossom and then
Come: sing for us over and over again.

Egg

For Phoebe

I love a boiled egg, me, for breakfast, lunch or tea.
It nourishes the appetite
The deeply yellow and the white,
The crunch of shell beneath my spoon
Reminds me of the sailing moon –
I love a boiled egg, me, for tea.

The miracle of egg! See! For breakfast, lunch or tea.
The perfect oval in my hand
Still warm. Its feathers soft and bland
The scrunch of straw beneath my feet
The clucking of the hens who greet
Me. Will I find their fresh surprise?
You bet! There is no finer prize.

I love a boiled egg, me, for breakfast, lunch or tea.
A slivering of crunchy toast
With butter – that I love the most –
A shivering of seaweed salt
A cup of tea that tastes like malt:
The perfect meal. Hens, I beg –
Give us this day thy perfect egg.

Lullaby Bird

For Iria

The Lullaby Bird has one blue eye
The other eye is green
Her feathers rustle as she moves
To bring you special dream

Sometimes she smells of new mown grass
Sometimes the scent of pine
Will drift towards you as she floats
Beyond the reach of time

Sometimes she plucks a heavy harp
Sometimes she'll tune a flute
She'll often zizz a tambourine
Or on a drum she'll root

The Lullaby Bird loves liquorice
Stem ginger, aniseed
The Lullaby Bird plays hop and skip
And then she'll do her deed

She'll throw her shawl around you
To sanctify your eyes:
Our Lullaby Bird's miraculous.
Sleep wise.

Robin

For Charlie

I violin in starlight
When frost appears at noon
I catch the midnight apple
When the crust fills up my spoon
I whirligig the clarity of sky and sea and air
I violin in starlight you are fair.

I piano for the roses
When lost without their bloom
I snip the falling cartwheel
Of the leaf without its tune
I harpsichord the memory of cloud and rain – and dare
To piano for the roses in your hair.

I triangle the cobweb
Which clings against the moon.
I feed the dancing Robin
When he comes to clean my broom.
I purify the bonfire and in its shoot of flame
I triangle the cobweb in Your Name.

Birdsong

For Wytham Woods

The path lay cleared in the Orchard –
it took me by surprise –
The grass lay soft and flattened where the
mower with his scythe
Had taken winter's suffering and patterned for the Spring:
The path lay cleared in the Orchard,
Bells may ring ...

It only took a moment – which caught me by surprise –
The light shone right, the sky wide, bright,
the Birdsong in my eyes
Said don't be so ridiculous! How can you move away
With paths thus freed in the Orchard
For your stay?

My walk led straight to the Orchard –
it took me by surprise –
The trees sang Yes! in the Orchard
beneath those floating skies.
And simply thus the Way is shown
Among those clouds, so high, so blown:
My path lay clear in the Orchard's
Twilight rise.

The Realms of Gold

My first and only trip to Amsterdam took place in the 1950s when my school linked me up with a Dutch penfriend. She spent a rather dull fortnight with me in Edgware, and we then took the boat to Holland. Amsterdam was still recovering from the effects of the Second World War: it was a city licking its wounds, trying to remember it could be elegant and inviting but not yet having the energy or the resources to be either.

My penfriend lived with her mother who worked all day and in the evening went early to bed. We spent much of our time walking the city – and visiting two art exhibitions I shall never forget. In one small gallery we discovered a collection of paintings by Van Gogh. I had never seen such a miraculous use of colour. His sunflowers seemed to hold light in every petal. I could feel the frenzy of his work beating into my body.

In another larger and darker gallery, I stood entranced opposite Rembrandt's *Night Watch* and then admired his portraits, some of his own face, with their exquisite details of skin tone and knowledgeable eyes. After a journey home

in impossibly rough seas when my pale grey duffel coat became drenched in salt spray and yesterday's supper, I sat at my desk to write my first truly original essay on the remarkably different painters I'd seen in Amsterdam.

Holidays abroad with my parents culminated during the summer of my first year in the Sixth Form. We spent a fortnight in Brittany, during which we met a charming elderly French couple who invited us to stay with them in their house outside Paris. My parents weren't particularly interested, but the following summer they accepted the invitation on my behalf. They persuaded me it would be an excellent six-week opportunity to improve my spoken French and take hands-on lessons in French cookery.

Their house was old-fashioned but charming, with an enormous kitchen and impressive gardens. I struggled along with my basic French, making conversation over mealtimes as best I could. I shopped with Madame in the market every morning, selecting from a magnificent array of fresh, brilliantly colourful food. I helped to make their three-course lunch, to clear it, and then to start all over again with the evening meal.

Monsieur spent all day, every day, in the garden, growing a wide variety of vegetables and fruit, mowing the lawns, weeding, pruning and picking flowers for the house. The French couple's quiet domestic routine was pleasant but dull. I read all the novels I'd brought with me in the first fortnight and then attempted some in French, which required a great deal of patience.

One afternoon I came back from a long walk I'd taken to explore a neighbouring village. Monsieur was standing at the top of the stairs. As I walked up them and tried to pass, muttering a formal good afternoon, he caught me in his

arms and planted on my lips a wet and utterly revolting kiss. I wrenched myself away, almost fell down the stairs, managed to slide past him and dashed into my bedroom. I slammed the door, yanked a rocking chair against it and collapsed on the bed, my heart beating with fury and dismay.

The house was completely silent. I realised that Madame was out. Her husband had been deliberately waiting for me, having planned his ambush with considerable care.

I'd no idea what to do. If I reported his behaviour to Madame, I guessed it might either be the end of a long marriage or the start of bitter quarrelling. If I left abruptly without reason, they'd worry about my lack of explanation. I felt completely trapped. I knew I'd have to pretend the incident had never happened, put on the bravest face I could, avoid looking at or talking to Monsieur and go home as planned.

I opened my diary, my hands shaking, and began to count the days to my escape.

I woke up the next morning, praying Monsieur would already be in the garden, wondering whether I could face another three weeks of what had rapidly become a nightmare vacation. A telegram arrived from my parents. For a few moments I thought they might be calling me home because one of them had been taken ill. In fact it was brilliant news. I'd been awarded a State Scholarship in English and History. This meant my father would allow me to stay on for another two terms in the Upper Sixth until I'd gained a place at university.

Several new members of the French family arrived for lunch and to stay for the next month. There was more shopping to do and masses of food to prepare. Lunches took two hours or more. Suppers lasted most of the evening. Nobody seemed to notice that Monsieur and I barely spoke

to one another or that I never looked him in the eye. When the day finally came for me to leave, I tried not to show my intense relief and joy.

My first proper experience of living in Italy was my three-month stay in Perugia during the summer of 1959. I wanted to learn Italian so it could form part of my honours degree at Reading University. I travelled to Perugia with friends I'd met earlier in the year when I worked for Foyles in London. I'd saved every penny to fund my trip, and paid for the Italian course at the University in advance.

The three months became a useful lesson in survival. I was eager to leave Edgware's stifling suburbs and could hardly wait for my first taste of real independence. We'd booked into a convent which proved to be full of nuns who made lesbian passes at us. We quickly upped sticks and moved to an apartment that gave us the freedom to come and go as we pleased.

The small city was dominated by its summer influx of students who came from all over the world. I remember an Australian whose beautiful dark-haired wife was heavily pregnant; a French girl whose entire wardrobe consisted of two suits with short skirts and long jackets, one bright mustard-yellow, the other pillar-box red. She looked stunning in both. Several wealthy Americans spent their time organising flamboyant love affairs between lonely individuals; and gangs of handsome Italian men hoped to take any attractive girl to bed if they were allowed to do so.

Formal lessons took place every morning at the University, where our tutor would move up and down the aisles of an enormous room talking at the top of his voice in Italian and gesticulating wildly. Our afternoons were supposed to be devoted to private study, which meant having

a long if frugal lunch and finding a quiet spot to lie with a notebook under the glorious Italian sun.

I didn't drink alcohol, I didn't go to bed with boys, nor did I learn as much Italian as I should have done. After one of the friends I'd travelled with borrowed my swimming costume when I'd expressly asked her not to, I decided to survive on my own for the few remaining weeks. I moved to a top-floor flat of a crumbling block of flats where I wrote a lot of atrocious poems by candlelight and fell in love with an Italian lad whose mother never took her eyes off us in case we kissed.

We never did.

During my second summer at Reading University an advertisement in our local newspaper asked for an English tutor to a five-year-old boy for the summer. An Italian aristocrat, well-dressed, charming and polite, interviewed me in a London hotel. We agreed on the details of the post and I flew to Milan a few weeks later to an elegant apartment, his bored American wife who spent most of the day having her hair done and buying clothes, and their child: a sweet-faced boy with almost no English but an enthusiastic wish to learn.

All went well until the family decamped to the Italian Riviera and the Count's elderly mother's villa by the sea. Several other members of his family were also staying there, and the evening meal quickly became a nightmare. I'm Jewish by birth but not belief – except when it comes to listening to people with anti-Semitic views. Then my blood boils. The matriarch spent evening after evening coming out with a stream of obscene and abusive twaddle. I put up with the fascist rubbish for a month, silently staring at my plate and barely able to eat. Then one evening in the middle of

another filthy diatribe I stood up and told her exactly what I thought of her. I travelled home the following afternoon, still furious, but proud of the fact that I'd made my feelings plain with every shred of dignity I possessed.

I received a letter of apology from the Count. He told me that had I made it clear from the start I was Jewish, his mother would never have dared to open her mouth. I didn't believe a word, convinced that my departure would probably only have exacerbated her disgusting views.

But this experience didn't put me off Italy. The country had got into my blood and I spent some of the summer in 1963 in Florence and Rome. I remember sitting in one of the squares in Florence reading a report in *The Times* about an audacious raid fifteen men had made on a Royal Mail train travelling from Glasgow to London. The gang had got away with £2.6 million – £50 million in today's money. The Great Train Robbery seemed a long way from the grace and elegance of Florentine paintings and sculpture.

Twelve years later, I spent a long weekend with some Swiss friends in Italy, motoring through Tuscany with them while they decided which holiday cottage to buy. It was fascinating being able to see inside people's continental homes, many of which were gloriously modern with tiled shower rooms and enormous balconies. One crumbling, ancient villa, set in the middle of wild neglected fields that smelled of garlic, had been abandoned for many years and would have made a marvellous setting for a film. The estate agent told us that one of its top-floor windows had been bricked up to harbour a member of the family who'd gone mad.

Shades of *Jane Eyre* made me shiver.

My second novel for teenagers, *Coming of Age*, is set partly in Florence. I knew the city well enough to write about it, although I also travelled to Fiesole to refresh my memories and to do some specific research. Sam paid for the trip, for which I was extremely grateful.

Every morning from the hotel high in the hills, I took the bus down into the city. I spent hours walking, thinking and sitting in cafés working out the plot. Then I went back to my hotel to write. I took home three filled notebooks which I subsequently typed up and never changed a word.

After the novel was published by Simon & Schuster UK in 2003, I started planning its sequel, *Return to Fiesole* – but its plot focused on a full-blown love affair between my heroine and the Italian she'd travelled to find in Florence: her dead mother's lover. I'd already begun to write for the adult marketplace and I knew the S&S children's list would never accept it.

Reluctantly, I called a halt to the project. Instead, I invented a new pair of teenagers living on my doorstep in Oxford who became the protagonists of *Lost and Found*.

The Sound of Silence

In 1953 we were both fourteen, sitting in the wonderful old library in North London Collegiate School, all oak panelling and wooden shelves, supposed to be writing essays.

My best friend leaned across the table. "I found out last night from my next-door neighbour," she whispered. "A French kiss is when the man puts his tongue into a woman's mouth, just like ..." She blushed. "Well, just as if."

Deeply shocked, I put down my fountain pen. "Why *French*?"

The blush deepened from pale pink to scarlet. "Because they're particularly good at it."

The teacher on duty frowned us into silence. But not before I'd decided to go to France as soon as possible to do some field research. When, four years later, I did, the kiss was not at all what I'd hoped for, as I have just explained.

Browsing and borrowing in libraries, and actually working in them, are totally different activities. When I was a child there were no such things as "children's books". I used the Edgware library – then a one-floor, one-room hut, now a

major centre – on my way home to Hale Lane to borrow anything I liked the look of. Nobody ever questioned my choice.

One of the first jobs I had in Oxford as a graduate was as a trainee librarian in The Taylor Institute, the foreign languages library. Their enormous catalogues were recorded in blotchy black handwritten ink. Upstairs sat a moribund librarian who belched like an indignant rocket if we dared walk past. The Reading Room was always full of students in the pale-sweat stages of examination panic; and the Head Librarian's Room, where books tumbled over each other as they climbed towards the ceiling, revealed chaos of the first order.

When I moved back to Reading to get married, the University gave me a job in their library. The post soon came to an end when I discovered I was pregnant. As a leaving present their Librarian gave me an enormous pile of towelling nappies. I'd have much preferred Pampers.

Living in Oxford many years later, embarking on *Larkswood*, my first historical novel for the adult marketplace, I needed to do serious, detailed research – and only reading back copies of *The Times* would fit the bill. That most marvellous of libraries, the Bodleian keeps treasured copies in enormous red leather binders. A letter from my literary agent vouched for my honourable intent as a reader; an oath of allegiance and a promise not to burn the place down accompanied my determination as I started work in the library on a daily basis. Next door, Blackwell's supplied coffee and biscuits at frequent intervals.

After years of working on my own in tiny rooms, in control of the space, the solitude and the blissful silence, sitting in a public space alongside other rustling, whispering,

computer-tapping, chair-crunching students came as a shock to the system. The treasured copies of *The Times* needed to be ordered in advance, volume by volume, so a planned day of research became solid weeks and more. They are not only staggeringly heavy to manipulate but priceless. Their paper is like moth-wings, their fonts so small normal eyes need a magnifying glass, and some of the most popular pages – for example, the announcement that "This country is at war with Germany" – are so threadbare they are fading into their own graves.

But order the copies I did, bursting with gratitude that such research was made possible by a team of dedicated librarians, and leaving the library every afternoon with a file crammed with invaluable handwritten notes.

Then everything began to change. By 2007 the Bodleian decided it no longer had the space to house its mountains of books within Oxford itself. Dr Sarah Thomas, a highly qualified, enormously experienced and visionary American, was hired as Bodley's Librarian, to supervise the most enormous operation in its history. After an extensive search for suitable land and local labour, Dr Thomas found a £26million site in Swindon. An air-conditioned, state-of-the-art book storage facility was built, complete with 153 miles of shelving.

On 28 December 2011, the seven millionth Bodleian book was moved in to complete this massive undertaking. Richard Ovenden, now Bodley's distinguished Librarian and an author in his own right, is today the owner and protector of a staggering ten and a half million books and maps – and counting. If seven million books take up 153 miles, how many more miles of shelving are needed for ten and a half? You do the maths. Answers on a postcard please.

On a day in 2012 I shall never forget, I was the first ordinary reader to be shown around the facility. Lindsay Fairns, one of their brilliant Managers, who can find her students anything they need at the drop of her mastermind hat, beckoned me into an enormous high-ceilinged cave, filled with shelves fanned with cool air and lit when you moved and needed the light.

"There she is," Lindsay said.

And there indeed she was: a copy of my first novel for teenagers, *Girl in the Attic*, sitting on her own, away from my other novels, because of her size and not because of anything else.

By that time I'd written three other novels for young adults, and after years of work I'd been given a contract for two historical novels to be published by Orion. I now needed *The Times* for both projects, and time was of the essence. I was shown into a small private room where Lindsay had laid out several leather-bound volumes. I knew I'd never have time to travel from Woodstock to Swindon on a daily basis. Once again, I needed an Oxford library.

I reached into my handbag for my chequebook. Special requests need to be paid for. Now my expeditions to Oxford were planned on a military basis. *The Times* was delivered to the Vere Harmsworth Library – the Rothermere American Institute – in Parks Road. At 9.00 a.m. every morning, to avoid the early morning rush hour, I took a taxi from Woodstock, armed with a trolley filled with notebooks, folders, pens, thermos flasks, elevenses, lunch and tea. Here I could read, think, take notes, eat lunch in the basement, brood over coffee and, my head reeling and my eyes burning, collapse in the taxi which arrived at 3.30 p.m. to take me home.

The librarians were outstandingly helpful. Different

editions of *The Times* arrived on request like miraculous clockwork. And every time I opened the doors of the Rothermere, after the noise of the journey, the bustle and traffic of the town, their walls held within them the peace and quiet that enable the working mind to settle down, to concentrate, to think, plan, read – and write.

The sound of silence was golden.

Here is a poem about my childhood.

Finding Quiet

Our voices echo in the gym and bubble over meals
We chatter as we change for games, deciding noisy deals
On who we owe the most to, or when we plan to wed:
We smoke a cough of cigarettes inside the garden shed.

The milkman's horse comes clattering as dawn breaks
through the sky
Our front door slams, Dad's car zooms off,
relief heaves into sigh.
I call for Tessa on my way, our arguing begun,
And once at School, high ceilings hear
To Be A Pilgrim sung.

In bed at night I listen as their wrangling begins –
"I want more money, darling. I don't forgive your sins."
I shut my ears and hope to die in case I hear them shout
But then he closes mouth.
For weeks there's nobody about.

I find long quiet moments in the gardens of my School
Beneath the spread of cedar where
those prickly needles rule:
A corner in the library, a crouch beside the lake
Or writing on my own before we drink our milky break.

The silence of suburban life can wreck the human race –
"Good morning!" has no meaning if eyes never meet.
My space
For finding quiet lies within the life behind my eyes
Where gardens matter most because a garden never lies.

Less is More

Writing short stories that really work for their living is one of the most difficult of crafts. Every word should matter. It must either be there for a purpose, or get deleted if it isn't doing exactly what it says on the tin. It's a hugely underrated skill. I once spent three weeks preparing an hour's talk for a local secondary school on how to write a good short story. During my preparation, I read hundreds of them, loving those by Roald Dahl in particular for their imagination, wit and wild savagery.

During my talk I quoted in full a short story by Richard Yates, an American novelist better known for his novels, in particular *Revolutionary Road*, written in 1961. Sam made this into an extraordinary film, starring Kate Winslet and Leonardo DiCaprio, that clung faithfully to Yates's original intentions.

The short story by Yates that I think is a masterpiece is called *Bells in the Morning*. It's only three pages long. It features two soldiers, Cramer and Murphy, who squat in the German trenches of the Ruhr towards the end of the Second World War. It's a freezing Sunday morning and they

151

hear church bells. For a few wonderful moments they think the sound might be announcing the end of their horrific nightmare: the filth and the squalor, the waiting, the hardly sleeping, the killing of men they've never met and don't really hate. Then they realise the bells are merely and routinely celebrating Easter Sunday.

My crushing of the three pages into a few lines hardly does justice to the way Yates tells his tale. Every single detail is authentic, from the twang of the soldiers' voices to the description of the misty early-morning landscape and the tasteless coffee powder the men prepare as a drink. In the space of a few minutes, Yates coaxes his readers into position, not only making sure they'll believe every word, but that their sense of disappointment when they realise there'll be no end to the cold and the mud and the infinite pointlessness of everything is as sharp as that of the protagonists. We don't merely *know* about the soldiers' predicament: we *feel* their agony.

When baking the short story cake, you'll need a few crucial ingredients. Strong characters, as few as possible. As short a timespan as possible. A setting that is vivid, real, quickly grasped and easily understood. And the ability to keep readers guessing, so the end of the tale twists its knife as deeply as possible into their hearts.

Above all, there must be passion. Love, hate, despair, hope, shattered dreams – but oh so subtly drawn. The sacred rule of the best writing – *Show don't tell* – is crucially important here. Don't step aside as a narrator to start pontificating on the whys and wherefores of a situation. Just throw your readers into it, hook, line and sinker, and make them feel it for themselves.

Here's an example of one of my short stories. It's the most autobiographical I ever got, but it works nevertheless. It's also authentic. I wasn't exactly trapped in the trenches of war: I was cobwebbed in London with my mother. It was a different kind of mud altogether and no bells on Sunday, no truce of any kind, ever brought about its end. Only her death.

Apples and Pears

At noon, a dusty sun high in an even dustier London sky, Ella Richardson emerged on to the Finchley Road from her meeting, feeling battered and bruised.

A freelance editor and journalist, Ella often told herself she had to be prepared to take on *anything* publishers offered. At first, Tweet and Sourwell seemed friendly enough. But legal-speak was absurd. It didn't make any kind of sensible sense. In fact, Ella had decided back home in her cramped Oxford cottage, most of it was garbage. When asked to edit a particular legal document she'd totally rewritten it. As they read it, the faces at Tweet and Sourwell turned from shock to disbelief to permafrost.

On such a hot day, too.

Ella hitched her heavy briefcase on to her shoulder, wishing she'd chosen flat shoes and wondering how long she could last before making a dash for the loo. She hadn't liked to ask Tweet, let alone Sourwell, whose bodies obviously had no natural functions of any kind whatsoever. The Finchley Road wasn't exactly littered with lavatories, public or otherwise. It was a question of choosing between filth or obscenity.

She had no choice.

She'd have to tackle her mother in that ninth-floor flat of hers, or climb on to the train from Paddington to Oxford with wet knickers.

Ella stood outside the towering block of flats and hung on to the bell. She knew from bitter experience that a lot of hanging would be needed. Her briefcase bit into her arm. The demands of her bladder dominated her universe.

Eventually the voice at the far end of the moon said, "Yes? … Who is it? … Speak up, I can't hear you."

"It's only me, Mother." Ella tried to smile casually at the lurking porter with his cold are-you-a-terrorist eyes. "I've brought you some lunch."

There was a long silence. Then the voice quavered, "Lunch? Did you say –"

The porter relented. "'Ere you are, then," he said. "Why don't I let you in?"

Ella's mother stood by the front door looking flushed and guilty. She wore an off-white dressing gown spattered with crudely designed, bright red roses, and a pair of enormous once-fluffy slippers. She held a handful of Kleenex tissues to her mouth.

"How nice to see you, Ella, dear … You should have told me … What have you got for me?"

Ella made a dash for the loo. "Wonderful sandwiches." She gasped with relief. "And yoghurt. And two bananas and four Mars Bars."

Ella ran the blissfully cold tap. *Sod Tweet and blithering Sourwell. See if I care … I've got plenty of other clients and they all have decent lavatories.*

On the plastic-topped table in the ugliest kitchen in the world sat a greasy glass dish. On it crouched one ancient apple, its skin puckered around the stalk, and a thin, dark-green pear with brown blotches.

Ella plonked her delicatessen offerings beside them. Her

mother rapidly slid everything out of its packaging and began stuffing a sandwich down her throat.

Ella said, "Are there any plates?"

Her mother waved a crudely-designed arm. "In that cupboard." Mayonnaise filtered its luscious way down her chins. "So … Ella Bella … What have you been *up* to recently?"

"Oh, this and that." The cupboard handle seemed to be covered in a thick layer of oil. She pulled out two hairy china plates.

Her mother began to maul a second sandwich. "Working hard, are we?"

Ella found it difficult to swallow. "Of course, Mother. You know me. Work, work, work! I hardly ever stop –"

"Pay you well, do they?"

Ella wished bitterly she'd never rung that bell. "Well enough, thanks."

"My latest gas bill! … I've never seen anything like it in my life. And it's still summer. God only *knows* what it will be like come the winter." She stared pathetically at the wrinkled fruit. "God only knows."

Ella stood on the corner of the Finchley Road. The sun beat down on her. The image of the ancient apple and its elderly companion crowded her mind and wrenched at her soft-centred heart.

On the street outside the greengrocer sat an amazing variety of fruit. Mangoes gleamed beneath the sun. Oranges and lemons winked and shone. Apples and pears, plump, juicy and freshly picked, nestled together, kissing lips.

Ella waved a sweaty hand. "May I have six of those, please, and three of those, and a whole basket of those."

The greengrocer leered at her. "Enjoy our fruit, then, do we?"

"Oh, yes," Ella said. "We simply *adore* our fruit."

Ella banged on the door of her mother's flat. The porter had seen her coming and had gratefully accepted a £5 note.

"Who is it?" the voice shrieked over the sound of a concert on the radio with trumpets and a piano competing for pride of place. "I was just taking a little nap."

"Let me *in*, Mother … I'm in a *terrible* rush … I've got a *train* to catch."

Keys scrabbled at the door. It creaked open.

"Good heavens! Twice in one day! I *am* a lucky bunny."

Ella heaved into the kitchen to greet the ancient companions.

"I thought I'd bring you some fresh fruit."

She dumped the bag full of mangoes and pineapples and oranges and lemons and grapes and peaches and strawberries and a large collection of Victoria plums on the slimy table.

"Why Ella Bella … What a *wonderful* daughter you are. And how *lucky* I am to have you."

"Aren't you just."

Ella bent to fish a plate out of the cupboard underneath the sink. On it sat a pile of bright fresh fruit.

She pulled it out.

The apples and pears and lemons and grapes sparkled seductively in the kitchen's dusty light.

The Encyclopedia of Visual Art

Taking over at the invitation of the Oxford company Equinox as project manager and project editor of Elsevier's enormously ambitious ten-volume art encyclopedia in 1979 was a challenge, to say the least.

The ideas behind it, a clutch of essays on art, and a few double-page spreads, had been mouldering in a cupboard for several years without anyone really knowing what to do with it. Sir Lawrence Gowing, a renowned English artist, writer, curator and teacher (1918–1991), and at the time Slade Professor of Fine Art at University College London, had agreed to be its General Editor but had long since given up hope of it ever being published.

Every autumn the spreads would be revamped and taken to the Frankfurt Book Fair, where buyers failed to materialise because nobody believed in it enough to invest. The project was then replaced in its dusty cupboard and forgotten.

I was intrigued by this back story, passionately interested in art and needed a challenge. I arrived to find a letter in an untidy desk from my predecessor. She told me the project was a killer, that I was a hack journalist with no formal qual-

ifications, that art historians as a breed were rude and arrogant, and warned me not to take it on.

I threw the letter into the bin and cleaned out the desk.

Feeling marginally better, if a great deal dirtier, I set to work. I opened three large metal filing cabinets. They were full of neglected manuscripts, some of them obviously unread. I poured over the initial brief. I was given a one-page list of everything that needed to be done over the next five years. Feeling faint and more than a little queasy, I went home to think it over.

Nothing ventured, nothing gained. I decided to take it on. I requested three quiet months in which to read and check what assets the company already owned, to assess what needed to be done, how long it would take, how many staff we'd need – and how much money we needed to invest.

I wrote to the Advisory Board, introducing myself, thanking them for their patience and asking for their continuing help. The Board, comprising Professors John Boardman, Norbert Lynton, Ronald Pickvance, John Steer and George Zarnecki, together with Dr Michael Evans and Mr Basil Gray, were superb. Over the following five years we became a real team. Each an expert in their particular field, they admired my enthusiasm for the project, my staying power and determination to succeed. I'd never have been able to hold the project together without them.

Elsevier agreed to give me time to review, revise and plan. I read every manuscript and chucked out a third of them. I edited the others and sent them to their authors for approval, together with a list of editorial questions and requests to update. I mapped out detailed plans for many more.

I met Sir Lawrence Gowing only once when he came to Oxford to give a lecture. I collected him from the station, drove him to our offices for coffee, and then took him to his

college. He made it perfectly clear he thought I'd never get anywhere with the project. He considered it to be too massive for anyone to compile and grossly underfunded. He also heartily disliked one member of the Equinox team with whom in the past he'd had several bitter arguments.

I put all that behind me and battled on. Five years later, when he was given the page proofs of the completed volumes, none of which he'd ever seen or been asked to read before, and a request to write an overall Introduction, I was told Professor Gowing almost keeled over with surprise, shock – and, finally, admiration. He couldn't and didn't fault a single word.

Our in-house editorial team, led by Robert Peberdy, was small, hand-picked, professional and utterly brilliant. We were careful, methodical and organised. Our picture researchers never lost a single transparency – and we handled thousands – and we managed to keep track of many of the original artworks' travels from one city to another as they were bought and sold. Our special researcher, Mel Cooper, continually ferreted out accurate and detailed information for anything and everything. We were all intent on proving to the world *it could be done*.

It was. We did it. We sold the project to both Macmillan and Encyclopedia Britannica, and none of us could have hoped for anything better than that.

For De Spilliaert

At The Royal Academy 1971

You can hear the wind in his paintings.
It's a tough, shredded wind. It pants,
Sighs, dies, then rises into life.
There's no mistaking its perpetual sound.

Only the one room. Nobody about.
His people are alone, they listen too.
Veiled in a railway carriage, hatted, gowned,
A widow hides with shadows lapping her.
On a bare beach a skinny creature runs,
Grainy, relentlessly blown against the sky,
Almost beyond your reach.

He shuts a door. Silence sets in.
A table dressed in white squats in defiance
Not a mouth to taste: the very picture of formality.

A pause. Years break.
A face begins to glimmer, others faint.

Then he finds laughter's cry.
A woman stands smiling beside a wood.
She plays a violin. Its thin, high call,
Absorbed in snow and caught within the trees
Makes melody.
And she is not alone.
Although no other figure goes with her
She is the Wind's Voice and its Messenger.

Paolo Uccello's Hunt in the Forest

after restoration

Every mouth springs open, every leg runs lean
Dog leads master, horse leaps rider
Dawns the forest. Rank outsider
Runs blue river's sacred water
Every mouth stays open, every breath rings clean.

Every voice comes calling, every eye stares wide
Horse snorts neighing, dog snaps baying
Stag hangs slaying. Centre staging
Crescent moon glints sacred water
Every voice cries calling, galloping the tide.

Mark the sharpened arrow … listen to the scream
Oak plantation's narrow pathway points its deadly gleam
Hound and stag and master lock in ruthless coil
See! The battle's over – take away the spoil.

Every rosy doublet, every jewelled glove
Every polished stirrup watch the act of love:
Every mouth is open, every leg is lean
Forest consummation's
Hunting scene.

The Whirlpool of London Life

When John Anstey offered me the post of Features Editor on the *Telegraph on Sunday* magazine, I knew two factors would probably become flies in my ointment of excitement and happiness. John assumed I was a member of the National Union of Journalists. I was not. He also thought my politics leaned more to the right than they did. My father had been a staunch, unrepentant Communist and I'd read left-wing newspapers at home until I left for university. Then my political views became more complicated. I was not passionately left wing but more middle of the road.

John Anstey ruled his kingdom with a rod of iron. He rarely emerged from his office; all our meetings took place within it as we clustered around his desk. I hoped the job would last, and swiftly found a two-bedroomed flat in West Hampstead opposite Westfield College, continuing to work as well as move house. It was exhausting and the flat became an unmitigated disaster zone.

Situated on the ground floor, it had previously been occupied by a man who'd never paid his bills. He'd been

blacklisted, so I could never get a plumber, a decorator or an electrician to come anywhere near it. I shared the cramped back garden with the first-floor occupant. My initial foray into it revealed the detritus of an all-night party which took me several weekends to clear.

Then a new girl moved in and life became hell. She was a gambler, playing poker in her half of the garden all night if the weather was fine, and above my bedroom if it rained. She'd dispose of her rubbish by throwing overflowing bin-bags out of her first-floor window on to my front garden, leaving me to dispose of the mess. I was grateful to have a job that took me out of my flat for great swathes of the day, but I knew I'd bought in a hurry and had nobody but myself to blame.

When the *Telegraph* post came to an abrupt end – Anstey never accepted any of my ideas for features and it seemed to me that the job's title entirely belied its real function by merely being his mouthpiece – I decided to sample something completely different. A job with the style department at Debenhams in Oxford Street was fun for about three days but quickly descended into farce. Nobody seemed to know exactly why I was there, although I eventually discovered I was meant to replace an elderly member of staff who'd not yet been sacked and who spent his entire days doing nothing but spreading malicious gossip.

Working for the underbelly of a large chain of department stores can be a revealing experience, rather like being in the back corridors of a busy hotel or ocean liner. It's rich fodder for the novelist, which was why I stuck it out for six months. Before I was appointed, I was asked to write a report on the Oxford Street store. I had nothing to lose and knew nobody who worked there, so I slammed into action and shot from the hip. I told the directors the place was a dump with inadequate store directions, bored,

unhelpful staff and sales notices that hung like lines of wet washing over every floor. Later, the store was totally revamped, although many other Debenhams, including the one in Oxford, remain in the doldrums, and have now permanently closed.

I left the unhappy Oxford Street store and returned to one of my early and continuing passions, children's publishing, to look after the marketing requirements of three different imprints that flourished under a single umbrella: Franklin Watts, Julia MacRae and Orchard Books.

The first two imprints were already well-established. I ploughed my way through their enormous backlists, reading at home all evening, on the bus from Hampstead to Golden Square in the centre of London, and all weekend. Orchard Books, a new imprint, needed a lot of attention, but I always had three bosses who all claimed me full-time. However hard and efficiently I worked, trying to serve them equally was an impossible task.

But I learned a great deal during my time there: how to write a great-selling blurb, how to give a launch party and keep track of every penny, what the children's book world were then reading – and how to make good use of every minute of the day.

The next morning – and as an unusually free agent – as I lay in my bath, an overflow from the upstairs flat started to leak through my ceiling. Water dripped down on me. Several large cracks in the ceiling warned me to leave not only my bath but, I suddenly decided, London itself.

I caught a fast train to Oxford and shot into an estate agent's office in an alleyway off Gloucester Green. I'd once known them extremely well.

One of the agents looked up from his desk. He grinned and waved a front-door key at me.

"We thought you'd be back," he said. "Go and have a look at this. It's in Wolvercote again, a lovely little cottage. It's just been renovated. It'll suit you down to the ground."

I sat on the bus clasping my hands together and praying.

"Please let it be wonderful. Clean and small, with nobody jumping on my head all day and all night, and my own back garden. I'll never ask for anything again – and I'll never go back to live in London. Not now, not ever."

That little cottage in Wolvercote became my beloved home for almost twenty years.

Digging for Victory

Ahead of me stretched an enormous green lawn, filled with funny brown lumps. A giant stood looking down on me. He had smiley blue eyes that glittered like sapphires and a gentle voice.

"What are those?" I asked, pointing.

"Those are made by moles," the giant explained. "They dig their way up from underneath us to see the sky above."

I was three years old. It was 1942. I was living as an evacuee in Leighton Buzzard, waiting for the Second World War to stutter to its perilous end.

I turned away, content with my gardener's answer. I'd been worried he'd tell me the lawn had been peppered with bombs in the night. I preferred the diggers to the sprayers. I looked up at the Leighton Buzzard sky, grateful for the quiet white clouds floating in their blueness, glad that I would have time to open a book or two. Only that morning I'd learned to read. The teacher at my nursery school had written HEN on the board and drawn a picture of the bird. I put two and two together and made four.

A passionate interest in gardens and garden design is one of the threads that has held my life together over the past eighty years. As a child in Edgware I remember throwing

my arms around the small silver birch in our back garden, only to hear the disdainful chuckle of the boy next door.

"She's off her rocker," I heard him muttering.

I continued to hug my tree.

After owning a series of backyard spaces only large enough for a sandpit, a bucket and spade, a washing line and a dustbin – although one memorable afternoon a swarm of bees hung on to my garden wall for several hours before deciding to move on – in 1987 I bought that cottage in Wolvercote, north Oxford, close to the borders of Port Meadow.

The builders had spent two noisy years renovating its interior, much to the dismay of the people living in the street. Its back garden stretched into the distance, completely neglected for more than forty years. At its end crouched an enormous ancient shed, stacked with crumbling wooden boxes, creaking shelves, lumps of ancient discarded domesticity and riddled with asbestos.

The day I moved in, I struggled to unpack a pile of boxes. Hot and tired, I decided to take a break. I opened the kitchen door and fought my way through the brambles and long grass to what I calculated might be the centre of my overgrown inheritance.

"Afternoon, young missus," said a voice from two gardens away.

I jumped several feet into the air. I was forty-eight years old and had assumed nobody could see me for love or money.

"This here veg has been specially grown for you." An object zoomed into the sky, spun around several times and landed on a clump of wild grass near my elbow. It was a perfect cream and green cauliflower. "Name's George. Howdee doo. Hope you'll be happy as a sandboy."

I was more than happy. I was ecstatic. I'd been welcomed to Wolvercote. Nobody in my street in West Hampstead had ever spoken to me. Here I hoped for civilised neighbours and a friendly "Good morning" from passing strangers. I ate the cauliflower raw, crunching my way through the heavenly fresh stem and flower. Then, miraculously, I found the kettle and teabags. Stronger and braver, I began to conquer the tidal wave of unforgiving cardboard.

A demanding teaching post at Oxford Polytechnic – now Oxford Brookes University – took me out of the cottage from Monday to Friday. But my weekends became totally dedicated to gardening, with a wonderful gardener and his equally wonderful teenage son.

Like all good stories, we began at the beginning and went on until we reached the end. We uncovered an air-raid shelter and demolished it, brick by brick. We dug up one bone, then two, then the entire skeleton of a dog. My gardeners were convinced it had once been a spaniel. I dissolved into tears. I sat forlornly in the kitchen all afternoon wondering what its name had been and how it had died.

We cut, trimmed, pruned and raked. We baked beneath the sun and soaked in the rain. We hired a massive rotator from Wytham, rolling it over the newly breathing, gloriously red-brown clumps of earth. We bought fresh turf and laid it piece by snugly-fitting piece, like a massive jigsaw puzzle. When we reached the bottom of the garden we discovered a cache of several hundred bottles, deep green and clove red, carelessly discarded during the Second World War. They lay covered in mud like soldiers in the trenches, dead and long-forgotten. We clanked all weekend. My neighbours complained bitterly about the noise but we continued to clank, clink and stink. The mud smelled of stale alcohol and urine.

Then we demolished the ancient shed, holding our noses and shielding our eyes against the ton of asbestos sheeting. In its place we erected a pine gazebo with windows and shelves. I sat on its polished wooden floor. I looked back on the entire length of garden from a new perspective. Project completed. Backbreaking but so worthwhile. A modern garden for Wolvercote.

I spent the following weekend alone for the first time in many months. I took a cranky deckchair out of the cupboard under the cottage stairs, into the middle of the newly laid lawn. Nothing had yet been planted, although a few desolate elderly trees sprang from the flat green turf.

And then suddenly I saw him: a fox standing outside my gazebo. He stared at me for several minutes, sizing me up. He looked confident and brazen, as if he were daring me to shriek or run, or to stand clutching my skirts on top of a stool as if he were a terrifying mouse. He was probably wondering what I'd taste like when eaten sliced with tomato ketchup on granary toast. Then he swished his tail to and fro, to and fro. Swiftly, snake-like and handsome, he turned away. In a flash he slid through the six-inch gap beneath the gazebo as if he were flat as a shadow.

I never saw him again, although I'm sure he and his family waltzed around my newly created paradise when I was safely away teaching, or asleep in my bedroom that overlooked the road.

Two weeks later I gave a supper party to celebrate the fact that I was now able to stay awake on a Saturday night after 8.00 p.m. Sir David Piper was among my guests. He and his wife, Anne, lived in the nearby village of Wytham. David told me he'd recently counted how many people he still had to support.

169

"I have twenty-eight mouths to feed," he told me sadly. "That includes the goldfish." He put down his glass. "By the way, I've been meaning to ask … Do you know of any good local gardeners? Overford Farm is getting far too much for us to manage on our own and there's always such a lot to do …"

I recommended mine – and, like the fox, I never saw my gardeners again either. They took over not only Overford but the whole of Wytham and were much too busy to look back, forward or anywhere but down.

In May 2016 I moved joyfully into an eighteenth-century cottage in Woodstock, close to Blenheim Palace. Once again, its interior had been carefully renovated but the small courtyard at the back had not, although second-hand Yorkshire stone now handsomely replaced old crumbling slabs. In front of the cottage lay some neglected cobblestones, a broken path, and a hideous grey plastic window box full of straggling plants.

I'd hoped for a glorious spring and summer. Instead, it rained every day from early May to the middle of July. The bay trees and interesting pots with shrubs from my previous garden mouldered and dripped. My new garden furniture – a sturdy round oak table with four matching chairs – threatened to turn green in sympathy. Every morning I slithered out, muffled in a damp raincoat, and immediately waded back indoors. I continued to wear thermal vests and leggings. My few hopeful summer frocks hung sulking in the cellar.

The day of Blenheim's Battle Proms concert arrived. I prayed hopefully all morning for sunshine. It finally struggled through the gloom at 4.00 p.m. Everybody gasped, smiled and cheered. Tourists walking despairingly

through Woodstock in their dripping macs threw them off and sat down on the nearest damp bench to eat their soggy sandwiches. One solitary voice from the churchyard began to sing *Jerusalem* in keen anticipation.

The following week I started work. With the help of a new gardener and his friend – and ironically caught in the middle of another lengthy and thunderous downpour – we cleared the courtyard of everything but its earthy beds. Five hours later, my companions lurched away in a van that almost sank beneath its weight. Our clearance revealed the fascinating brickwork of a bread oven, curved doors and sealed windows in the two stone walls. With its original shape now firmly re-established, my courtyard became an elegant retreat.

The front garden, however, proved to be a major problem. Trees and plants that I carefully arranged there in 2017 wilted and died in the often punishing heatwave of 2018. Thieves stole some of the shrubs in broad daylight. I made the mistake of planting baby rose trees among the cobbles. They looked delicately pretty – but trying to balance on cobblestones to tend roses is a hazardous occupation, particularly if you are almost eighty years old and your right hip is made of titanium.

Tourists who admired the roses began to sit on my windowsill in their onesies to take selfies. A child riding his bike on the pavement crashed into the rose bushes and screamed his head off. His mother banged her protestations on my window, almost breaking the glass. Autumn leaves got trapped in their thousands among the roots. When I watered the roses, powerful weeds started to grow among the cobblestones, laughing loudly as I pleaded with them to go sprout somewhere else.

∞

In March 2021, after spending six winter months glued to my desk, I launched myself at my neglected front and back gardens with the magnificent help of the Landscape Gardener, Simon Griffiths. The flower bed in the walled patio now has the wild abandon of a proper cottage garden: a haven for butterflies and bees who are so relaxing to see and hear over a refreshing cup of afternoon tea.

The front garden includes terracotta planters holding a marvellous yew hedge, healthy bay trees fed with compost and protected by small white stones, and a base of Flamingo chippings. These give an extraordinary Mediterranean feel to the entire effort.

It has been back-breaking but worth it: the real definition of good gardening.

For Sir David Piper

in loving memory

It was cool in the wild garden
Your rug lay on your knees
Your voice was soft, mellifluous
A murmuring of bees

You spoke with gentle wistfulness
In gratitude for spring,
The softening of the hoar frost's
Pale butterfly wing

You fought but never spoke of it –
Those years of filth and pain
That wrecked your body. Not a word
Escaped to lay the blame.

You bent to stroke a celandine
Whose egg-yolk-yellow hue
Shone from the mossy undergrowth
On cue

You were an inspiration
A flame, a light, a fire –
So with this tiny poem
We admire.

Wordwise: *Seriously Freelance*

In the early summer of 1990 I set off from Oxford to see my bank manager in his St John's Wood, London, office. He was a kind man with a lot of experience and he recognised a serious client when he saw one.

"I've spent the past couple of years trying to get away from actually publishing or writing anything," I told him. "I needed a break, to look at the world from different standpoints. Being Publications Manager for BUPA was physically and financially exhausting. I spent all my spare time sitting in taxis or trains, spending huge sums of money on fares. And it was intellectually stifling. They saw I was bored to tears, so they invented a health magazine I could edit, but it wasn't a comfortable fit with their other health insurance documents. Many people thought it was a waste of money. I'm sure it will never survive without me.

"Teaching at Oxford Poly was interesting until they asked me to do the job of two members of staff because one of my colleagues had a nervous breakdown. I couldn't do both jobs on a single salary with only seven days in the week. If they'd given me an assistant I would have soldiered on. I

wrote to the director and told him so, but I never got an answer. He just wanted to see how far I could be pushed.

"I got sick and tired of being bullied by students. They did nothing but complain about how the publishing department wasn't earning its keep. I was Publishing Field Chair, so the responsibility for the shambles fell on my shoulders. One afternoon a student cornered me in my room. He got so nasty I was afraid he'd pull out a knife.

"The following Saturday morning, while everyone else was out of the building, I piled all my books and files into bags and boxes, staggered out to the street, hailed a taxi and went home. I wrote to the director again telling him I'd resigned with immediate effect … Looking back, it was very sad. If I'd been a man, they'd never have dared to treat me like that."

I remembered how desperate I'd felt the day I left. I looked round my cottage and sold the only piece of furniture I could manage without and that was worth anything: my beloved upright piano. It had been a birthday gift many years before from Charles Rycroft. I watched it being carried away, £300 in my hand but my heart breaking.

"So now what?" my bank manager asked. "And how can I help?"

I pulled out of my briefcase a formal business plan.

"I want to set up my own editorial consultancy from home. It'll be called *Wordwise*. I know exactly what I'll be letting myself in for. When Sam was doing his 'A' levels at Magdalen College School, I went freelance in order to give him the support he needed. I still have contacts in the publishing world, I could still commute to London – but not five days a week – and there are several publishing companies in Oxford I'd like to work for. If the worst comes

to the worst, I'll sell the house and move south to the coast and somewhere cheaper."

"So you'd like a loan to get you off the mark?"

"Yes, please." I waved a set of figures at him. "I'm still paying off a mortgage but I don't have any other debts. My plan is to work for publishing clients four days a week, and write my own stuff for the remaining three. I'm longing to write for children. I have tons of ideas and they're beating at my mind, trying to get out!"

"I can lend you £5,000." My bank manager sifted through my documents. "On three conditions."

"Which are?"

"First that you stay with BUPA. If you fall ill and you're self-employed, nobody will pay you if you need time off. You must have health insurance to protect you." He smiled at me. "Second: get yourself a really good accountant and register to pay voluntary VAT. You can't be too professional. And third: don't work too hard. Don't accept too many commissions at one and the same time."

I managed to smile back. "I should be so lucky," I said.

I went home to find an accountant, to buy my first computer and laser printer, and to organise headed notepaper and a business card. I answered a couple of advertisements in *The Bookseller*. And I learned my first freelance lesson. Never work for anybody without a contract.

A company in Ireland sent me an enormous project that needed three weeks of solid work. They told me a contract was being finalised, then that it was being signed, then that it was in the post. It never arrived. I sent back their project, immaculately edited, together with a detailed invoice. A deafening silence told me I'd fallen foul of professional con-men. A month later, and they'd vanished from the face of

the Irish earth. I'd lost a month's worth of time and money – and learned a bitter lesson I never forgot.

From then on, I chose my clients carefully, mostly from London-based companies who weren't about to disappear when the sun went down. Although they were often slow to pay, the money did eventually come through.

There are several important basic rules I quickly learned as a professional freelancer in the publishing industry. The first is that entire offices can shut down for most of August and for more than two weeks over the Christmas recess. If I tried to contact people before and after the London Book Fair, the Bologna Book Fair and the Frankfurt Book Fair, I'd be wasting my time.

The ebbs and flows of the publishing year are predictable but frustrating nevertheless. I wasn't allowed to keep anyone waiting, nor miss a deadline by a single day, but those employed in large companies are never available on the phone, rarely answer emails and spend a great deal of time in endless meetings. The editor in one very large company who published my work only spoke to me twice on the phone in two years. Each time it was to tell me she was on the train and having coffee: she was travelling to Oxford to have lunch with me. My rare calls to her over those two years were never answered.

Of course, by that time the wonderful – and potentially dangerous – world of emails had arrived. They changed absolutely everything. People who sat next to each other in the same office no longer needed to talk. They twanged messages down the line instead. Formal letters, memorable handwritten notes, illustrated cards: an entire world of paper documents vanished overnight.

Silence became the deadliest weapon on offer. Walls of

it. Weeks of it. But if you can't stand the heat, as the saying goes, get out of the kitchen. Substitute the word "frost" for "heat" and you have exactly the same message.

I also immediately knew that I couldn't go it alone. The freelancer's home network is crucially important. An electrician when the lights go out; a plumber when the lavatory leaks; a heating engineer when the boiler dies; a designer for notepaper and website; a printer for launch invitations; a bookshop for ordering vital titles that only exist overseas; a cleaner for the heavy work; and a gardener when you can't see the wood for the trees, or next door's fence in last night's storm crashes on your newly planted herbaceous border. It's all too easy for a seven-day schedule to disintegrate into four when the domestic gumtree becomes a real intrusion and you're the only person to deal with it.

The single woman who works from home has no status and very little dignity. People assume I'm always available to chat in my front garden, take in other people's parcels, stand outside their doors trying to deliver them, help organise jumble sales, sit on local committees, become a church warden, sell poppies on street corners in November, and run the museum, the charity shop and the local library on a voluntary basis for at least two days a week.

If I say I'm too busy with my publishing schedules, I'm considered to be a selfish, self-absorbed loner who won't join the life of the community. I don't drink and I never go to pubs. So I'm labelled as snooty, mean and friendless. Once again, the flames, or the ice, in that kitchen can become very uncomfortable.

The most important link in the network chain is a computer technician who's reliable, trustworthy, discreet and affordable. Chief among them in my early days was my

great friend Anne Becker, who taught computer studies at Oxford Brookes University and would come to my aid in her precious spare time whenever I needed her. Some of my freelance commissions were formidably complicated: an analysis of a reading scheme was only one example. Anne knew a great deal about the latest technology, but she was not a nerd, she never patronised me, she was used to teaching people at all levels and I was always glad to see her.

When the recession hit the UK late in 1990 and early in 1991, nobody had seen it coming. My bank manager, however sympathetic, would not have been able to lend me £500, let alone £5,000. The sudden economic downturn hit us like a tornado. Editors who had been managing perfectly acceptable small lists were thrown out on their ears – and often took their lists with them to work on from home. Editorial rates for freelancers plummeted because there were so many more of us, all competing for the same jobs.

Instead of being able to work for half the week with outside clients, I needed to fill my time on a seven-day-a-week basis with commissioned work, in order to survive. My own projects sat on a distant shelf, gathering disappointed, time-consuming dust. But I'd taken a risk. I had no choice but to face the consequences, no matter what happened in the wider economic world. Lo and behold! ... There's that kitchen again.

Over the following eight years I built up a list of clients whose projects were interesting and varied. I deliberately chose *not* to edit fiction, either for children or adults, because doing so would have encroached too closely on what I was planning to do myself as a creative writer. So my day job focused on editing books on the humanities, psychology,

179

sociology, art history, business studies, politics, childcare and English Language Teaching.

I learned a great deal as I worked – but I also became a stickler for accuracy, correct spelling and consistency. The lists of queries I'd send back to authors were often dauntingly specific but I always knew I'd done an immaculate job. The devil is indeed in the detail.

In 1991, I managed to get my first picture book accepted by Little, Brown: *Tomasina's First Dance* was published in 1992. That same year I wrote a report for Nelson's English Language Teaching list on their readers, and one for Lloyds Bank Distance Learning Centre on their training materials. A wide variety of projects indeed ...

In 1993, Ladybird asked me to write and project manage a new English Language Teaching series for them called *English for Beginners* which I worked on with the marvellous illustrator John Lobban. I invested in my first printed brochure, outlining my services and listing those projects I had edited and the reports and books I'd written. I mailed the brochure to every contact I had. Marketing other people's achievements was a great deal easier than trying to promote myself.

Every now and then a publishing company would ask me to join them on a full-time basis. I was often tempted – but I always refused, fighting to retain my independence and control of my working life. And behind the scenes I was making a massive contribution to some lists.

During one particular year, a publisher of books on politics published twenty-two books. I'd edited eighteen of them. The fact that none of their staff ever asked to meet me, and I was never allowed to write to any of the authors directly, turned me into an out-of-house machine with no individual voice, no face and thus no identity. After a request to send their managing director my opinions on a project

she didn't have time to read herself – for which personal favour I wouldn't be paid at all – I decided they didn't deserve to have me. I never worked for them again.

In April 1998 I trundled off to see my accountant in north Oxford. In my briefcase were my files and end-of-year accounts. He flicked over the pages to the bottom line. I'd earned in excess of £40,000. In today's equivalent of roughly double that amount, it was a remarkable achievement for a freelancer.

"Well!" He sat back in his comfortably upholstered leather chair. "You *have* had a good year!"

Something in me snapped.

"As a matter of fact," I found myself saying, "I've had a *ghastly* year. I worked straight through Christmas and Easter without a break. I've worked seven days a week. I've just finished editing the most ridiculous book on the history of art I've ever had to read. It was originally written in French, then badly translated into Italian. I was asked to rewrite it in English. Halfway through I had to tell the publisher it was complete rubbish and it couldn't be done."

"But your other commissions ... They can't all have been so impossible."

"No, but that's not the point." I stared out of the window into the busy Summertown street. "I set up *Wordwise* because I wanted to write my own books. Instead, other people's lists have taken over my life. In the past year, I haven't written a single word of my own. I may have earned enough to live on, but I'll be fifty-nine in October. I want to write for children. The older I get, the further away I feel from their lives, their language, their problems, their achievements."

"So, Valerie." My accountant closed my files. "What are you going to *do* about it?"

I stood up, feeling rather faint. The small, bleak room swayed around me.

"I've no idea, but I can't go on like this." I managed to reach the door. "I'll keep you posted."

I walked slowly home. It took me half an hour and in that time I made some decisions.

My study was piled with seven books written by other people. I was already working on two of them. I returned the other five to their publishers with a note of apology. I finished editing the two remaining titles. I hired a decorator. Together we painted the cottage from top to toe. I put it on the market and travelled to St Ives in Cornwall, where I found a house on the top of a hill. It had a sensational attic with windows looking on to two different beaches and great washes of sky. It would make the most wonderful space in which to write.

By the time I got home, I'd received an offer on my Wolvercote cottage. The difference in price meant I'd have two years in Cornwall during which I could spend my entire time writing my own projects. I telephoned my accountant and told him of my plans. He wished me luck.

I asked Sam if he could spare the time to meet me in London. I told him I was packing up my cottage. He said, hold your horses. He offered to pay my bills if I'd stay in Oxford. The offer would let me devote my entire time to my own writing.

For a week I worried, walked on Port Meadow and worried some more. The girl who wanted to buy my cottage arrived with her father. I was obviously dithering and they needed an answer. Was I selling or not?

I was loath to lose my independence. But staying put was a much more practical plan. I agreed to Sam's offer on one

condition. If I hadn't sold a project to a publisher within two years, I would indeed disappear to Cornwall.

We shook hands on the deal. I unpacked the few boxes I'd started to fill, and took the cottage off the market. I turned on my computer and began at the beginning all over again.

I knew that time was running out. And I didn't have a moment to lose.

A Marriage Made in Heaven

I've been obsessed with writing picture book texts for sixty years. My passion for them began when I started reading them to Sam, and teaching him to read. As a child I learned the poems in Robert Louis Stevenson's *A Child's Garden of Verses*, first published in 1885, with its exquisite Victorian illustrations by Charles Robinson of privileged children wearing voluminous nightdresses and sleeping in feather-pillowed beds. Drawn in pen and ink, I duly coloured them in with thick oily crayons, and a great deal of love. On one of the end pages I also wrote a letter to my parents, asking them whether they loved me. I must have had many doubts.

But the market eighty years ago – and certainly during and after the Second World War – sold almost no picture books for children. The most brilliant, and now classic, picture book of all time, the American Maurice Sendak's *Where the Wild Things Are*, was originally published in 1963, two years before Sam was born. Sendak's great gift was not only to invent a simple but gripping story that every child could readily understand, but that he also drew and painted like a genius.

I can't paint or draw. So if I succeed in telling a good story in only five hundred words, or even less, I'm only one half of the essential picture-book partnership.

When Sam was three years old, I wrote a picture book for him. Here it is:

Simon and Matchlight

Once on a time, in a luxuriant jungle, there lived a remarkable giraffe whose name was Matchlight. All giraffes are tall and slim, but Matchlight had a neck so long it stretched way above her family and friends.

Matchlight could reach the highest and sweetest bananas in the trees. She could see fantastic views of winding rivers, market places, purple hills and darkening horizons.

Sometimes she complained that her neck was cold. So her mother knitted her a woollen coat. It had seven emerald buttons sewn with scarlet thread.

One evening, a famous explorer and his son, Simon, drove into the jungle in their enormous jeep.

The next day, Simon left their tent to pick some berries. And there was Matchlight with her long neck and beautiful woollen coat.

Matchlight told Simon how she could see the wonders of the world above the trees, talk to the birds as they flew and eat the ripest fruit. Simon walked back to his tent. He was tired of being only a small boy.

That afternoon, while his father was mending the jeep, Simon set out to find the tallest tree …

Yes! There it stood! Up and up – it was very hard work – up and up he climbed and he climbed.

At last he reached the top. But a mist hid the view, no birds sang, and all the bananas had gone. When Simon looked down through the leaves, he felt sick and dizzy. He clung to

185

the branches, too afraid to move. He began to shout for help.

When his father got back to the tent, he couldn't find Simon anywhere. The afternoon became twilight and darkened into night. Many hours later, under twinkling stars, the explorer stumbled on Matchlight with her family. He told them Simon was missing and burst into tears.

"I'm a famous explorer," he said. "But I cannot even find my own child."

Matchlight lifted her head into the sky. She listened, and listened again. Then, above the midnight trees, she heard the cry for help.

In minutes, Matchlight had bounded through the jungle. The sound came from her favourite tree, the tallest and the best.

Simon was overjoyed to see her.

"Climb on to my neck and sit on my coat," Matchlight said. "Now, hold on for the ride."

Matchlight raced back through the jungle to find Simon's tent, Simon's grateful father – and a hundred hugs and kisses in the early morning light.

This story haunted me for years. Every now and then I'd dig it out, read it aloud, fall in love with it again and plan its illustrations. Off it went to the best children's book publisher in town … And back it came. The publishers' objections were always the same. I stood accused of encouraging children to eat wild berries which might be poisonous, climb trees to dizzy heights which could be dangerous, and run away from their parents which could be positively fatal.

Only one day, all that changed. A publisher said yes, she liked it. She couldn't pay me anything for it, so there was no formal contract. But she had the text set in page proofs and found an artist. She was sure that at the next Bologna Book Fair the market would be interested in the story,

together with its set of rough sketches. If she managed to sell it, I might receive a contract. I might also be paid.

I waited for eighteen months, asking for news, for rough sketches, for updates on progress, chewing my nails and pulling out my hair.

Nothing, but absolutely nothing, happened.

Eventually I managed to convene a meeting with the publisher in her London office, the artist and her agent. The artist, who claimed to have been indisposed for the past year, arrived with two pencil sketches. One was supposed to be the inside of the tent. It looked like an enormous farmhouse kitchen, with a table, chairs, pots and pans and a full-size cooker. It had obviously been drawn for somebody else's book. The second was of Simon, up the tree, sitting with his back to the reader so that nobody could see the delight and surprise on his face at having reached the top. The publisher thought both sketches were wonderful. The artist swore blind she felt much better and would press on with the commission.

I went home and cried myself to sleep. The next morning, I consulted the Society of Authors and, following their good advice, I pulled out of the project.

But I went on writing picture books. I read hundreds of them. I sat in the children's section of the local library, looking at everything I could lay my hands on, reading the stories, examining the illustrations, having my own ideas – and quite often thinking I could do a lot better than *that*.

One afternoon I drove through Wytham, having turned off from the motorway to get to Wolvercote. I crossed the narrow bridge and followed the road past a wide flat field. On it stood a large scarecrow I'd never noticed before. His head dangled in the breeze, his trousers flapped

around his legs, wisps of straw stuck out all over him.

And my first published picture book, *Tomasina's First Dance*, was born. It's about a scarecrow called Tomasina who doesn't have enough straw in her body until she's rescued by another scarecrow in an adjoining field. That sounds banal, but it isn't. It's magical and it really works.

I sent the story to the editor of the children's books division of Little, Brown in London. She telephoned to say she liked it and had a young illustrator in mind. We all met in their London office. The illustrator was Heather Calder, a beautiful young art-school graduate with flawless skin and a mass of coppery curls. She'd never illustrated a children's book before. For the first time ever I had a partner who could draw the pictures that were locked inside my head, and interpret them in even more imaginative ways.

Heather sent me her painting for the front cover, which I still have framed in my study. I invited her to Wytham. We walked together in the woods and fields. She took hundreds of photographs. We ate lunch in The White Hart. Every single illustration Heather produced was exquisite … until it came to the front cover. It was nothing like her other illustrations and a hundred miles from the original painting she'd sent me.

Something terrible had happened to her and I tried desperately to uncover the truth. But Heather, literally, disappeared. Her agent had no idea where she'd gone. Nobody knew. In the end, I gave up searching for her, although every so often I have a dream that she's turned up at my door, looking exactly as she did the day we met. And I give her a new story to illustrate.

I dedicated the book to Sam. Heather dedicated it to her father. I knew that both people were the loves of our lives.

∞

The next picture book I had published was called *Look at Me, Grandma!*

I first sent it to the talented editor, Janice Thomson, who was then working for Klaus Flugge's renowned Andersen Press, founded in 1976. It's the story of how a young boy's life is suddenly changed with the birth of his sister. Janice loved it, and brilliantly suggested a last line which I immediately adopted. After months of trying to persuade Klaus to accept it, Janice admitted defeat.

The story was quickly taken up by The Chicken House in its very early days. I was never allowed to meet my illustrator, Claire Fletcher, and I found working very fast on set after set of pencil roughs which needed to be checked and returned the same day a poor substitute for my extraordinary relationship with Heather. But I loved the front cover and dedicated the book to its editor, Elinor Bagenal, and its publisher, Barry Cunningham, to both of whom I was enormously grateful. They accepted a second title, *The Creepy Crawly Thing*, but again I was told I wouldn't be allowed to meet the artist. I couldn't face another paper-only relationship, so the deal never got off the ground.

Over the years I have spent huge amounts of time and energy writing picture books. As I wrote on the flap of the hardback edition of *Tomasina*: I spent my childhood writing to please adults. Once grown up myself, I began to write for children.

"It's much more difficult. The child demands absolute honesty of voice and clarity of vision. You know immediately when you've got it right."

Looking back on those words, I think they apply to readers of all ages. Honesty of voice and clarity of vision are essential, whatever you are writing – and whoever you are writing for.

Not Only But Also

∾

I've already introduced the heroine and role model of my childhood and teenage years: my Headmistress at North London Collegiate School, Dame Katherine Anderson. Every morning she'd swoop into assembly in her beautiful rose-pink gown, her hair parted in the middle like the Victorians, but softer, and then rolled into a hand-made bun; her smile toothy but always genuine; her back straight and her eyes bright.

Dame Katherine had a natural elegance and warmth – but she also had dignity. She'd earned it and we respected and admired her for it. She was never bossy or patronising. I never ever remember her being ill or absent without leave. She'd stand by the window in the corridor outside her room, watching us girls at play.

Like all brilliant leaders, she was ever watchful. I suspect she was a virgin. I once saw her open a newspaper to see a huge photo of Elvis Presley planting an enormous kiss on the lips of his new bride. Dame Katherine looked deeply shocked, recoiling in horror and disgust that such gestures could even be possible. Holding the bare, trusting hands of

her small girls was more her style. That was her zone. That was where she blossomed and thrived, as indeed did they.

As did I. In fact, I spent the thirteen years at NLCS dancing, acting, moulding lumps of clay, agonising over Latin verbs, playing the piano, swinging my tennis racquet, singing hymns, reading everything the library could lend me, walking in the gardens, eating lunch in the dining hall, grumbling about the smell in the chemistry lab, not understanding the facts of life, wearing my daffodil with pride on Founders' Day, and writing essays on everything that blossomed in my tiny world.

The school in 1946 was still recovering from the effects of the Second World War. The cloakrooms on the ground floor were dark, a bit smelly, and still felt like air-raid shelters. Our elevenses milk ration, with its straw, arrived in small glass bottles. I hate milk, because Daddy's wife detested giving me anything that might prolong my life. She locked me in my ice-cold room in Maida Vale, perhaps hoping to find me dead as a doornail in the morning. I was frozen solid and developed asthma, but I went on breathing. And I always drank my school's milky offerings because by then I was starving more than thirsty. Nobody was ever around to make me breakfast, although a piece of toast, thick with chunky marmalade, which I always made myself, saved my day if not my bacon.

The school breathed vast sighs of relief and joy every morning at assembly. The bombs had stopped dropping, those midnight sirens had ceased wailing – and we were alive to prove we British could go on being exactly that.

Except that something had happened to the men.

We were a girls' school, dominated by women who'd grown to be as much like men as they possibly could to fight

191

the good fight through long working days and all too often sleepless nights. All my teachers were single. We called them Miss This and Miss That. When the first married teacher arrived in 1957 there was avid gossip among us Sixth Formers for weeks. Had she actually been to bed with her husband the night before, we debated. And if so, then what, oh what, was it really really like?

Some of us, including me, were innocent as daisies. Others were not. One girl, whose mother worked as a prostitute in Soho to keep food on the table, boasted of her own sensuous nights in Hampstead with an ex-marine her mother knew nothing about. At Reading University, one of the girls who arrived from Brighton was already heavily pregnant. We never talked about it. She gave the baby away the moment it was born and continued her studies as if nothing unusual had happened.

I only discovered the facts of life by reading *Lady Chatterley's Lover* in a public toilet when I was twenty-one. Although I'd read the whole of *The Kinsey Report* in our Edgware lounge, enjoying every moment – I assume my father bought it, although I never saw him read a single word of either that or indeed anything else – I hadn't actually understood what the process of love-making was all about. Nobody thought to tell me. North London Collegiate School teachers rambled on about dandelions and walking sticks, their faces scarlet with embarrassment. I was none the wiser, although some of my poems may have guessed at the essence of the sexual act.

At the University of Perugia I almost went to bed with an Italian boy, but at the critical moment his mother was rushed to hospital and he followed in his car. I never saw him again … Rescued by the bell? I'd probably have fallen

pregnant. Daddy's wife would have thrown me out of the Edgware house with indignant relish.

But the point of my having Dame Katherine Anderson as a headmistress during my formative years was that I had a role model who preached the value and importance of working outside the home. Not only were we expected to marry and have children. We also had a sacred obligation to become doctors and dentists, lawyers and nurses, journalists and photographers, painters, poets and musicians. We had to go on giving of ourselves until we dropped.

What Dame Katherine did *not* tell us was how on earth women could be expected to do it all. She remained single and had no children. She employed a full-time, live-in housekeeper for all her domestic needs and problems at home. She had a deputy head at school, a full-time secretary, several qualified chefs in the school kitchens, a dedicated driver with his car, and rooms full of other staff to call on if she needed them.

On one occasion I was told her housekeeper had gone on holiday, leaving her in the lurch. My mother gave me instructions to arrive at her door with a huge basket of everyday provisions. Dame Kitty accepted it gratefully, telling me she had no idea where the shops were in Edgware, she never had time to use them.

As I grew older I became more critical of her message. Of course I recognised she was brilliant at her job: a woman who, in the great tradition of Frances Mary Buss, had fought her way to the top of her particular tree and stayed there because she deserved to. Education, education, education, just like Prime Minister Tony Blair went on repeating throughout his premiership.

But her limitations, that nobody ever had the courage to mention – it would have been entirely disrespectful to do so,

who were we lesser mortals to criticise, could we do her job any better? – were pretty striking. She'd found her zone and never left it for a moment. She lived in a secure, comfortable, predictable world. Her schoolgirls were her family and she loved them wholeheartedly. They were all she needed to survive.

When I was older, a single mother with a growing son, I became one of the first women in the UK to buy a house on her own salary. It's not a situation I'd recommend choosing, unless you're completely dedicated to work, in all its shapes and forms, and unless you have the strength to fight your own battles without the help and support of a partner. The social stigma against women who live on their own with a child is less than it used to be, but it remains monumental.

When I first moved to Woodstock with Sam, other mothers with sons at Magdalen College School asked me to drive their children to Oxford every morning because they couldn't be bothered to get out of bed. I gladly agreed, hoping Sam would make friends with other local boys.

During the first term, I honoured my commitment – until I got 'flu and was trapped at home. The other mothers were furious. Nobody asked me how I was, or offered to help, and Sam travelled to Oxford on the bus.

I stopped my communal driving immediately. Several weeks later, one of the mothers asked me to a supper party, where she introduced me as "our chauffeur". I never spoke to her again. Well-intentioned neighbourliness can go seriously wrong with people who take the goodwill of others for granted.

After I'd left North London Collegiate School I chose not to go back, unless I was invited. The story I now tell about

the role of women in the modern world is infinitely more complicated than Dame Kitty's – and certainly more dangerous than she could ever have predicted.

Modern technology may have helped women in many ways, but it's also made them more vulnerable. Like the early suffragettes, I dared to step out of my comfort zone over and over again, in order to challenge the status quo, to prove there were new ways of achieving success, to test fresh waters and to sing new songs.

It was infinitely worth the fight. After I'd moved away from Woodstock, and then finally returned, I knew I'd become a stronger person with a hundred different experiences of other ways of living in other cities and in other ways.

The best view comes after the steepest climb.

Starry Night at the Oscars

On a Saturday in early March 2000, Sam arrived at my Wolvercote cottage unexpectedly for lunch. He'd spent 1999 in the USA making his first film: Dreamwork's *American Beauty.* I'd spent the past year close to Port Meadow in north Oxford writing my first novel for teenagers, *Girl in the Attic.* Our worlds had grown thousands of miles apart and yet he was still my beloved *wunderkind* who was magically transforming himself from theatre director to film maker in Hollywood – one of the most competitive arenas in the world.

Winston Churchill said that in battle you could only be killed once; in politics you can be killed several times over. In Hollywood, people are out for your blood in many equally complicated ways. The moment the arena opens to the lions it's Oscars night in Los Angeles.

Sam had arrived with a purpose: to ask me to be his date. I almost fell off my chair with astonishment.

"I'm between girl friends," he told me. "Besides, I'd like you to be there … It'll be a night to remember."

"But I've nothing to wear," I stuttered, imagining myself

tottering along the red carpet waving to the hysterical crowds in jeans and a sweater.

"Got that in hand too," Sam said. "Armani in Bond Street have put something by for you. All you have to do is try it on and sign for it." He waved as he walked down the path. "Your plane tickets are in the post ... See you in Hollywood."

The frocks Armani had on offer for me were made of clingy black silk. They had no backs, almost no fronts and were so long they trailed across the changing-room floor. I beat a hasty retreat when nobody was looking to Harvey Nicholls where the beautifully reliable Jean Muir sold me a plain navy top, a plain navy skirt and a stunning long-sleeved jacket with blue and purple stripes. In the Los Angeles hotel, professional hairdressers and make-up artists scurried from room to room transforming the ordinary into the extraordinary in twenty minutes flat.

Security was tight as a bumble bee's bottom. Every car was a snake-long Cadillac. Every driver could recite the story of a lifetime's film watching, and reveal as top secret who could drink a bottle of scotch in the back seat before you could say Greta Garbo. Every actor was a bundle of watery nerves. Every director hated all the others.

My brother had telephoned the night before I left for my big adventure. "Only crap films get Oscars," he sneered. I'd slammed down the receiver and stomped furiously to bed.

American Beauty won six Baftas for best film and five Oscars for best picture. Sam held up his marvellous trophy, shaking with delight. *The Sun* called it "The best film of the year." Sitting next to Sam in the audience at the enormously lengthy ceremony, I watched the faces of his team as they

hugged him and then accepted their awards: Conrad Hall for cinematography; Kevin Spacey for best actor; best original screenplay: Alan Ball. Best film, best director. The list went on. The entire evening had been a triumph for them all.

In the queue for the much-needed loo after seven hours, I watched the girls of America puking into the wash basins, and smoking something that stank to the heavens. They wore long chiffon frocks with no backs and almost no fronts. They were so thin their shoulder blades sprang from their bodies like the wings of broken birds. They could have come straight from Auschwitz.

Or more probably Armani.

Sitting on the bus to Wolvercote two days later, one of my neighbours climbed aboard.

"Watched your son on telly I did," she told me, hitching her baby on to her knees. "Saw him get his Oscar. First film, too. Good for him. He's got a very glamorous new girl friend. Sitting right next to him she was … Do you know her well?"

"Very well indeed," I told her. "It was me."

Writing for Young Adults

The first thing I did when I made the life-changing decision to survive as a full-time writer was to put my Wolvercote cottage on the market and travel to St Ives in Cornwall. The journey and my search for a new home became the foundation for my first novel for young adults, *Girl in the Attic*.

I wrote up my brief adventure (which I describe in more detail in the talk I gave for the Edinburgh Festival, below) as a short story, but I didn't know what to do with it. So I sent it to Janice Thomson, who'd been so helpful on *Look at Me, Grandma!* I managed to drag Janice away from her London desk and took her to lunch. She waved my short story at me and plonked it on the table.

"This," she told me, "is going to be your first novel."

I almost swallowed my spoon.

"Think about it," Janice said firmly. "You've got a storyline that needs a lot of fleshing out, proper characters that need lots of work, and the time and space for 40,000 words." She grinned. "Don't look so terrified. I'm not saying it's going to be easy, but I know you can do it."

I went home on the train, scribbling, thinking – and feeling absolutely petrified. Everything I'd previously written – stories, features, poems, reports, picture-book texts, an entire series of ELT books for Ladybird – had one common denominator: brevity.

This 40,000 words felt like a mammoth challenge. I'd been given a mountain to climb, on a freezing cold day, with sleet and snow tumbling from the sky and not a pair of walking boots in sight. And no Donald to teach me how to survive and conquer.

The second thing I did, back at my Wolvercote desk – not moving house but getting down to serious work immediately, which was bliss – was to join a professional organisation that accepted would-be writers and taught them the basic skills. Pamela Cleaver was a director of the London School of Journalism; her special field was writing for children. She'd published a seminal book on the subject, *Ideas for Children's Writers*, and was obviously an expert. Although I tried to pretend I'd never written before, within a fortnight Pamela had sussed me out. I confessed that I'd written all my life, but now wanted to make it a full-time commitment and needed someone who could teach, edit, help and guide me through the early months.

Pamela was magnificent. I wrote a first attempt at a novel which was full of badly digested semi-autobiographical lumps. I knew in my heart it was rubbish. Pamela took it seriously. She told me it was very bad indeed, but that I'd probably needed to get it out of my system. She even pointed out the few good bits. I'd described the hideous orange marigolds that sprouted all over Edgware's front garden, for example, as having a sour, evil smell. I got a big tick for that.

200

So then I started all over again – this time, with a first draft of *Girl in the Attic* that took me two years to write and rewrite. When faced with another rejection slip I'd allow myself a suicidal twenty minutes. Then, if I hadn't received any constructive feedback, I sent the same draft out to sea on another hopeful voyage.

I had a constant image in my head of sitting in a wooden coracle, surrounded by waves, desperately trying to find the warmth and reassurance of a sandy cove. The temptation to give it all up and start editing other people's books again grew fiercer as time went by – but I stuck to my guns and with my own work.

Then, finally, a new day dawned. Stephen Cole arrived at Simon & Schuster UK as Editor of their recently formed children's books list. I'd already submitted my novel to his predecessor, Bronagh McVeigh, who'd returned to Ireland and the love of her life. Stephen ploughed through the slush pile of stories he'd inherited and rejected all of them – except mine. He sent me a three-page report, asking me to rewrite the last third of the story. I was grateful, delighted, hard-working and totally committed. Together, we got it right, and the novel was published the following year.

It had been a very steep learning curve and I needed every day of the couple of years it took me. Going to weekly creative writing classes given by the novelist Ann Schlee in Oxford certainly helped. I remember one afternoon reading aloud a scene I'd just written to the group of twenty other would-be novelists.

As I heard the sound of my own voice echoing through the room, I realised just how bad it was. I'd invented a scenario where my heroine, Rosalie, was contemplating suicide on a Cornish beach in the middle of the night. The

six pages of manuscript went into the bin the moment I got home. It was melodramatic, unbelievable, pretentious and downright silly. She was never a girl to take such pointless action. Instead, much more believably, she stays to fight her corner and eventually to forgive her brutal, drunken but apologetic father, with all his faults.

I am my own sternest and most ruthless editor. I thrive on constructive feedback. Ann Schlee was always polite and ladylike, but cosy, reassuring comments often get the author nowhere. My wonderful Pamela could be ruthless, direct and even rude – but she was also usually right. She had four capital letters she used to dump in the margin of my pages from time to time. MEGO stood for My Eyes Glaze Over. Whatever Pam fell asleep over vanished immediately into the midnight sky.

One of the most important things I had to adjust in *Girl in the Attic* was my dialogue, not between adults but between the teenagers themselves. When Stephen read my first novel, I was sixty-one. He was thirty years younger, and thus thirty years closer to the market I was writing for. I lived alone, Sam was in New York, and all my friends had grown-up children. If I ever managed to eavesdrop on teenagers, they'd be on the school bus, smothering themselves either in private slang or predictable swear words, neither of which I could use. Time and again Stephen's note in the margin would read: "They wouldn't *say* that. It doesn't sound right." And I'd go along with his comments, and change my text accordingly.

I was lucky enough to have Stephen as my editor for all four of the young adult novels I published with Simon & Schuster. In fact, after my second novel, *Coming of Age*, was published, Stephen left to become an excellent writer for

children himself, but he continued to edit my work. Such continuity is rare in today's publishing world where a beloved editor can be here today and gone tomorrow, all too often to a competitor which forbids any further relationship. What's also rare in children's publishing is that Stephen is a man in a world dominated by women publishers, who often use their books as substitutes for the children they never had. He has a male viewpoint which is a lot less warm and cuddly than normal in this particular field. I appreciated that a great deal.

Everyone has their own management and editorial style. I love and thank editors who work their way through a hard copy and put their comments on the manuscript. I find this much easier to work with than seeing what are now called "track changes" on screen. But times change, and woe betide the freelance writer who can't keep up, who fails to understand high-tech words or to have and to maintain in first-class order the very latest equipment.

It's an expensive business.

By the time I'd written *The Drowning*, my fourth novel for Simon & Schuster, I realised I wanted to spread my wings. The 40,000 words that a few years before had felt so dauntingly lengthy and precarious were now not enough. I often tried to talk to teachers in schools about what their students were reading. Most of them were far too busy to be bothered – and all of them were utterly fed up with the continual changes in the curriculum which made their lives increasingly difficult.

Talks given to children in bookshops were complicated to organise. On one occasion I hired a taxi and after a two-hour drive reached a bookshop only to find they had no space for me or an audience. Instead, one of their staff drove me to a school, where I was asked to give two separate

203

talks to two different audiences who were different ages.

Luckily and quite by chance, I'd brought two different talks with me, fully typed up and ready to be given. Halfway through the second talk, the local photographer arrived to take snaps for the local newspaper. I was asked to stop in mid-flight, stand in the garden with the whole school, have my photo taken and then go back inside to pick up where I'd left off. It became a ridiculously demanding day – and nobody paid me a penny.

Sometimes, talking to a school could give me back as much as I'd given. One such day I spent with Magdalen College School in 2007, giving two sessions, morning and afternoon. By then, I'd organised the two-hour time slots so that each one involved my giving a short talk, and then running a workshop.

I'd divide the class into smaller groups who each had to come up with a book proposal and then present it to the rest of us. At the time, I was writing an early draft of *Larkswood*, worried that its theme of incest would never be accepted. So I was fascinated when two of the workshop groups, entirely off their own bat, invented stories that involved brothers and sisters falling in love with one another. They must have been reading my mind …

One problem every children's writer has to face is the lack of space book reviewers are given to discuss their latest favourite read, at all levels. We fight for three lines, a forty-word mention, and celebrate for weeks if we get them. The outstanding children's book magazine, *Carousel*, which used to publish three times a year, edited by Elaine and Dave Chant, was always a brilliant analyst of current trends and a champion of top-quality work. As the wonderful artist and illustrator, Fritz Wegner, says: "A write-up in *Carousel* is as good as being in the Honours List."

Alas! It is no more. But every single writer for children in this country owe Elaine and Dave a huge amount for their dedication, knowledge and focus over many years.

After I'd given my talk to the Edinburgh Festival, one schoolboy flung his arms round me and told me it was the best one he'd ever heard. He was part of a marvellous group of students who'd come from all over Scotland to its great annual celebration of books and reading, and the people who make them possible. I knew without being told that my audience had really listened to me. They'd read my novels, they'd understood what I was trying to say – and they wanted more.

Here follows the talk I gave to a great gathering of enthusiastic students at the 21st Edinburgh International Book Festival on Thursday 26 August 2004.

"Where Do You Get Your Ideas?"

Although I was sixty-five in October, in terms of young adult publishing I am only two years old. It's great at my age to be such a baby. The world is still full of surprise and delight. When I walk into a children's bookshop and see copies of my own novels, I have to pinch myself to make sure I am not living in some wonderful dream. As a new voice and a newcomer, I am honoured to be here in Edinburgh at this, its 21st Festival. Thank you so much for inviting me.

When *Girl in the Attic* was published in 2002, my neighbours started to look at me in a different way. I was no longer just the dumpy, frumpy, track-suited and snow-booted creature who jumped around Oxford's Port Meadow at all hours of the day – and sometimes the night – talking wildly to herself; the irritating disturber of the peace when

during dark and troublesome times I played Handel's *Messiah* so loudly – singing all the solos myself – that the village of Wolvercote rocked in agony.

I was no longer just an editor of academic books the size of tombstones.

I was no longer just the self-employed businesswoman who ran an editorial consultancy from home and who spent hours on the phone every week trying to get publishers to put that cheque in the post for work she'd done months ago.

Nor was I just the girl who wrote picture books, such as *Tomasina's First Dance* and *Look at Me, Grandma!* Those were for "kiddies". Those were illustrated by artists. Without their skills, my story was as nothing, so the picture books didn't count in the scheme of things; they didn't really matter.

But a book for "young adults" … Well, now, that was different! I mean, it almost looked like "the real thing". Something grown up people could read, without looking ridiculous.

Yes, sir! The moment the book could be picked up, looked at, handled, sniffed and hopefully bought, I'd become somebody else. You know, one of those funny mad kind of people who spend all day messing about with … what do you call 'em now … let me think … oh, yes, how silly of me, my old memory playing tricks with me again … Now I remember …

Messing about with words.

No actors. No lights, camera, action. No music. No costumes, no make-up, no extras. Just me, alone in my study, with a bottle of black ink and my fountain pen.

People began to ask me questions which fell into a predictable pattern.

The first question was, "How long did it take?"

As if writing a novel is like riding a bicycle from Aberdeen to Blackpool: set off Monday, reached my destination

Thursday. As if writing a novel is a race, a competition for who can do it in the fastest possible time.

"Yes, sir, I work a nine-to-five day. Churn 'em out. Write five novels a week. Piece of cake."

Gross! No wonder we're all so fat …

The answer to, "How long did it take?" is: *all my life*. Any work of art – an opera, a symphony, a painting – takes its creator all their lives to produce. Everything they are, everything they have become up until that moment when they can say: "That painting is now painted, that book is passed for press," has gone into that particular piece of work.

So I answer, "All my life." When people then ask me, "So how old are you exactly?" I say, "One hundred and five and counting," turn on my heel, and vanish.

The second question friends and neighbours ask is, "Am I in it?"

"Of course you are," I say, watching their faces for signs of outrage, guilt, alarm, joy and expectation. "Everyone I've ever met is 'in it'. Everyone I've ever laughed with; cried with; brushed shoulders in a crowded room with; stood behind in the supermarket queue with; spotted from the top of a bus; sat next to at the theatre; stared at opposite their seat on a train; loved; fought with; hated; written to; opened the door to or spoken to on the phone is 'in it'. Without the people in my life there is nothing to write about."

But the third question people ask me, "Where do you get your ideas?" – well, now, *there's* a question and a half. I could stand here talking about that until Monday week.

W W W. It's a bit of a mouthful, isn't it? I sometimes wonder: when little green aliens from Mars eventually land on our planet and we start spouting W W W at them, whether they will stare at us and decide we are talking gobbledegook. They are much better off out of it.

Whoosh! … They are almost up and away …

Rapidly, we could try to explain that W W W is our World Wide Web; that it is everybody's best friend and so unbelievably useful; that on the World Wide Web we can get everything from instant information on any topic we could possibly imagine, to a chat with someone we've never met, to tickets to Disney World or Glastonbury, for the Orient Express, or our groceries from Waitrose.

In other words, W W W is our modern miracle.

Or is it? Can we "get ideas" on the World Wide Web? Can we press a button and demand them on tap? Is there an "ideas shop" I could access?

"I'd like to order three major characters, all teenagers, wrapped in silver foil," I tap into the computer. "And four minor characters, different ages, one of them should be French. I'd also like one square mile of city centre, two miles of rugged coastline, three packets of weather (please include a storm), a skeleton in a cupboard, a dollop of spook, and one large tablespoon of magic dust."

Three hours later, a van pulls up outside my door. A man in a T-shirt climbs out. The shirt's logo is: IDEAS ON TAP. He plonks the ingredients on my doorstep. I pay for them with my plastic card. Then I wait until the stroke of midnight. I light the candles, shake the contents of the bag and spill them on to the table.

What do I have here? Easy as apple pie! The ingredients for novel number five?

Not a snowflake in hell's chance … It doesn't happen like that.

Nothing that's really worth doing ever happens as easily as that.

And anyway, my life as a writer of stories is dominated by

different Ws. The five brilliant "question" words that all begin with a W:

Who? ... Where? ... What? ... When? ... Why?

Every fledgling writer, every trainee journalist, is taught to answer those questions:

Who is the story about? Good guys? Bad guys? Young, old, rich, poor?

Where does the story happen? Glasgow? Sydney? Bombay? Berlin?

What is the story about? A fantasy? An assassination? A war?

When does it happen? Now? Three thousand years ago? Two hundred years into the future?

And why am I bothering with it? Why do I hope you will want to read it? Why am I so obsessed with the storyline that I can't leave it alone? Why is its theme, its message, so crucial, so topical, so original?

There is of course a sixth W question, like a sixth sense, which every writer asks themselves a hundred times a day. It is a kind of extension to the first five.

It is the question: what if?

A girl is running through the woods. It is midday: hot and unbearably humid.

What if ... she stumbles across a rare orchid?

What if ... she has a secret assignation?

What if ... there is a storm and she is struck by lightning?

What if ... she is accidentally shot?

What if ... she is being chased by a bull?

What if ... she is never seen again?

I let my imagination run riot before I make a decision. Let me see ... Yes, I have it!

The girl has a secret assignation with a man she has never met before. He is in fact her father. At least, he looks remarkably like the only photo she's ever had of him, the one she has treasured since her childhood. But before they can even begin to talk, a shot rings into the air and the man falls dead at her feet.

Sounds good to me, man! I mean, like, hey, wow! It's so dynamic, isn't it?

No, it isn't.

Because that little voice in my head will say: wait a minute, Mendes. Not so fast. There's a seventh question panting at my heels. More than that: it dominates my writing life. And once again, I pull out a question using those Ws.

The question is: Will it wash? Is my story believable? Does it have integrity? Does it ring true?

Or is it flabby and hollow, pumped up melodrama, filled with a string of lazy, crazy coincidences, shallow, cardboard characters and cheap, cliché-ridden tricks?

So where exactly *do* I get my ideas? Let's begin at the beginning.

Sleep.

Sleep is far and away the most important feeder of my creative process. It is the pool into which I dip to get all my ideas. Without a good night's sleep I am creatively paralysed for the next twenty-four hours.

My most important creative time is at the crack of dawn, before I've turned on Radio 4 or heard the sound of my own voice. In summer, I sit in the garden. The birds are my sharers of celebration. So are my two wild squirrels, Elvis and Presley, who come to scrabble, dig and feed. I sit watching them with a cup of tea and an apple. The thinking, the planning, the decision-making begin. I start to scribble in one of my small notebooks, trying to monitor the thoughts

engendered by sleep before they burn into the noise and light of day and I can hear them no longer.

The second most important source of all my creative ideas lies in exercise. I walk at least three miles a day and often more. For me, *getting out and away* from my desk and all that high-tech stuff, under the sky, in all weathers, gives me the space and freedom to think.

I need hardly add the third most important source: good health. Good writing must be fresh, energetic, vigorous, dynamic, accurate and *alive*.

For me, a novel begins with a "defining moment". It can be a split-second incident that sears its way into my consciousness and hangs there, like a spider in her web, staring me full in the face and refusing to budge.

For *Girl in the Attic*, I'd been house-hunting in St Ives in Cornwall. I'd grown weary of the huge amounts of editorial and project-management work I'd taken on. I had, accordingly, grown out of love with everything around me: my beloved Oxford, the people in my life. At that moment I'd gladly have bought a tent in the middle of a field – anywhere, it hardly mattered. All I wanted was to be left alone to write my own stories, to rediscover the sound of my own voice.

An estate agent took me to see a grim little bungalow. It had belonged to an artist who'd died there. Her heavy oil paintings hung cheek by jowl on every wall. As I climbed into the attic, I glimpsed two teenagers. The "vision" was born out of my own internal depression. A girl sat painting at a desk beneath a window. A dark-haired boy stood behind her, looking at her longingly. I knew at once their names were Nathan and Rosalie and, even before my glimpse of them had blurred and vanished, that I'd write about them.

The novel took me several years. At every rejection slip, the spur that forced me back to the page for yet another

revision was my determination not to let my teenagers die, unheard of, in that dusty, neglected space beneath the eaves.

Sometimes when a novel is rejected, no explanation is given. Thanks but no thanks. The pain of a "straight" rejection is indescribable. I've offered my heart on a plate and it's been thrown back into my face. I have to swallow my own heart to keep it beating. For the first twenty minutes, I wonder if I'll be able to gulp the dose of what tastes like a poisoned chalice. But I must, in order to stay alive. Then I have to find the courage and energy to start the process all over again, dig out my heart and put it on someone else's plate.

But sometimes an agent or a publisher can be more helpful: they can tell me what they think is missing in the story. In other words, *they* can furnish me with an idea – and that idea can take root.

Over those long months of rejection, I began to receive one single message about *Girl in the Attic.* The title was brilliant. The storyline evocative, even tantalising. But it needed to be one hell of a lot more spooky; more spine-chillingly-thrillingly-willingly *scary*.

I kept being told that the storyline needed a ghost.

Boy, did I hate *that* idea! Ghosts? Those stupid, boring, flapping white sheets that moan and clank their chains on the stroke of midnight? Hamlet and his father on those freezing battlements? Charles Dickens and his Ghost of Christmas Past? Please, give me a break! How on earth was I ever going to do something original with *that*?

Well, I think I did. When my storyline was really strong and powerful *and there was an absolute necessity that only a ghost would do*, this is what I wrote.

Nathan has escaped at night from his hotel room. He has run through the dark streets of St Ives to find the girl who lives

in the attic of a cottage. He desperately wants to talk to her. He disturbs her as she's sitting in a semicircle of candles, chanting a prayer. Their dialogue is interrupted when Rosalie tells Nathan to get out of the cottage as fast as he can: she can hear someone coming. It's her father, Jake Croft: a widower, a smuggler, an ex-prisoner, a drunk and a bully, who takes out his anger on his only child.

But not this time. As Nathan, trembling, hides behind the kitchen door, Jake thunders in and out, hauling chairs around, calling for Rosalie but getting no reply. He lurches away in his van. Breathing a sigh of relief *(quote follows)*:

[Nathan] slipped back into the kitchen.
I must check that Rosalie's OK.
He raced up the stairs to the attic, pushed abruptly at the door and stood in a sea of moonlight. The candles had been blown out. Thin plumes of feathery smoke fanned upwards towards the moon, like pale moths trying to escape.

"Rosalie?"

In the stillness that met his voice Nathan knew the attic was empty. He stood over the desk, turned on its small lamp. The painting of the two shadowy people on the beach had gone. He moved towards the window, pressed his hands against the curtains, knowing even as he did so that Rosalie was not behind them.

He switched off the lamp. The moonlight seemed to crush against his shoulder. For a moment he looked out at the garden, the shivering grass, the moonlit branches swaying in the wind, the high clouds chasing across the sky.

Behind him he heard the faintest chink of bottles.

He spun round. The smell of salt and tar seemed to fill the attic. He heard other sounds: laughter, the faintest of voices. More clinking. He looked out to the garden, thinking they must have come from there, then back to the attic and gasped.

In the semicircle of candles stood three shapes, almost like bodies, transparent as moths' wings, their arms hovering around each other. An old man and a woman, but he couldn't make out their faces, and another much younger woman with flowing curly hair.

Nathan blinked. The shapes began to circle round and round in perfect harmony, as if they were dancing to the beat of a drum or the cry of a violin, their heads flung back in delighted silent laughter.

The circling grew faster and they began to spin. The shapes became a single whirling spiral of light.

Then they slowed, stopped, separated, climbed the arc of moonlight – and vanished through the window into the dark shimmer of sky.

Nathan's legs gave out beneath him. He sat at the desk, trembling, too frightened to move, to look round again. He spread his arms over the wood, comforted by its warmth, laid his head down. Covered in moonlight, he seemed to sleep.

He woke, minutes later, deeply refreshed, as if he had been swept out to sea, dived into its utmost depths, reached into the centre of his own being.

He stood up, looked down at his feet, at the attic floor. He stooped to touch one of the candles. The wax at its base was still warm. He could smell the sharp, invigorating cleanness of its burnt wick.

And then he noticed.

The candle at the tip of the semicircle had vanished. So wherever Rosalie had gone, she had taken it with her. *(End of quote)*

My ghosts here are not just scary monsters, inserted to entertain and enthral. They *serve a purpose.*

They become Nathan's passport to Rosalie's respect and affection. The fact he's seen them qualifies him in her eyes. It means he's tuned into her wavelength, he's become worthy of her attention – he's become someone she can trust.

In other words, we have entered a new scenario: the beginnings of true love.

My "defining moment" for *Coming of Age* arrived early one morning. It didn't involve a ghost, but it was pretty scary.

I'd been walking on Ludshott Common in Hampshire: miles of National Trust land, part dense woodland, part flat meadow and wild field. Absorbed in my thoughts, I was in a heavily wooded part, where a narrow path dipped steeply over the thick roots of trees.

Suddenly, out of the quietness of the woods reared a black stallion. I remember looking up at its dark belly, its flailing hooves, which were almost on my face. I flung myself away from them on to the brambles – and heard the woman rider laugh as she galloped off.

Later, I realised that although I could remember that particular incident only too well, I couldn't remember walking into the woods or returning from them. The "defining moment" had given me a place, a possible incident with far-reaching consequences – and an essential theme: memory and the ways in which it works.

The incident lay buried in my head for two years. But one afternoon I was visiting Stratford-on-Avon. I'd seen a production of *Romeo and Juliet* and I was walking down the steps of the theatre, after the performance.

Suddenly, I felt as if I were pushing my way through a gauze curtain into the dining room of a solid Victorian house. Standing around the table were Amy Grant, her father, Aunt Charlotte – and Hannah Turner, the new woman in her

father's life. I knew that Amy's mother had been killed in a riding accident on Ludshott Common – and my second novel for teenagers, *Coming of Age*, was born.

When a moment such as the horse-riding incident hangs around in my head like that for years, there's always a good reason, a deep, underlying one, that pulls at my soul. Traumatic loss of memory has haunted me since childhood. In an incident that I have kept secret until admitting it now, one afternoon at school I was physically abused by a member of staff. I was six. I remember being told to "stay behind" alone in the classroom at the end of the day. I remember a door shutting. Then I remember walking down the long school drive and out of the school gates. I shall never know what happened to me in the interim.

My third novel, *Lost and Found*, is set in Oxford. It's the place I chose to live as a postgraduate at the age of twenty-one. Although I've left Oxford on several occasions, it's the place to which I've always returned. It sings to me and pulls me back. It's my real home.

The "defining moment" for *Lost and Found* happened to me at a crowded bus stop. Two teenage girls came walking towards me, both with bare, slender arms and legs, delicate faces and long, smooth hair. Neither could have been more than fifteen years old. One of them pushed a toddler in a buggy. It was perfectly obvious at a single glance which was the mother and which the supporting friend, for on the mother's face was a look I defy the best actor in the world to capture: a mixture of guilt, embarrassment, pride and triumph.

I began to wonder what had happened. Who was the father? What was the girl's life like? And then, out of force of habit, I began to ask myself: What if …

What if the toddler was not the girl's son, but her little brother?

216

What if the toddler belonged to a neighbour and the girl was babysitting?

What if the toddler was her young cousin?

Why was I so sure the girl was a teenage mum? *Because I could read her face.* In the flicker of a second, I glimpsed, saw and understood the truth.

In *Lost and Found*, my hero, seventeen-year-old Daniel, falls in love with the girl who has moved into his old house. Her name is Jade. Daniel discovers that Finn, the child he'd assumed was Jade's little brother, is in fact her son.

Now the child's father, a man called Kieran, who was Jade's former music teacher at her old school, has burst back into Jade's life by turning up in Oxford, out of the blue. Jade has just spotted him busking on a street corner with a group of other musicians. Kieran has seen her. He has also seen the child in her arms. He has guessed the truth … Up until that moment, he had no idea he had a son.

Jade, stunned, trembling and confused, tells Daniel that Kieran is Finn's father. Although it's not the news Daniel wants to hear, in a strange way it brings him closer to Jade. He feels instantly more protective towards both her and Finn. Jade quickly learns to trust him – and one morning, she asks Daniel if he'll collect Finn from his nursery school while she goes to London with her mother on an urgent errand. Daniel rushes off to collect the toddler on his skateboard. It starts to rain; he has an accident. He is a fatal fifteen minutes late. It's a major turning point in the story.

Lost and Found is my most ambitious novel to date. I need to feel that each new piece of work is in some subtle way better than the last. That I have grown in confidence, in maturity, in story-telling technique.

For me, the breakthrough in *Lost and Found* is that I had

the courage to tell the story from more than one viewpoint. *Girl in the Attic* is Nathan's story. *Coming of Age* belongs to Amy Grant. But in *Lost and Found* we have four voices. My hero, Daniel's, story is told in the third person, and he's the lynchpin of the piece. The novel begins with the death of his grandmother; it ends with his public acceptance of the new "gran" in his life.

But Daniel is surrounded by three other voices: Jade, the "rainbow girl" with whom he falls in love; Laura, Daniel's new, adopted grandmother; and finally for a single episode towards the end of the story, the fourth voice of Kieran McVeigh, Finn's father, and the man who betrayed both Jade and himself – and ultimately, of course, who has betrayed his own son.

I knew the voices worked because of the ease with which I could imagine each of the characters. I could see them looking at me. I could hear them talking. What they had to tell me was clear as a bell. At no time did I ever have the feeling that I was inventing the impossible.

Lost and Found is not run-of-the-mill teenage pap. It's not a single-voice confessional. My four protagonists are different ages, different sexes, each from different worlds. Initially separate and self-obsessed, by the end of the story I have woven them together in a complicated plait.

So: these "spurs" that trigger the whole process: these "defining moments". Why are they so important? Because they come upon me unawares. I don't choose them: they choose me. But I need to be ready and waiting.

I don't walk down the street with a mobile phone clamped to one ear. I don't sit on Port Meadow with my head in a book. At parties, I'm the one with their back against the wall, looking on. I watch, listen and observe. I'm the eternal sponge. I must be able to spot the secret wink between two

people behind a closed door. To hear that faintest hint of sarcasm in the treacly greeting. To understand the truth behind the glittering façade.

The setting is crucial. My characters *belong* somewhere – and it must be a place I know. There's no substitute for tramping the streets, noting the scent of early morning, the colours of the rain-cloud sky, the wild grasses of the meadow, the perilous depth of the slippery mountain stream.

In *Lost and Found* I chose as a focus for the novel the Oxford Canal. It becomes the place of the kidnapping, the place for the showdown, the place where Kieran finally tells Jade the truth about his own life. I've walked up and down its towpath a thousand times in all weathers. A friend of mine used to live on one of its narrow boats. I persuaded him to take me on a day trip, so that I could feel the pace and movement of the water beneath us.

It's called first-hand research. *You can't tap into that on the world wide web.*

So, then: here is Daniel again, on the Oxford canal, desperately looking for Finn. Laura had taken him to consult a psychic medium called Sylvia. She tells Daniel she thinks Finn is somewhere close to water *(quote follows)*:

He walked purposefully towards the boat that lay in front of him.

A man stood at the open door, jabbering into a mobile phone. Daniel held up the photo of Finn, pointed to it, mouthed, "Have you seen this child?"

The man shook his head, shrugged his shoulders, turned his back and continued his conversation.

Thanks for nothing!

He walked towards the next boat, tapped at a window,

climbed across a plank on to the boat and knocked at the door. There was no answer. Something threatening about the silence made him feel uncomfortable. He scuttled back to the towpath.

The next narrow boat, *The Great Escape,* lay hidden behind dense overgrown brambles and wild geranium. Striped muslin curtains shrouded the windows. The contents of its roof gave little away: a battered hosepipe, a bundle of chopped wood and an ancient mackintosh huddled across it.

He didn't feel like tapping on the door.

This is useless. A complete waste of time. I'll never find them.

He'd almost turned away altogether – the boat was so obviously closed and empty – when he spotted something underneath the mackintosh.

A scarlet sweater. One sleeve lay along the wood like a motionless snake.

Daniel froze.

Kieran had worn a scarlet sweater the day he'd vanished.

Was this just a coincidence? Desperate as Nathan was to find *anything,* was he now merely clutching at straws?

The boat looked so private, so secretive. Could this be where Kieran had taken Finn? Were they inside? If they were, how could he prove it without banging down the door?

Nothing would feel better, right now!

He remembered Laura's warning: "Don't tackle Kieran on your own."

He stepped away from the boat, checking the windows. Through one of the curtains he could see a chink of light – but nothing more. No voices, no chimney smoke, no rattle of cooking pans, no scent of food.

But suddenly there was something else.

The beautiful lilting notes of a flute, clear, plangent, lovingly confident, rang into the air.

Someone had begun to play *Greensleeves* on a flute.
It could only be Kieran McVeigh. *(End of quote)*

What about "ideas" for my characters? Where do I "get" them?

Once I know *who* I'm writing about, my task is to get underneath their skin. To burrow my way into their lives right through to their very hearts. What is their problem? What do they most want in the whole wide world? Whom do they most love and hate? What are their deepest fears, their fiercest ambitions?

Above all, what makes them memorable? How am I going to get *you* to care about them as much as I do? For the key is that I'm desperately in love with them all. Even the villain. Particularly the villain. Unless *my* heart goes out to them, how can I expect yours to do the same?

I remember listening to my tutor at a writing class.

"I write all morning," she said. "And when I get up for lunch, I feel wonderful."

Hmm, I thought. Who's the lucky one! I write all morning and when I get up for lunch I'm exhausted. I've burned my soul to a cinder. It's a crucial part of the whole process. *No ashes, no phoenix.* No burning out yesterday, no fresh new sparkling sensitive work today.

So: if my characters have had an argument, I'm boiling with rage. If they're miserable, I'm in floods of tears. If they're worried, sleepless, fraught, I'm beside myself with anxiety. If they're locked in a love scene, I'm passionately in love with both of them. I have to be. It's the only way I can get the message across the deep divide between my imagination and those words on the page.

I recover from the exhaustion of the morning's work by getting out of the cottage and walking. Sanity returns under an open sky. For let me spell it out: this creative life is one of madness. *Nothing less will do.*

But hold on a minute. All this stuff about ideas. The whole point of what I want to do is *to tell a good story.* I may have the most brilliant and complex ideas ever known to humankind, but strung together they might be as boring to drink as yesterday's teabags.

A good story is not just about putting the right words in the right order – though God knows that certainly helps. It's about building characters whose lives *you* desperately care for. *You* want to read on. *You* are dying to turn the page. *You* can't put the thing down until you have reached the final curtain. And then you feel lost and lonely without it. The biggest compliment you can pay me about any of my novels is to say those five wonderful words: "I couldn't put it down."

Sometimes, after all my meticulous planning, my characters upset the apple cart, big time. They find their *own* voice and take on a life of their own. This only happens if I've built them on foundations that are solid as a rock – and if I have the confidence *to let them tell me* who they are.

In *Coming of Age*, this happened in a scene which became the turning point of the entire story.

Amy Grant's mother had been killed in a riding accident. Although Amy was there at the time, she can't remember what happened. One afternoon, six years later, she finds an old postcard addressed to her mother from someone who signs himself, "ever your loving Marcello".

Amy is bewildered and horrified. She'd put her dead mother on a massive pedestal. She can't believe she may have had a lover. So she takes her older brother, Julian, out on to Ludshott Common to question him. She thinks – and she grows more convinced by the minute – that Marcello may have had something to do with her mother's death, might even have been her killer. She has the

incriminating postcard in her pocket, burning into her thigh.

My original plan said, "Amy and Julian sit down on a wooden bench and Julian tells Amy all about Marcello."

But when it came to writing the scene, Julian began to talk to me in his own voice.

"You must be joking," he says to Amy. "No way! I'm not telling you anything. It's all in the past. Forget the postcard. Destroy it. Let sleeping dogs lie. If you play with fire you'll get burnt."

As her brother coldly walks away, Amy realises for the first time in her life she's utterly alone. She has nobody to rely on – and if she's serious about uncovering her mother's past and getting at the truth, she'll have to do it by standing on her own feet and making her own decisions.

There's one person in all this who's very important to me: my Simon & Schuster editor, Stephen Cole. I often have the image in my head of a tightrope walker. A good, well-told storyline stretches taut and firm between one landing post and the opposite one the other side of the circus tent. Daily, the author walks the tightrope, edging along its difficult and dangerous knife edge.

Stephen's job is to make sure I don't fall off, that at all times the storyline is credible, energetic and true. There's no safety net, and on any page I might slip and fall. A weak idea is a weak link in the chain and could be fatal.

What Stephen *dislikes* is just as important as what he likes. When he likes something, he'll give the line a tick. I'm overjoyed. When he hates something, he'll fight against it tooth and claw.

Sometimes I fight back. For example: I've just read the proofs of my fourth novel, *The Drowning*, which Simon & Schuster will publish on 1 August 2005. The novel is about a girl called Jenna Pascoe, who wants to be a dancer, but

whose entire future is put into jeopardy when her little brother, Benjie, drowns. After his death, Jenna discovers that Benjie had been bullied at school.

In the first draft, I wanted Jenna to find an anonymous note under Benjie's pillow. The note said: *Sorry, you dunce, we've fooled you this once.* Stephen hated it. I persisted. Stephen went on hating it. I rewrote the note into a rhyme filled with childish obscenities. Stephen raised the roof. He wrote me a long email telling me in no uncertain terms it was not only rubbish but obscene rubbish – which secretly I knew. But part of me wanted to see how far I could push it. Part of me wouldn't give in.

What Stephen didn't know was that one summer afternoon at school when I was ten years old, a "friend" of mine whose mother detested Jews told me that if I went into the boathouse by the side of the pond, I'd find a special present hidden in a hole. What I found, in the dusty heat of the boathouse that summer afternoon, was a small piece of paper. It read: *Sorry you dunce, we've fooled you this once.*

But novel writing is not about settling old scores. It's not about dredging up the painful memories of your own past and trying to slip them in so that nobody will notice. Stephen *always* notices. He has a kind of sixth sense – God alone knows how – that winkles them out. And he won't let me get away with it.

I write all my new work in the morning. I'm up at five o'clock with the birds. After a hot bath and a hot breakfast, I start writing all my new work in longhand. Five hours later, by eleven o'clock, although I'm tired, I might still be at my computer. That's when I might go over the top. I lose my sense of judgement. I take my descriptions a step too far – and Stephen will brilliantly jump in to cut them back.

In *The Drowning* Jenna falls in love with a coastguard. His

name is Meryn. On only their second date, their lunch is interrupted when Meryn is called out by the Royal National Lifeboat Institution to rescue a ship in distress. Jenna runs out to the harbour to wait for his return. In the wind and rain she hops up and down at the water's edge, imagining the worst and praying for the best.

When Meryn finally comes in on his boat and clumps up from the shore, Jenna rushes into his arms. I gave them their first kiss. I said: "It tasted of the salt of the sea."

Oh, boy! I said to myself. Mendes, that's really terrific stuff!

Stephen wrote one word in the margin: *Yuck*. No argument. A *yuck* is non-negotiable. I don't argue. He Who Must Be Obeyed has roared at me from Aylesbury. He Who Must Be Obeyed Gets His Way.

I replaced it with: "I want to kiss him, but not in front of all these people."

It's not hard to see how much better *that* is. As Stephen goes on reminding me, *less is more*.

I don't write "happy endings".

Life isn't neat and tidy: it has thousands of loose, wobbly bits. It's a living, changing succession of days. However hard we try to control it, life doesn't come in bite-sized chunks. It ebbs, flows, swirls, roars and dies. People don't come in identical packages but in skins of a million different colours. We are not cloned Dolly the Sheep lookalikes.

Nobody ever lives happily ever after.

If you want my stories to work towards a happy conclusion, you'll be disappointed. My stories work towards what we struggle to find in real life: *a way forward.* There is all the difference in the world. Some problems have been resolved. Many have not.

The crucial point is that within my story, everyone has changed. My protagonists fight their battles with as much

honour and dignity as they can muster. That's all any of us can ever do.

"Where do I get my ideas?"

From a good night's sleep. From walking, gardening, thinking and moving under the freedom of the sky. From good health. From those defining moments. From the pain of those rejections. From the setting. From the logical threads of character knowledge and building. From the voices of the characters themselves as they begin to tell me who they are. From the pace and drama of the storyline. From my editor's inspired guidance.

"Oh! Yah!" a neighbour of mine persisted, as I mumbled an answer to his question. "I mean, like, I have good ideas sometimes. But writing a story? Hell's bells, I wouldn't know where to start."

"It's really quite easy," I said, looking him in the eye. "Begin at the beginning. Don't bother too much about the middle bit, it's sure to write itself."

I turned on my heel and muttered over my shoulder. "Oh, and by the way … Stop when you get to the end."

Larkswood

One of the most exciting moments in a novelist's life can occur during what begins as an ordinary conversation between strangers. During a trip to Grayshott Hall, while I was researching for *Coming of Age*, I met a man who'd been born and bred in Grayshott and knew the area like the back of his hand. He told me a remarkable story.

A hospital near Ludshott Common had caught fire one night, tragically killing some of its elderly occupants. The remains of the building were pulled down and for many years the ground on which it had stood stayed fallow. Then a developer bought it and decided to build a disco. One night, while the music blasted to the heavens and the dancers flung themselves into the air, that too was completely destroyed by fire.

I was instantly gripped by the double tragedy. It got me thinking. What if I could write about a patch of land that in some strange and terrifying way had been contaminated? How might it affect the people who owned it, lived on or near it – and what would it take to cleanse the ground of its ill omens?

Two years later, again in Grayshott, I asked John Owen Smith, the knowledgeable local historian, known to his friends as Jo, to show me the exact spot where the fires had burnt. I'd imagined dense woodland, overhanging trees, a Hansel and Gretel setting, darkly tragic and mysterious. Instead, I was faced with a flat, featureless landscape, bulldozed into disappointing anonymity. But no matter: Jo confirmed the truth of the story. And by that time – I'd written two teenage novels in the intervening years – I was ready to take my ideas further.

I spent that week walking on Ludshott Common, until I'd found the exact spot I needed for my own imaginary secretly evil deed. In a patch of dense woodland near Grayshott Hall lies a small clearing: a circle of trees that shelter a flat patch of ground full of pine needles. It's large enough for a burial, yet sufficiently secluded to remain a private place. I had no idea what I wanted to happen there. I only knew that until I'd found that specific spot, my story had no beginning, let alone a middle and an end.

I travelled home deep in thought, wrapped in the week's memories. The following morning I sat at my desk to write a letter of complaint to a utility company. Instead, within twenty minutes I'd written the opening sequence to *Larkswood*. The novel went through umpteen drafts, further edits and amendments. But when it finally emerged as a finished story, those few introductory pages remained exactly as I'd written them on Day One.

Harriet comes flying across the fields, carrying a tiny coffin with its stillborn child. She buries the coffin in the woods and races back the way she's come, desperately praying nobody has spotted her, and that somehow or other she's given the child the blessing it deserves.

As I turned away from the computer I also realised that the novel would have at its dark heart a subject known as the last taboo: incest. Harriet's brother and sister have had a passionate affair and the stillborn baby is their secret tragedy. The lives of the three siblings will be totally changed by this dangerous, illegal and forbidden relationship. I knew I'd have to work very hard to weave a plot that was both real and believable, and then sell the story to a publisher who was prepared to take the challenge and the risk, and whose sales force would understand and support my story.

Shaking with surprise, I printed out the pages and took them into Oxford. I read them over coffee in Blackwell's bookshop. I thought they held water: they rang true. Most importantly, I wanted to know what happened next. I had a point of entry into the story. I saw Harriet as a girl in a long frock, living in late Victorian England. But I also wanted to write a novel set in 1939: the year when the Second World War began.

So the second problem I gave myself was how to link the older generation with their successors. Who were they, what were their names, how had they survived the time gap, and what part did Grayshott itself play in the process? The house was presumably their family home. The woods and fields surrounding it would have been their private gardens – their inheritance. Had the children of the family done something so serious that it would defile their name, their reputation and their house for generations? And who ultimately was to blame?

Before I left Blackwell's, I browsed the books in the history department. I was lucky to find the newly published *1939: The Last Season* by Anne de Courcy. It became my guiding

star. As the *Sunday Times* review succinctly puts it on the back cover: "De Courcy neatly interweaves diplomacy and dancing, house parties and the House of Commons, Anglo-German negotiations and Ascot, as the music and the tinkling of glasses rise to a hectic crescendo along with the roar of advancing German tanks."

Anne is that rare combination of a brilliant researcher and a lucid writer. She interweaves facts seamlessly, so the reader grasps the complicated, ominous politics of the time and toasts the social whirl. My 1939 protagonist, Louisa, a serious, level-headed girl with enormous courage and determination, has a younger sister Milly, the apple of their mother's eye and a social butterfly. I put Milly's escapades into a series of letters she writes to Louisa, knowing that the parties she attends, the clothes she wears and the opinions she voices – she can't believe the war will ever happen, that if it does, it will be over by Christmas – were exactly right for the time.

I spent years struggling with *Larkswood*. I had weeks, often months, when I got stuck on the plot, when I changed tack and started work on another novel. But always, doggedly, I returned to Louisa. She wasn't the character who was hard to get right, but her incestuous ancestors certainly were.

The nub of my problem was this: if I wanted to write seriously about incest and its effects on a family, *there needed to be long-term effects*. I knew that Harriet had buried a baby, so in a way I'd swiftly got rid of the problem among the roots of the pine trees. And although the introduction was gripping enough to whet the reader's appetite, I worried that I might also have wiped out the heart of the story before it had even begun.

As I trudged around Woodstock, sped around Blenheim, wrote and researched and read and wrote some more, that question haunted my days and nights alike.

∞

One morning I left my cottage for the Woodstock library. I'd just walked past the large graveyard on Hensington Road when the realisation hit me like a thunder clap. Harriet's sister, Cynthia, had given birth to *twins*. And the second baby survived to tell the tale. First he'd been given to another family, hidden away, called by his adopted family's name. Then he'd been told the truth about his parentage. He left to fight in the Great War; and, somehow or other, had survived to find his birth father, wherever he might be.

I rushed into the library with my fresh ideas to talk to its librarian, Gillian Morris. Gill herself was the mother of triplets, so she knew first-hand about multiple births. I needed to read everything that had been written at the time – 1897 – about having twins.

The second child Cynthia gave birth to that morning, whom I called William, was the character I had to fight for, tooth and claw. An American publisher who reluctantly accepted that incest lay at the heart of the story began to insist, after we'd agreed the publishing deal, that I killed William off as soon as the plot would allow. In other words, I had to wipe the problem away. Sweep it under the proverbial carpet as if it had never existed.

But I couldn't agree to do that. What, I argued fiercely, was the point of the story if that was all I had done with it? Where lay my courage now? In tatters in *two* forgotten graves, not merely one. Everything I'd fought to make public would have been crumbled into a dusty ruin beneath the hefty, old-fashioned boot of censorship.

So I pulled out of the deal, retrieved my story and resurrected its original message. I make no apologies for sticking to my guns – though at the time the decision to do so was very difficult.

When Orion told me they wanted to publish my original version, even they had some qualms about the complicated storyline. I'd suggested that Cynthia had slept with two different men that fatal night: the singing teacher with whom she'd fallen in love – who first made love to her, and then said he wanted nothing more from their relationship – and her brother to whom she turned for comfort. So her twins had different fathers.

I agreed that was a step too far, and changed my story accordingly. That's different. That's called accepting constructive feedback and working with the people who act as your first professional readers. It's not censorship, it's experienced editing that's spelled out *before* any deal has been signed or money has changed hands.

So: here is the short article I wrote for Orion and the paperback edition of *Larkswood*, in 2014.

Writing Larkswood

The most difficult thing about writing *Larkswood* was without doubt the length of time it took me.

As an author I have moved from picture-book texts – short, pithy and incredibly difficult to get right – through to novels for young adults, which for my then publisher, Simon & Schuster, meant no more than 40,000 words, to a leap in the murky dark and the adult marketplace: any length, any historical period, as many characters as you need, as much freedom as you can swallow.

Gulp.

Dizzy with the sense of liberation and challenge, I took a giant leap.

I thought *Larkswood* might take me seven months.

It took me seven years, and more.

I am seventy-four years old, and this novel has taken me every single one of those years. The cake I ate for breakfast every morning was made of grit, determination and stamina. There wasn't any cream, though on a good day there may have been the taste of cinnamon and ginger, and if I had had a really successful night the week before, there might also have been Earl Grey tea.

Of course, it would have helped if I'd known what the hell's bells I was doing. I didn't. I knew I was a good storyteller. I knew what my storyline was going to be about. I knew, with a kind of stubborn, mule-like obstinacy, that the dark heart of *Larkswood* was an incestuous relationship between a brother and sister.

And there, oh, right there, was the sticking point.

"You haven't got a chance," publishers told me. "It's the last taboo, incest … We couldn't touch it with a barge-pole … Shut the door behind you, would you?"

I'd stomp off, tearful and red-faced but more determined than ever. Not only was I going to write a story about incest, but I was going to get it right. Absolutely right.

The first hurdle to clear was the research. For me, reading books is essential but never enough. It's the primary source material that gives me confidence. That means old newspapers, magazines, periodicals, bus tickets: actual documentation published at exactly the time my characters are living.

In my beloved Bodleian Library in Oxford, the crucial source material still exists, thanks to the dedicated staff who understand its importance. In the Vere Harmsworth Library, they took pity on my enormous age and weight and gave me a blue trolley. We used to call it my Blue Moon. On to this exquisite contraption I loaded copies of *The Times*. Red-leather-

bound and weighing even more than I do on a good day before breakfast with one leg in the air, these enormous and most marvellous of documents gave me chapter and verse.

Here lie the great political documents of the time, and so much more: the declarations of war and peace, the Parliamentary speeches, the Court circulars, the advertisements for household goods – cough remedies, garden shears, ladies' underwear and pipe tobacco. Here you can check on the weather, local gossip, the age of the Lord Mayor, and how one of his underlings got burnt alive by getting blind drunk and falling into the fire in his shabby lodgings near Botley-under-Limerick.

Now, the most important point about all this miraculous reading is knowing when to stop. How not to take so many notes you never want to open your own file when you get home. And how to translate what can eventually be a veritable sea of information back into the lives of those characters you first dreamed up all those years ago.

That, folks, is the art of the storyteller.

And let me tell you this.

It's a secret.

And it takes as long as it takes.

It won't be rushed.

It won't be crushed.

And if you are as determined as I was, it's worth the patience and it's worth the wait. First, you have to be accurate. Then you have to be original. Then you have to grip your readers by their throats and never allow them to escape.

As an author, the only words I ever want to hear are: *I couldn't put it down.*

Those five little words bring such tears of joy to my eyes that I have to go away and write another story.

Daddy's Girl

How do you deal with one of your main characters if they go missing in the opening chapter and you have absolutely no idea where they have gone or what will happen to them?

How do you realistically develop a second protagonist when at first he presents as the seductive hero of the piece and gradually disintegrates into villainy?

Daddy's Girl was the most complicated of my novels because although I knew how it would begin, for many months I didn't know how it was going to end. Part of me worried obsessively, trying to make decisions that would hold water. Part of me had enough confidence to allow my characters to tell me where they had vanished to and exactly how; just how evil they would become – and indeed how their individual stories would mesh, unravel and conclude.

Although even the ending changed towards the finishing post. I'd originally intended young Eleanor to drive away from Cornwall that Christmas morning not knowing where she was going or what might become of her. But one rainy November night, that suddenly changed. I realised she was

going home – and that she'd decided to return to Somerville College Oxford where her story had begun. Older, wiser and considerably more mature – a young woman, no longer a naïve Daddy's girl – she goes back to her studies in spite of uncovering her father's appalling villainy, and in spite of her Cornish lover's unforgivable betrayal.

The biggest problem with allowing your characters to speak for themselves is that you have to give them time to talk – and yourself as a novelist the time and space to listen. This demands the most sophisticated patience, and a determination not to throw in the towel after many frustratingly difficult days.

One afternoon, researching in Oxford's Vere Harmsworth Library, with no other readers about, I stomped up and down the aisles playing judge and jury, trying to decide whether or not Walter Drummond was a paedophile. It's a dangerous subject to throw into an already febrile mix. I was tempted but decided against it. I didn't want it as the dark heart of the novel, and to dangle it from the sidelines seemed to trivialise the subject rather than treating it with the seriousness and respect it deserves. That same afternoon I went home on the bus trying to work out exactly how the desperate, end-of-her-tether Moira had managed to travel incognito from St Ives to London, and then eventually to the south of France.

At the end of May 2007, I gave a talk to The Dragon School on how ghastly it was in fiction when people went missing and never returned – and when their disappearance was never fully explained. The only too real case of Madeleine McCann had just hit the headlines: everyone was praying she'd turn up, safe and sound. I can still hardly believe, fourteen years later, that the mystery of her disappearance remains tragically unresolved.

But as a novelist, you can't open a can of worms and allow the beasts to crawl over your story as they will. You have to impose some kind of realistic order to prove you've worked it all out. I don't think every story should have a happy ending. But readers expect the writer to have a completed storyline up their sleeve and then spilling on to the page. The missing child or adult must be found alive or dead. Otherwise the disappearing act remains a hollow trick, a lazy device that leads absolutely nowhere. Forced to come to their own conclusion or merely to shrug their shoulders, the reader feels disappointed instead of satisfied.

During the most difficult and complicated days of *Daddy's Girl* I often received fan mail from people who'd read *Larkswood* and really loved it. Their messages were touching and heartfelt, and I was always deeply grateful and encouraged. Many wanted a sequel – a request that has haunted me and one I've finally decided to fulfil – which is the biggest compliment of all.

"I couldn't put it down," followed by, "Don't leave me here. Tell me more. I'm longing to know more," is indeed a supreme vote of confidence.

I chose to set *Daddy's Girl* in 1936 because during my research for *Larkswood* I had read a lot about the 1930s. As an historical novelist, you quickly realise that the future may loom over your characters, and you may know what's in store for them – but that's hindsight. It's your characters' *past* that reveals who they are. It's where they've come from. Edwardian characters – my particular passion – have been built from Victorian bricks and mortar.

So my younger-generation sisters in *Larkswood*, Louisa and Milly, grew up during the 1930s, and their parents were Victorians. The year 1936 – the year of the abdication of

the Prince of Wales, in effect the year of the three Kings of England – fascinated me. I read everything ever written about Wallis and Edward. And to my delight, I was hugely helped by John Forster, Librarian and Archivist at Blenheim Palace. Over lunch in Woodstock, I told John about my ideas for a novel set in Woodstock in 1936.

John was truly wonderful. He not only drove me around the Palace gardens, pointing out the landmarks that would have graced the grounds in the late 1930s, but he invited me to look at the Visitors' Book that Wallis and Edward had signed at the end of their secret and crucial weekend party at Blenheim in June 1936. That was when Edward bought Wallis from her husband, Ernest Simpson, thus enabling her to obtain her divorce.

One of the Palace's treasured possessions – and closely guarded under lock and key – actually seeing and reading the Visitors' Book became my seal of approval for *Daddy's Girl*. It spurred me on during my writing, and encouraged me to imagine even more vividly just what an enormous step Edward's abdication must have been, and the seismic shock it was to the general public.

With the press baron Lord Beaverbrook's agreement, the Press had been gagged. Although newspapers all over the USA and Europe had been writing about Edward and Wallis's affair all that summer, and publishing photos of them together in distinctly compromising positions, people in Great Britain had no idea what had been going on in Royal circles. And in many cities, where the Prince had fought to improve conditions for working people, he was hugely popular. Which made his abdication speech in November 1936 even more of a shocking surprise.

But those in Royal circles knew exactly what had been going on. I'll never forget the night I decided that the British

establishment must surely have *encouraged* Edward to abdicate and colluded in his downfall. It was obvious he was flaunting his obsession with Wallis Simpson. None of the people who were close to him believed he wanted to be King, or that he was prepared to make the personal sacrifices it entailed.

With John's unique encouragement I set to work, talking to many of my friends in Woodstock whose families had lived there in and before the 1930s and who gave me a host of fabulous details about the history of the town, its underground network of tunnels, the food people ate and the shops and restaurants that had flourished and survived.

Eleanor Drummond lives in one of the oldest houses in Woodstock – in what used to be the teashop *Harriet's* – and the owners kindly showed me around their private quarters, including the attic rooms and the cellars. All grist to the novelist's mill. Similarly, the Librarian of Somerville College, Dr Anne Manuel, allowed me to wander the College's gardens and corridors. First-hand research at its best.

I knew St Ives in Cornwell and had already used it as a setting for two of my teenage novels, but *Daddy's Girl* demanded another visit. I went down for a week to spend all day, every day, in their public library, where I was allowed to read tiny local newspapers from the 1930s packed with information and gossip about the town, the weather, the tides, the storms, the heroic rescues and the tragic accidents. And with a final draft of the novel under my belt, Captain Philip Moran, who knew the history of St Ives better than anybody, was kind enough to read every word and correct a host of tiny but significant details.

The result? A novel I am truly proud to have written and now publish under my own imprint, VMBooks.

Somerville College Oxford has an impressive number of firsts to its name. It educated the first woman Prime Minister of the United Kingdom, Margaret Thatcher, the first – and only – British woman to win a Nobel Prize in Science, Dorothy Hodgkin, and the first woman to lead the world's largest democracy, Indira Gandhi, Prime Minister of India for much of the 1970s.

When I started to write *Daddy's Girl*, it was my first choice of College for my heroine, the young and very naïve student from Woodstock, Eleanor Drummond. The Staff of Somerville were interested in my project, enthusiastic, knowledgeable and encouraging. I was even given the name of an actual Head Porter, Scroggs. He leaped instantly to life beneath my pen, partly because of his glorious name. It spelled loyalty and discretion.

Set in 1936, I needed to get hundreds of period details absolutely right. There was then only one College telephone. It sat in the Porters' Lodge and nobody answered it after five o'clock. All the students were girls. They were expected to behave with decorum, especially when out and about in Oxford. Anyone who broke the College rules was either fined or sent down. The 150 students were hand-picked by the Principal, Helen Darbishire, a renowned Wordsworth scholar. She reminded them on a regular basis how lucky they were to be among the chosen few.

They still are.

I met their distinguished Fellow Librarian and Archivist, Dr Anne Manuel, for lunch at Somerville on 24 August 2021. Their Staff are swiftly recovering from problems the pandemic has hurled at all of us. Their kitchens have been totally refurbished. Stunning green ferns in terracotta pots decorate the halls and beautiful reception rooms. Their

lovely lawn is being relaid. Meticulous preparations are being made for the return of all their students, both within the UK and from all corners of the world, not only to the College, but to the marvellous cultural life of Oxford itself.

Here is a poem I wrote for them when I got home.

For Somerville College Oxford

Strong women's faces shine from every wall
Oatmeal tiles decorate the hall
The stairs that beckon us to eat and talk
Still echo with those famous voices. Walk

With me while grass covers rich earth again
And, scattering seeds, we take away the pain
To plan an autumn where with open book
Our Somerville reborn, we dare to look

To plan, to read, to check incoming guests
To nurture minds returning to their quests:
Strong women's faces shine from every wall –
Our futures beckon and we shall walk tall.

The Eyes Have It

When I was a child, I used to march around with a book under my arm and, whenever possible, my head in it. I became skilled at finding a nook somewhere – an empty room, a large tree with a sturdy branch I could climb up to – where I could read without interruption from other bothersome human beings. In Edgware we had a small apple orchard and kitchen garden behind the fenced-off lawn, where I dug my own patch of hallowed ground. There in the summer months I'd hide, with my current spell-binding escape into story, among the prickles of gooseberry bushes, the flap of wet washing and the humming of busy bees.

I can't actually remember the moment when I realised that although I could see the page in front of me, the rest of the world beyond it had become a little fuzzy around the edges. It may well have been in a maths lesson when, as I sat in the back row of the class, I knew I had no idea what the teacher was writing. I could hear the scrape of her white chalk on the black board. I could see the sweep of her arm and her slug of dark brown hair cut with military precision

243

like a man's. But 2+2=4? For all I knew, she could have been giving us a secret formula for the atomic bomb.

For many months I kept my increasing short-sightedness a secret. I could see well enough to cross the roads on my own as I walked the suburban streets to school. I could recognise the faces of my friends and enemies. I could catch a netball, sometimes score a goal, hold a spoon the right way up, drink soup without spilling it, climb the stairs, take a bath and spot a rainbow in a cloudy sky. Wasn't that good enough?

When it came to facing the school's visiting optician, I sneaked into the medical room and memorised the sets of letters on the chart. She assumed I could see pretty well everything.

My mother caught me out. We were shopping for shoes in Clark's on Edgware's High Street, and she pointed to a pair in the window.

"Where?" I foolishly asked, squinting.

The question was my sudden downfall. I was pushed into the local optician's office and forced to confess the relentless truth. I could read lines one and two on the chart. The rest was mystery.

I could not have hated my first pair of spectacles more than most of the world hated Herr Hitler. They were heavy. The frames were round and clumsy at one and the same time. Their lenses were so thick my eyes looked like pinheads. They made the bridge of my nose a permanent boiled-ham pink. They chafed my ears. They slid when I blushed. They steamed up in a warm room and blurred the entire world in the rain.

My school enemies, who all had perfect vision, started to call me Plain Jane or Blue Stocking. One of them snatched

the specs when I'd taken them off to change for gym. She hid them underneath a smelly pair of navy knickers. I stomped blindly home with them in my satchel (the specs, not the knickers) and dunked them in my bath before I could bear to put them on again. The following day I made sure she couldn't find her hockey stick. It's probably still buried in the mud near the edge of the school pond.

Throughout my teenage and university years, although the frames got classier, more colourful and had shapes like the wings of a flying bird, the spectacles ruined my hairdos, my make-up and my confidence. I mean, who wants to kiss a girl with glasses? The prospect looked so complicated that most of my boyfriends gave up before they'd even tried.

One memorable evening I met a boy called Jeff at a dance at one of the Cambridge colleges. He was tall and handsome with enormous pale blue eyes he used to tap with his finger tips as a party trick. He worked in a college room that housed the biggest computer the world had then invented – and he wore a pair of contact lenses that covered the entire surface of his eyes. When he asked me to marry him, I turned him down. I didn't love him, I wasn't interested in his socking great computer, but – rich, hard-working and devoted – he would have made an ideal husband, and I was both horrified and deeply impressed by his eyeballs.

Thinking things over back home, I took all the courage I'd ever possessed into my beating heart and visited an elderly but highly experienced optician in the centre of London. He agreed I'd be a good if early candidate for hard contact lenses. The objects duly arrived in the post. After weeks of determined struggle, during which my mascara streaked

down my cheeks in rivers of exasperated and most unladylike swear words, the air turned blue but I mastered the technique. Don't blow your nose too hard because your eyes might pop out in the process.

Over the past sixty years in which I've probably worn around thirty pairs of lenses, there have been some truly terrible moments. During an important job interview, for example, my left eye blinked and the right lens shifted out of position. I spent the following hour trying to answer and ask intelligent questions to seven professional gentlemen all staring at my stuttering lips. I subsequently received a sad but standard letter of rejection.

A gust of wind in the street can – and does – blow dust which feels like fragments of broken glass on to your eyeballs. Trapped between the naked eye and the unbending lens, the specks of foreign matter can cause unimaginable pain. Bus stops are abandoned and shopping bags dumped in the gutter as the wearer, screaming with agony, tries to remove her eye.

But, like childbirth, these moments are swiftly forgotten in the normally marvellous vision contact lenses can give without destroying the contours of your face, the shape of your cheekbones or the fabulous length of your eyelashes. Mine are real, honest injun. I've never worn a fake lash in my life.

Then my elderly optician retired. In his place – and in his immaculate new offices in London's secluded De Walden Street – sprang my Magician of Marylebone.

Andrew Gasson is a man of many brilliant parts. As well as being a pioneering and top-of-the-range contact lens specialist, with every modern contraption you can think of gracing his consulting room, he is also a traveller to exotic

246

places and a brilliant photographer of their birds, a passionate devotee of good cricket, a stylish wearer of immaculate suits, a lover of cats, and an author. His and his sister's book on cat food is fabulously useful, and he has even written an illustrated guide to Wilkie Collins, author of *The Woman in White* (1860) and *The Moonstone* (1868), and popularly known as the father of the detective novel.

Our regular annual meetings consisted of increasingly complicated eye tests followed by long discussions on the state of British and American publishing. On one occasion I paid him an extra visit to check an historical fact about glasses I needed for *Larkswood*. On another he told me in great detail about a spooky short story he was planning to write. We parted company only because another client had come knocking on his door.

Andrew's consulting room is on the ground floor behind a simple reception desk, expert receptionists who know more about the eyes of hundreds of Londoners than they will ever reveal, comfortable chairs and the usual coffee machine and magazines. But his basement is a complicated warren of a medical books library, an entire bathroom, shelves of inspiring spectacles, springy new carpet, another consulting room, and flickering machines that measure how well your brain is working and whether you are likely to survive the next ten years.

When there is a Third World War – and when Covid-19 becomes Covid-29 and threatens to overwhelm us all – Londoners will gather in such basements to talk, eat and sleep. I'm sure there must be a secret door that leads underground directly to the Houses of Parliament and Buckingham Palace. Andrew's complicated eye-testing contraptions are probably linked to the breakfast table of Her Majesty, warning her of the density of her cornflakes,

the amount of Vitamin D that has been added to them, and the freshness (or not) of her lightly boiled egg.

Meanwhile, Andrew has got to know me, my publishing achievements, battles, progress, problems and workload extremely well. He digs out my records on a bunch of handwritten cards that flutter back into the last century when the horse and cart still delivered coal to heat De Walden Street's expensive complexions.

Seven years ago he reminded me that my eyes had become not just middle-aged but elderly. Or, as he called it, "Mature".

"Like a good wine?" I asked him hopefully.

"Maybe," he admitted, waving his Parker pen at me. "Except that your eyelids are far too floppy for my liking and will soon need doing."

He opened the door to his room. There outside it stood his example of what a good surgeon's knife can do. A tiny lady, obviously in her eighties, with the enormous clear eyes and smooth eyelids of a teenager, smiled at me.

"After I had my eyelids done," she explained, absolutely on cue, "my children said: 'Mother! We never knew you had such beautiful blue eyes!' "

I was hooked. I went home and reached for the telephone.

I will spare you the gory details, but the Consultant Ophthalmic and Ocuplastic Surgeon, Mr Hugo Henderson at The London Clinic, took twenty years off my age.

Andrew met me as usual the following year.

We both agreed.

Elderly? Perhaps. Floppy? Never …

My annual appointment with the Magician of Marylebone had become one of the landmarks of my year. Until now.

Because of the Covid's bite, I'm still prevented from travelling to London by bus or train. The virus stampedes among us, mutating along the way. I knew I needed to find a local optometrist, but I'd persuaded myself it could wait.

Only here's where the story goes into top gear.

Last week – beginning 19 October 2020 – was one of the most exciting of my life.

On Monday, my wonderful printer, Darren Millward of JDP Solutions, delivered the three new covers for my three new titles: *Beatrice and Alexander, Finding My Voice,* and *Daddy's Girl,* designed by the brilliant Paul Downes of GDAssociates.

On Tuesday at 8.00 a.m. I launched myself at my study to spring-clean it, and emerged four hours later with a bag full of ancient documents, an idea for a set of short stories, and a transformed sanctuary.

On Wednesday Darren handed me an early birthday present: his four-month-old daughter Iria's feet, photographed in black and white and meticulously framed.

On Thursday I celebrated being 81 by taking some dear friends to The Orangery in Blenheim Palace for a delicious lunch. The autumn sunshine filtered into the extraordinary room in wafts of delicate noonday light. Outside, the trees sprang from their sharp green grass, their foliage orange and yellow in the miraculous turning of the year.

Photos of my family arrived in a surprise delivery. My grand-daughter, Phoebe, is now a startlingly beautiful three-year-old. Charlie can hardly see through his waterfall of hair. Joe has a grin like the Cheshire Cat. Ali's lovely face is half-buried in the marvellous huddle of bodies – and my handsome laughing Sam wears his spectacles dangling around his neck.

On Friday I waited all morning for the first of my new typeset projects to arrive with Mike, my very special

postman who has just celebrated 41 years of service. And there was the title page of *Beatrice and Alexander* with my logo on it. VMBooks had been born. My small publishing dream had become an astoundingly real place.

I drank a cup of sweet tea and sat down to read *The Times* and *The Bookseller*. Predictably, instead, worn out by the excitement and the feeling of having run a very long race to the end of the line, I fell into the deepest of slumbers. An hour later, the telephone shrieked from the other side of the room. Wrenched awake, I found I'd fallen on the floor underneath the nearby chair with a lump the size of a large orange already grown on the back of my head.

The phone went on ringing. I sat up very slowly. The world sparked with fairy lights and my left wrist turned black with bruise.

I was lucky. I hadn't broken anything. But those fairy lights reminded me. I had to say goodbye to my Magician of Marylebone. I sent him a sad email. His reply was brisk and workmanlike. This was no time for sentiment. He agreed my decision was "sensible".

So it's hello, soon, to my new and local optometrist, Morgan's in Kidlington.

"I've just turned 81," I explained to them on the phone with a sense of astonishment and pride, having given them the complicated details of my life and times condensed into two minutes flat.

"Never you mind," the voice said soothingly. "When we replace your two pairs of contact lenses and your reading glasses and the specs you wear without the lenses, and the bifocals you wear when out of doors – with or without today's regulation corona virus mask – when we replace them, we'll recycle them to people in the Third World, who *really* need them."

Writing Beatrice and Alexander

People often ask me where I get my ideas. It's a very good question. Without ideas, lots of them, a novelist has nothing to say. The answer is: from absolutely everywhere. A chance conversation in the street with a total stranger. Reading an intriguing story in a newspaper. A sudden memory. A birthday party.

Reading other people's work.

I first started writing *Beatrice and Alexander* in 2008 after reading *The Bolter* by Frances Osborne, a biography of Idina Sackville. Idina scandalised 1920s society and became an infamous seductress. She walked out on her wealthy husband, who was a serial philanderer, and in doing so abandoned her two sons. Published by Virago in 2008, it's an enthralling account of a dazzling but bitterly troubled life.

The book started me thinking about the three different types of women: those for whom family is everything in the world; those who have children they don't really care about; and those who long to have children of their own, but remain barren.

My novel is set in 1911, when there were no tried and tested fertility treatments. The stigma that hung over women who married but failed to conceive was monumental. It blighted their entire lives.

My thread of research led me to a second book, *The Horse and Buggy Doctor*, by Arthur E. Hertzler, M.D., published in 1938 by Harper & Brothers, New York & London. It's the most brilliant memoir I've ever read of a long life spent in medicine. The illustration on the jacket, and the few inside the book (which aren't credited, sadly) are at the core of *Beatrice and Alexander*. In their honour I've called my hero Alexander Hertzler, and it's his American story – if only a small part of it – that lies at the heart of my own invention.

I'm an author who likes to do her own research. Many writers have large teams of people buzzing around them, gathering facts, figures and all else besides. I love to stomp off on my own, often checking every blade of grass and counting the lamp posts, partly because I never know what else I might find. But the early and late sections of *Beatrice and Alexander* take place in New York. I knew there was no way I could get there and start stomping.

So, through a Literary Agent in New York I had at the time, I found the most brilliant American researcher, Kelly McMasters (kellyinbrooklyn@gmail.com). Kelly knows New York like the back of her hand. She read my complicated brief and understood immediately what I needed. Maps of the city in 1911, details of the then hospitals, records of the length and breadth of medical training, what people swallowed when they fell ill: you name it, I needed it. For three months Kelly beavered away, sending me chunks of information she'd patiently found and photocopied on my behalf. And then more: material she thought I might need. That is the mark of the true researcher. They follow their

thread in case it might lead somewhere useful. Kelly went beyond my brief, giving me ideas I would not have had without her. I cannot thank her enough for all her help.

Twelve years is a long time to keep ideas for a storyline alive and fresh. Other projects kept getting in the way. But my *Beatrice and Alexander* characters wouldn't leave me alone. By 2019 I had four different versions on my computer. I decided enough was enough. Do or die. I must either knuckle under and confront all four versions head on, or give up on the project and wipe the dusty, jumbled indecisive slate clean.

The reason I'd stalled at exactly the same point in all four versions quickly became obvious. Some of the novel is crucially set in Charlbury, Oxfordshire, and involves horses. Although I knew and loved the little town, I couldn't find an exact spot to place my Davenports. And although I can admire horses enough to smile and stroke them, if you were to put me on one, I should fall off faster than you could say Dobbin.

And then something quite miraculous happened.

One summer morning on Monday 1 July 2019, I caught the bus from Woodstock to Charlbury to begin stomping around, trying to find an exact location. By this time I had a whole series of scenes written in my head. But it was where to put them that had become the problem.

As I was wandering backwards up a hill, staring at every house or cottage I passed, trying to get my bearings in a vague early-morning stupor, I bumped into an old friend. Nobody who wanders around like that in the close-knit village atmosphere of Charlbury goes unchallenged for long.

I told her why I was there, what I was doing, what I was writing – and what I was looking for.

"You need to talk to Sally," I was told. "She's great. She's our Vicar. She lives the other side of the Church."

Within the space of ten minutes I had whizzed down the hill, crossed the charming narrow streets, admiring the vivid purple and pink hollyhocks wafting from every porch along the way, and I was in the Church, walking around it with a mounting sense of excitement. Something told me this was a breakthrough moment. I could see my characters coming through the door. I could hear their voices in my head. I could imagine the funeral: see the tears in the congregation's eyes, smell the alcohol on their breath.

On Monday 8 July, the Reverend Dr Sally Welch of St Mary's Charlbury met me and was kind enough to let me walk in her back garden. It was extraordinary. It was exactly what I needed: the backdrop to my storyline for so many years living within my imagination now became a working reality.

The Old Rectory next door still has its stables. Tears of relief and joy filled my eyes. I had my exact spot at last. I knew where my horses would live. I had the sloping garden ahead of me: the exact place of the River Evenlode, the railway line, the fields and woods that rose behind them – and so much more.

Now all I needed was An Horse or Two. Or preferably Three. Not to ride away on, no siree. Just to admire from close up. I no longer owned a car. I couldn't afford to trail around the countryside in a taxi looking for a set of stables that would probably be closed when I arrived.

But suddenly, there was Millie Coles, the marvellous Groom at Park Estate in Blenheim. On Tuesday 16 July 2019, in the blazing midday heat, I spent a glorious hour admiring Millie's steeds, being shown their gear, watching

them stand patiently listening to my questions and Millie's confident, knowledgeable answers.

One of the horses in particular, Domino, with her swirling coat of black, white and orange, now has pride of place in *Beatrice and Alexander*. I was allowed to stroke her. To look into her all-too-perceptive eyes. To see the cleanness of the sawdust on the ground the horses pawed. To become a part for a few moments of their utterly magical world.

So once again, here I am thanking Blenheim – and this time in particular my Millie – for the love, dedication and care that go into her work, and made mine possible.

The horses and the heat and the baking fields beyond the stables where Millie showed me her own two steeds had fair worn me out. Millie spotted I was flagging. She drove me back to the Palace. I sat down with a coffee in the Blenheim Pantry – a perfect space to think and scribble notes – and then hopped, skipped and jumped back to my desk.

By Friday 4 October 2019 I'd edited and polished the first 80 pages and written a full synopsis of the remainder of the story. I set myself a deadline to complete the novel by the end of December 2019. And I did it, with tremendous zest and enthusiasm. When field research works as well as this, it can be a novelist's inspiration. Perhaps I should send Domino a year's supply of carrots with my name on them.

In fact, that's the best idea I've had all day.

Domino, here I come.

Lights, Camera, Action

I'm standing at the top of a flight of stairs, gripping the banister, my heart pumping with delight. It is 1946, I'm seven years old and the world is my gleaming oyster. I've just been to my first school audition as a dancer. We're putting on an end-of-term Christmas performance of excerpts from Tchaikovsky's *The Nutcracker*, and I've been given a big nod of approval. I shall wear a pair of ice-white tights, a sleeveless top and a stiff crimson tutu that sticks out from my small body like the prickly leaves of a pineapple. I shall perform the dance of the Sugar Plum Fairy: my happiness bubbles over, making my eyes sting with happy tears.

I skim downstairs to the changing rooms, singing the music. Tchaikovsky wanted that particular dance to sound "like the drops of water splashing in a fountain". I make a huge effort to be precise, tinkling and delicate. I pull on my uniform – a dark brown knee-length skirt, a cream blouse, a regulation tie and a brown blazer sporting the school crest of a ship on the ocean wave – with shaking hands. I shall dance, prance and run all the way home, not even stopping to buy sherbet lemons, to tell my beloved cat the sensational news.

The joys of childhood don't get much better than that. Failing a maths exam, fielding vile racist remarks, losing my memory during an abusive incident, being bullied in the garden shed, trapping one of my fingers in a lavatory door, struggling to understand Chaucer, reciting Latin verbs, wearing a hideously uncomfortable badly-fitting bra, enduring the stink of the chemistry lab – all the nasty bits of school life pale in comparison and fade into oblivion beside it.

The glorious high scent of daffodils on Founder's Day, singing in perfect harmony in the school choir, raising the roof with our school hymn, *To Be a Pilgrim*, bringing the house down in *The Merchant of Venice*, whizzing tennis balls over their tight net, lying in the long grass by the lake, gazing up at a cloudless summer sky, being made a prefect when I was nineteen during my last term in January 1959, reading the telegram telling me I'd been awarded a State Scholarship: those are the memories that fizz like the best champagne and are worth recording and replaying, over and again.

Throughout my school days, I loved to sing, dance and act. They demanded an ebullience, an exuberance, an enthusiasm for life that come naturally to the child. I had private ballet classes with a stiff, rather dour ex-ballet dancer, in a small room full of mirrors in Edgware's high street, to supplement the more informal dance classes in the draughty school gym, when I'd fling myself energetically and sometimes brilliantly all over the place.

The disciplines of ballet taught me to stand properly: posture is all. I may have wrecked my feet trying to conquer the world *en pointe* in hastily darned ballet shoes, but it was much more enjoyable than bashing a hockey stick in a muddy field, or attempting to chuck a netball over the heads of other passionately sporty girls.

Neither hockey nor netball needed music. I did. It fed my soul and watered my ever-active imagination. In the Edgware lounge, where nobody ever went but me, I'd play our small collection of gramophone records for hours on end. I shifted the armchairs to the edges of the room to give me space to dance; or sang along standing on a patch of carpet, the windows open to the sky.

Years later, I bought Handel's *Messiah* with its complicated score, and learned every note, often spending all evening going over and over the same arias or chorus line. With perfect pitch, as I grew older my voice dropped from soprano to alto to baritone. In church when it came to singing the hymns, this often surprised my neighbours who wondered whether I'd changed sex in the space of half an hour.

My parents bought me a small, newly-made baby-grand piano in pale oak, with stiff keys and a pristine interior. It sat in a window corner of the lounge and I adored it. For many years I had piano lessons every Saturday morning, eager to leave my house which was always deep in shambolic preparations for the weekend. I never managed to learn how to sight-read, but once I knew how the piece should sound, I could quickly pick it up and remember it. The theoretical side eluded me: I couldn't stand the thought of taking and passing music exams – I had quite enough of examinations at school and detested taking them, even the ones I was good at – but I sure could play my beloved oak-made instrument.

My piano teacher was a handsome woman with piercing blue eyes, an enormous mole which sprouted a single obstinate black hair on her chin, and a giant puff of snow-white hair. She and her husband, also a musician, lived the other side of the motorway that bordered Edgware in a small suburban house groaning with pianos. There were two

large, black, shiny grands in the double living room, where regular musical soirées kept the neighbourhood entertained or infuriated at least once a term, and one small rather sad upright piano in the spare bedroom. Their house rang with music all day long. I'd slip in through the kitchen at the back, where pale pink underwear continually dripped above the range, to the sound of Bach or Elgar, and clatter downstairs thirty minutes later to a joyous Strauss waltz, a haunting Chopin étude, or a divine piano duet.

One Saturday morning I played Beethoven's *Für Elise* so beautifully that my piano teacher flung an arm around my shoulders. Dabbing at tears of joy, she asked whether I'd ever considered becoming a concert pianist. I walked home thinking about it. Spending my mornings practising arpeggios, my afternoons learning sonatas and my evenings climbing into ball gowns and waiting in draughty city dressing rooms? It was not the life I wanted. But of all the musical instruments in the world, for me the piano wins, fingers down.

I was, however, sorely tempted to train as a professional actor. The plays we staged at school at the end of every summer term dominated my thoughts and passions for thirteen years. After our performances of *The Merchant of Venice*, in which I played Jessica, Shylock's daughter – there's a photograph of me in the school magazine, standing in costume on the balcony: the first and only time the school ever published my photo in what was to be the last of my school appearances – I received three written proposals of marriage: one from a neighbour, a teenager whom I thought of as a spotty youth, and two from adult friends with whom I sang in the local choir.

I turned them all down with apologies for not being old

enough to marry. One of my friends, who left North London Collegiate School at sixteen to become a legal secretary, married a naval officer a year later. He wouldn't allow her to earn her own living, so for three years she cooked and cleaned and almost died of boredom. Then she walked out on him and slammed the door. She qualified as a doctor and eventually married a dentist. At nineteen I was indeed old enough to marry anybody, but I had much more interesting things to do.

One of them was to go to the theatre as often as I could. The Golders Green Hippodrome was a regular Saturday night attraction, if I wasn't jiving in a North London night club with my latest beau in my gathered felt skirt and figure-hugging silk top. One memorable summer in 1955, when I was sixteen, my parents took me to Stratford-on-Avon to see Vivien Leigh and Laurence Olivier playing together in *Macbeth*, directed by Glen Byam Shaw.

Tickets to see the couple, who were theatrical royalty, had been rapidly scooped up, so we were lucky to be there. It was a brilliantly acted evening, crackling with tension and the electricity between the famous couple. Leigh, who looked dazzling in a long green skin-tight dress, was the most beautiful woman I ever saw on stage. I'd already seen her outstanding Scarlett O'Hara in *Gone with the Wind*, which still thrills me to this day, but a live performance is something else – and *Macbeth* is one of the most difficult of plays.

At Reading University my singing, dancing and piano playing stopped abruptly: there were no local choirs, nobody went dancing and my piano sat untouched back home. But I could – and did – act. After staging a production of Luigi Pirandello's *Lazarus* in Reading, we took it to the Edinburgh Festival, travelling to the great city as a coachload of shabby

but enthusiastic students and staying as a strictly chaperoned group in a large grey-stoned lodging house.

It was a fantastically useful and demanding experience. I played the young wheelchair-bound heroine, Lia, whose notoriously difficult role involves her getting up out of her chair at the end of the play and walking towards the audience. One evening – after many attempts – I got it one hundred percent right. For a few magic moments that felt like an eternity I held the audience spellbound. It was a most astonishing feeling, but I could actually feel the strength seeping back into my imaginary numbed limbs.

After the performance, a London agent burst into our dressing room and asked me to join his list of clients. I said that if I agreed, I'd have to go to RADA and be properly trained. On the way back to England, as our van sped into the night, I knew I had one overriding problem that would prevent me becoming a professional actor.

I am a lark, not an owl.

I'd realised this afresh during the few weeks we were at the Festival. While my companions sat up until the small hours gossiping and drinking beer, and then slumbered until noon, I'd be asleep by 11.00 p.m., and spark awake at the crack of dawn: having a bath, making breakfast, doing the washing up from last night's supper – and trying not to consume all my energies before the evening performance.

Spending my life trying to defeat my natural rhythms would be an impossible task. I wasn't interested in becoming a screen actor, had hardly watched any television and knew that if I was serious about writing, I'd have to get used to a solitary life within four square walls. But I'd also have to earn a living at it, so large-scale projects, like novels, were beyond my early reach. As you'll appreciate by now, you have to be prepared to work with, listen to and develop the

same group of characters for months, if not years, on end, while the professional journalist can be instantly employed and rewarded.

I took Sam to the theatre as often as time and money would allow, but as a child he preferred the cinema. We went to Stratford-on-Avon together several times where, as a typical teenager, he did his best to pretend he did not belong to me.

It came as a marvellous surprise when he started to direct his own productions at Cambridge University. Peterhouse had just built and opened a new theatre. Sam claims he spent two and a half years trying to get his friends to come to rehearsals, and his last six months there studying around the clock. He was awarded a first-class degree in English, so he must have been doing something right all along.

Going to see his early work was thrilling. He'd done nothing particularly theatrical at Magdalen College School, and the closest he'd got to leading a team – which is what being a director is partly all about – was on the cricket pitch. But that changed the moment he reached Cambridge, when the cricket pendulum swung towards his obsession with the theatre.

Student productions, although mounted on shoestring budgets, can be inventive, daring, innovative, hilarious, raw, bawdy and brilliant because their teams are given the freedom to be themselves and develop their own ideas. In any one production, there's always a single performance, a set, a costume, a piece of music or a voice that shines head and shoulders above the rest. I went to see every single one of Sam's Cambridge productions, expecting a little extra each time, and always being more than rewarded and deeply impressed.

When Sam began to direct for the Royal Shakespeare

Company in Stratford – particularly with his versions of *The Alchemist* and *Troilus and Cressida* – my happiness knew no bounds. I could see the pathway he was beginning to create with tremendous speed, and yet with increasing confidence, losing nothing of the quality of his productions along the way.

When Sam took over the Donmar Warehouse he needed to strike a balance between putting on productions in which he was passionately interested and those that the theatre-going public would want to see. Running your own theatre, being responsible for its financial survival as well as the team of people who help, comes in addition to the planning, casting, auditioning and rehearsing that theatre directing involves. Many directors do not want the double burden of administration and creativity; and if they do take it on, they need to know when to stop.

Sam's massively successful ten-year stint at the Donmar not only earned him the award of a CBE from the Prince of Wales, but encouraged Steven Spielberg to make him an offer that took him to Hollywood with *American Beauty* and the first of a string of remarkable films. My favourite is *Road to Perdition*: I was allowed to see it on my own at a private screening in London. It was a truly memorable afternoon.

Although I have never been a passionate cinema-goer, my novel writing has been greatly influenced and enhanced by listening to the extraordinary American writer and lecturer Robert McKee. His seminal book, *Story: Substance, Structure, Style and the Principles of Screenwriting*, based on his analysis of hundreds of films, was initially written for screenwriters. But novelists can certainly benefit. His seminars, made up of three long twelve-hour days, are a potent mix of complicated analysis, hard-hitting jokes – often, in London,

263

at the expense of his largely English audience – and a showing on the final evening of the 1942 film *Casablanca* starring Humphrey Bogart and Ingrid Bergman, and directed by Michael Curtiz, complete with a frame by frame analysis by McKee. You'll never watch films the same old way ever again.

I found the seminars stimulating and refreshing, partly because McKee is an American, and the only creative writing classes I'd been to were run by English women. McKee's viewpoint is broader, sharper, more astringent and often hilarious. He dares to be incredibly rude about greedy agents, sloppy writing, lazy authors, hypocritical politicians, corrupt politics and a host of other matters that daily affect the writer's life. By insisting on the highest of standards, McKee has done a great deal to improve professional attitudes throughout the industry.

Over the course of three years, I attended the seminars three times, and never regretted a moment. McKee's lectures were basically the same each time, although he updated the details by including new films and their teams. But every seminar I went to meant something different to me, because I was writing a new novel and had reached a different stage in my own development.

McKee helped me to get into good habits, not only of working every day and never taking one's finger off the pulse, not only of making sure that what one is writing is the truth, the whole truth and nothing but the truth, but of visualising every scene as if it were intended for the large screen. Describing what your characters look like, the details of what they are doing – eating, sleeping, driving – everything must fit, every detail must be accurate. Dialogue must be pungent, riveting, articulate and revealing, full of meaningful innuendo. Nobody can be bothered to read or

listen to endless small talk, signifying nothing.

McKee also gave a single-day seminar called *Love Story*, which contained so much material that it could have filled a week. The day ended with a showing of *The Bridges of Madison County*, adapted from the short, powerful novel by Robert James Waller. The 1995 film was directed by Clint Eastwood and starred Clint Eastwood and Meryl Streep. Once again, McKee's analysis got behind the camera to reveal techniques that hit the right spot every time: a masterclass in watching, listening and learning from the best in town.

Successful writers today, after what may often be years spent behind their silent, isolated desks, are expected to be able to speak to audiences large and small, without any proper training, as if they were to the manner born; to reveal every detail of their private lives to large, anonymous audiences; to travel to literary festivals up and down the country in all weathers, often at their own expense; and to have led the most exciting, daredevil and original lives.

But most writers take up the profession because it chooses them, because they are better with words than people, and because they prefer to invent their own families and live through them than spend their time commuting, in open-plan offices, at committee meetings, organising budgets and next year's diary.

Like the song says, there's a right time for everything. The writer who wants to be published must first and foremost be prepared to work every day as if it were their last; to put their heart and soul into every word; to focus on the immediate page in hand; and have the determination to get to the end of the story. Half-finished, half-baked and half-hearted work is nothing but mediocre rot. Complaining

about writer's block is a way *out* of the problem instead of its resolution. Get unstuck by doing more research, rewriting a twenty-seventh draft, editing a fifty-first, listening to feedback if you are lucky enough to have it, and never, ever giving up. Backache? Headache? Measles, mumps, broken wrists and ageing hips? Nobody wants third-class excuses. Everyone wants first-class product, delivered ahead of schedule and polished until it shines.

If, when you've reached that miraculous end of your project, your written words have inspired screenwriters and theatre directors to take over where you left off, then you are very lucky indeed. Somehow or other, your imagination has captured the modern marketplace. And your silent vision will be matched with actors and actresses, directors and personal assistants, storyboarders, set designers, lighting engineers, cameramen, musicians, costume makers, make-up artists and action.

Just remember one thing in all the hullabaloo.

Writers are the source. We are the start of the river that leads into the great churning sea.

Without them – without us – there is only a blank page.

Living in Woodstock

If you were to ask me who I'd nominate as my Favourite Woodstock Person, without a moment's hesitation it would be our extraordinary Postman, Mike.

For more than forty years, our Mike has been pounding the beat on our behalf. Through puddles of wet pavements, lethal snowy cobbles, ankle deep in smelly leaves, burning under scorching skies or wheezing on fog-bound mornings, our Mike appears like magic through the Woodstock mist. Not to fine us, lecture us, check on our blood pressure, mental health or enormous waistlines, but to give us documents of all shapes and sizes with our names on them.

Yes, sir. Whether we are a miss, a near miss, a madam, a squire, or something akin to none of the above, our Mike delivers. We may have died five years ago, but he will solemnly ensure the post slithers through that slit in our door with never a nudge or a wink. It's the numbers that matter as well as our names. If you've ever lived in Woodstock, you're probably here for life.

Of course, our Mike adores the job and it loves him. Lean, handsome, seemingly tireless, self-effacing, meticulous

and discrete – with legs to die for in his Postman's shorts – I'd trust him with my life not to get it wrong. When I lived for a brief, mostly uncomfortable time in Long Hanborough, I'd regularly receive important documents addressed to my next-door neighbours. How they dreaded seeing me waddling up their path with another bundle for them in my hands ...

That never happens with Mike. He learned to read several lifetimes ago. He could tell more stories about us all than you've had baked beans on toast. But he never, ever, steps over the Postal Line. Ask him no questions and he'll tell us no lies.

Here is my tribute. Another forty years, Mike, please ...

For Our Postman Mike

Stand to attention and salute
The wonderful world of jute:
Those envelopes both large and small
That somehow seem to Tell It All –
We're overdrawn, the Gas Man's Been,
Install that meter, change your scene
Move house again, stay where you are.
God help us all! How far

Those days when Valentines were scanned
On paper, writers' hand we recognise.
That far-off land I still adore.
It is the apple and its core.
This online's rubbish. Who's to tell
Whether the writer cannot spell
Her name? Sign here IN INK
And stop this ghastly online stink.

Stand to attention. I salute
Our marvellous world of jute.
The tiny hand-revealing note
That any morning gets my vote.
It's more for Mike – but here's the thing:
It makes him sing.

Small Is Beautiful

In May 2008, a useful but dilapidated electrical shop in Woodstock was transformed overnight into a Haven of Books. Rachel Phipps had arrived.

It had long been Rachel's ambition to have a bookshop of her own. Small and compact – there are no dusty attics or basements, no slippery stairs, and no coffee tables on her pavement – it packs a massive, confident punch. Rachel knew from long experience as a bookseller exactly what to do. An avid reader, she keeps up with the tidal wave of new material and "gets a buzz" out of knowing what her readers might like and why.

But she not only sells books, stocks her shelves, knows where to order the books from, pays her invoices, talks to sales representatives and sits for hours on the phone when things go wrong. She also tracks down the most out-of-the-way documents from anywhere in the world that make it possible for historical novelists, like me, to hold together the threads of an idea so that it works in practise. For *Beatrice and Alexander*, for example, Rachel found for me a medical memoir published in New York in 1938 that became the

backbone of the entire story. When I told her I couldn't have written the novel without her, she didn't believe me.

I hope she does now …

And that's not all. Since May 2008 Rachel has organised book groups on poetry and fiction in the shop every month; set up and maintained an annual Poetry Festival; and run evening talks from more than 235 authors, some of them more than once. The Woodstock Bookshop has grown to be a cultural hub both readers and writers depend on as an essential part of their lives.

When the pandemic closed the bookshop, everyone prayed for its return. And when it did, gradually, open its carefully professional doors again, with both Rachel and Merle Esson masked and standing guard, twanging away at the rusty till, unpacking those stubborn boxes and dusting the window display, nobody was happier than me.

Here, with belated congratulations on the shop's marvellous thirteenth birthday, is my tribute.

For Rachel Phipps and
The Woodstock Bookshop

Through thick and thin you battle to keep The Word alive
Those boxes keep on coming, deliveries arrive –
The cardboard and that wrapping! The dates!
The covers! Too
Those customers whose tramping boots have
stained your carpet blue.

Through thick and thin you sit there, in winter,
heat and shine
In dazzle and at twilight to publish – sometimes – mine:
But overall you know that behind the bookish deals
Stand people and their voices whose lives
you've often sealed

By setting up those evenings when they've arrived to talk,
To tell a listening audience that yes! They more than walk:
They write within our England.
They thrive because of you
Our Booksellers United – and all who've battled through.

No Ideas But In Things

"Tobias Mellwood ran as fast as the burning sand would allow, down the beach towards the lazy edges of the sea. Sweat poured into his eyes. The relentless noonday sun dominated the sweltering cloudless sky."

The opening of my next novel? Possibly.

A lesson in how to "show don't tell"? Yes, exactly that.

There are very few absolute rules in the world of the novelist. Don't merely *tell* me that "It was a very hot day." *Show* me. Give me specific details. Make me *feel* the heat. Only then will I start to feel concern for Tobias Mellwood who might be running away from his maniac of a brother or celebrating the fact that he has finally learned to swim.

One of the other rules is: There are no ideas but in things.

Of course the well-told story centres on its characters, its plot, its storyline, its need to make the reader desperate to turn the next page.

But our lives are dominated by the *things* we have around us. Our breakfast toast and marmalade, our jeans and trainers, our huts, igloos and bungalows, our caravans, our window boxes, our shopping baskets, our tambourines. The

novelist must choose which ones to use and to what purpose. The storyline is held together by a thread of *things*.

I describe this Memoir as being like "a necklace of beads": different shapes and colours, differing textures − rough, smooth, light or dark − held together by the plaited thread of time.

In the same way, any good story needs things the novelist selects from the thousands surrounding their lives to reveal the necklace of their story. Tiny thimbles will qualify. Who worked with them, wore them, and why? Feathers dropped from a fan outside a cabin door. Who sits waving the air with it? Was it the killer herself?

Detective Inspector Morse spent his life scrabbling around for clues. The smaller they became, the more beer he needed to answer the questions − but answer them he more than usually did. Poirot's "little grey cells" were often fired into life by handwriting on an ancient document, a hairline crack in a bottle, the stain of lipstick on a china cup.

In my latest novel, *Beatrice and Alexander*, a small lace handkerchief smelling of stale hyacinths suddenly becomes an humiliating insult Beatrice discovers in her husband's smoking jacket. The thing is more than its embroidered lace. It is also what it stands for: infidelity. Proof she never wanted to find stares her in the face. Its set of initials mocks her. The square of linen has not spelled out a name *for her* − but it surely means more than a sneeze to her husband.

In *Daddy's Girl*, Eleanor Drummond has to clear her father's studio after his sudden death. She finds a small brass key in an ancient leather purse. Why is it there? What might it unlock? In an ancient bureau she finds a bundle of love letters. Who are they from? And so the thread of discovery unravels its path to the truth.

The novelist needs to keep her beloved readers guessing and turning the page. In my teenage novel, *Coming of Age*, I used a faded postcard from Italy with its message of passionate love. In *Lost and Found*, the sleeve of a red sweater reveals a man and a child sheltering in a narrow boat on Oxford's canal. In *The Drowning* Jenna finds her younger brother's diary after his tragic death. In *Larkswood*, Louisa discovers a family portrait hidden in the attic. She puts two and two together – and finally begins to make sense of the past.

Some of the most beautiful things in Woodstock today can be found in Louisa Maybury's magical shop on Market Street. Today more than ever we appreciate and admire the efforts of craftswomen from "foreign parts" who, against all the odds of the recent pandemic, continue to bring to the world their brilliant creative gifts. Here is my tribute.

Magic Carpets

Here lie the labours of a far-off land
Where groups of women murmur in the sand
Where skies flame pink with heat
When lovers meet
Where fingers flick their needles as they weave –
How deft! What speed!

Here lie the remnants of a sari worn
To shreds, then rescued, then reborn
To cover shoulders cool
Unpack the mule
When, travel weary, limbs begin to bend
To night's rich end.

I love the terracotta and the gold
The turquoise flurry and soft cushion's fold
The careless fling of patch
Where colours catch
So feet may move securely as they walk
To eat and talk.

Here lie the secrets of a far-off land
Where families live cheek by jowl, crammed
Together day by day
With them we pray
Their way of life will soar with rainbow's hue:
Our special few.

Especially for Blenheim

I first moved to Woodstock in 1976. I wanted to live here in order to be within walking distance of Blenheim. It made an extraordinary difference to my life then, and has never been as important to my health and survival than over the past eighteen months. Whatever the government regulations were since March 2020, and however complicated the almost daily changes, Blenheim made an effort to keep up, keep smiling, and keep their gates open to their magnificent gardens, even though its doors had to close to the people who paid their dues.

Behind closed doors, their extraordinary efforts carried on regardless. A new café was built where the old stables once housed the Marlborough family's horses; Christmas trees were planted in their thousands; new houses for local residents sprang from surrounding fields. When in December 2020 Blenheim's Christmas Lights display was allowed to go ahead because it took place in the open air, I wrote a poem to celebrate the event. Its visitors went wild with joy. After being starved of enjoyment for many months, they could put FUN back on their list of things to do and places to take their children.

I enjoyed writing the poem so much I decided to write more, directly dedicated to the events and the work Blenheim were holding and doing. So here are those Christmas lights; the Grand Bridge being restored to its former glory; the marking of time when clocks go forward which involves the Blenheim team in hours of frenzied activity with some invaluable decorated faces; the famous Column of Victory as it stands protecting its gardens and the visitors who walk in them; Matthew Crabb's extraordinary oak chair carved with a chainsaw from a fallen tree; and a tribute to a special new species of bees who hum in Blenheim's forests, happy as we are to be allowed to live and thrive.

On behalf of all of us who live close to Blenheim or who travel from around the world to visit and admire: thank you.

Blenheim at Christmas 2020

At the end of a year spent in darkness
We have an explosion of light
A reaffirmation of spirit
To stamp on that virus of blight.

So now let us celebrate Blenheim
Its Palace, new lit, sparkling, piled
With stars for the visitors watching –
With light from the eyes of the child.

The front of the Palace comes dancing
Triumphant in crimson, then green:
It sings as its colours keep changing
It bows to our fabulous Queen.

In spite of the hazards of winter
We flourish. We've nothing to fear
With our reaffirmation of spirit
Let us thrive at the end of our year.

A New Day Dawns

For the Blenheim Team 2021
with special thanks to Richard Bowden

The finest view in England trembles before our eyes:
The lakes in Blenheim turn to marsh, blotting starry skies
Their edges creeping nearer to centres dry as dust –
The finest view in England
Turns to rust.

I walk a changing landscape where always I'd assumed
However dark the future, Blenheim's would stay tuned:
The lovely Bridge's crescent would sweep above the pain
Its waters fresh and filled
With summer's rain.

The finest view in England now needs the helping hands
Of stonemasons and experts, conservators and bands
Of those who build, repairing, rejoicing as they sew
Let's work to save our England:
Quick! Quick! Go …

I walk the Bridge at dawning as diggers lie in wait
I watch the Palace outlined and glimpse the Woodstock Gate.
Repairs begin in earnest: we'll dredge, we'll fill for hours:
The finest view in England
Will stay ours.

Spring Forward at Blenheim Palace

For John Richards, Clock Man Extraordinary

The swinging of the pendulum exactly marks the time:
Precise, intense, immaculate, John checks the hour's chime.
A second out? Two minutes on?
Then something must be done
To sharpen up the reckoning until the battle's won.

Today a pair of Blenheim's hands will reach to alter time
Precise, intense, immaculate, it's worth the slippery climb.
He nods approval, springs ahead to stroke another face:
Gold-plated bronze – that ormolu must win
the beauteous race.

The tick! The tock! The chiming! The ringing of the bell
The marking of each minute, the timing of the spell
It casts on Blenheim's gardens. It's later than you think
We've lost an hour! Hurry! We're on time's very brink …

And yet John changes nothing for the chorus
wakes at dawn
Whether or not the drawing-rooms tick matching.
Swords are drawn
In time to fight another day. Church bells their peals ring.
Join hands and lips and prayers as we spring
forward into Spring.

Column of Victory

On the longest day of the year I have
The most far-reaching eye
To scan, to mark, to fascinate
Each bird that soars. I spy
On every dawn that sparks her light
To cleanse a foggy moon
On the longest day of the year
I am in June.

I see our Lake as its waters break
Across a goslings' nest
I smell the scent of a breakfast spent
Before a morning's rest —
For some of us watched hours long
Over a baby's cry
We've had the longest night of the year
That's why.

As the longest day of the year recedes
I stay to hear leaves fall
To scan, to mark, to fascinate
The shortest and the tall.
I am The Spire of Blenheim's Land
Its pinnacle, its Beacon Grand
On the longest day of the year I stand
As servant to you all.

Heart of Oak

For Matthew Crabb

Deep in the forest you'll find it
Where the trees begin to fall
Deep in the forest the wind blew cold
And thunder took its toll
Another flash of lightning pierced
That heart of oak. It knew
Its time had come, its years full grown
Among the ash and yew.

Deep in the forest they found it
When the storm had done its worst:
Across the path the heart of oak
Lay dead – but never cursed:
A thousand tiny creatures raced
For shelter as it lay
Sprawling and beaten, flat as mud
On that bewildering day.

Deep in the Blenheim forest now
Sits something new from old
An oaken chair with oaken leaves
Carved as the chainsaw told
Our story for tomorrow's world
A new script's reckoning –
Come now rejoice and sit with me
As, hearts with oak, we sing.

Where the Bee Sucks

For Blenheim's Filipe

Where the bee sucks, dare I go
Into private trees that throw
Safety's arrow? There's their hive
This is where they buzz and thrive.

Where the lambs bleat, I can hear
Pink mouths suckle, mothers near.
Blenheim's harvest starts to yield
Grains unique to its rich field.

Where our bees suck we rejoice
In their colour and their voice
Where the lambs bleat, they grow strong.
Harvest while our days are long:

Trim those hedges, stack that hay
Work long hours come what may
Buzz and bleat, our story's told
Watch our green grass change to gold.

And Finally ...

L et me end with the thread that was among the first to be spun: my Polish-born grandfather.

When he died, my mother failed to tell me. She sent me a letter after the event, telling me about his funeral, saying how sorry she was that I was much too busy working in Oxford to take any part.

I was devastated.

I sat at my desk with Oxford University Press in Oxford, remembering my Zeida.

His tiny workroom with its enormous table, floor-to-ceiling window to the garden, well-worn tape measure and lethally sharp scissors. The square piece of white chalk he drew over his carefully smoothed fabric to mark the crucial boundaries. The ever-abiding scent of chicken soup that floated from the kitchen, filling every corner of the ground-floor of his house. His wife, who never said anything, but sat all day long in the same heavily cushioned chair, getting up every now and again to stir the soup and add a pinch of magic ingredient.

His enormous double bed with its immaculate puff of

eiderdown. The two bottles of cherries soaked in brandy that always sat on a window sill in the second bedroom, waiting for a drunken knees-up evening that never seemed to happen. The way he solemnly presided over his Friday evening suppers with their strictly observed patterns of eating and drinking, glaring at my wicked father when he dared to mock them. His sharp eyes that twinkled with laughter at me, his spectacles that never increased their prescription, his carefully laundered shirts, his grey beard that I used to stroke, the whiskery smile that looked into my own adoring eyes and made my day.

I sat there, mopping my face when I realised I'd never see him again, and hand-wrote this poem. It remained pinned to my notice board until the day I cleared my room and left it for my successor.

For My Grandfather

He always gave me sweets, the boiled kind.
They hid behind the door, within the chest
Of polished, burnished gold mahogany.

He never said much to me. Couldn't read
In English. Thumbed his Book
Of Hebrew Prayers until they fell apart.
But he stayed on.

He never liked me. Girls don't matter much
To his mind, born in Poland then
And bred to pride and price only the men.

I understood. I watched, admired
His patience, learned his calm
And careful ways. He was a man of peace.

I loved him above all.
He never knew.
It doesn't matter much.
Does it to you?

Writing a Sequel

When I set sail in the Good Ship *Larkswood*, way back in the Middle Ages, it took me much longer to get home than I'd originally intended.

The winds blew me into uncharted waters. The storms were positively petrifying. I lost my way, my compass, my bearings and my hat. Indeed, there were many dark nights when I almost drowned, or jumped overboard, or both.

When I finally reached land on that extraordinary morning, Orion stood waiting for me on the quayside.

"Here's our contract, Valerie," they said. "Oh, and by the way, here's some money … Don't spend it all at once."

I collapsed in a silent heap of wild relief, gratitude and exhaustion.

Then I remembered something. From the joyful recesses of my mind, it came to me. A second journey beckoned. I had intended *Larkswood* to have a sequel. I had left my Hamilton clan on the very cusp of war. Whatever had I been *thinking*?

I wandered into my small garden and burst into tears. I could barely find the energy to walk a single step, let alone pick up my bags for another ocean voyage.

We published the hardback *Larkswood* with a launch at Blenheim Palace. The Orangery sparkled. The Palace – in late February 2014 – had just opened after its long Christmas vacation. (Those were the days.) I thanked my friends, signed a lot of copies and limped into a taxi to be taken home. My right hip had become so excruciatingly painful that I could neither stand, walk or sleep. Putting on my socks took me most of the morning. Taking them off took me all evening. I was having serious problems writing *Daddy's Girl*, the second novel in my two-book Orion deal.

But you know what they say, don't you? Never give up, never give in, never say never. As Churchill always said, KBO: keep buggering on.

After my monstrous carbuncle had been skilfully removed, and a modern titanium and miraculously pain-free hip joint inserted in its place, I organised a second launch party at Polly and Patrick Neale's delightfully welcoming bookshop in Chipping Norton. The shop has a special room on the first floor for such events, and although I was still hobbling around with a walking stick like an ancient crone, I never thought I'd survive the hip operation, so every day was a most miraculous gift of joy and hobbledon. This time we published the paperback. It had been given its jazzy Christmas-market cover. And it cost less.

Much to everyone's astonishment, *Larkswood* began to sell. For a couple of ground-breaking, world-shattering weeks it even powered its way on to the bottom rungs of *The Bookseller's* top fifty list. Overjoyed, I emailed Orion to let them know. They could hardly believe their eyes. When Waitrose chose it as their Book of the Week and kept ordering copies, the Managing Director of Orion's fiction list gasped: "Waitrose have never asked us for more of *anything*"

I used to shop every week at the Waitrose store in Witney. (Those were the days …) I used to linger around the shelf where *Larkswood* sat competing with another Jamie Oliver or Alan Titchmarsh. I used to chatter to anyone who'd listen.

"Read good fiction, do you?" I'd ask them. I'd pluck my novel from the stand. "This one, for example, is brilliant. Wrote it myself, so I should know."

Now, don't get me wrong. We're not talking millions of copies here, top of the pops or world tours starting in Australia. I wasn't born yesterday, I was born in 1939. I mean, I ask you. How ancient is that? I've been in and around the publishing world for longer than anyone I know. *Larkswood* is a novel about *incest*, for heaven's sake. I can hear the sound of tut-tutting a mile off. Disgusting smut. The last taboo. Shut the door on your way out and stay away from me.

Incest is *still* a dirty word. Many markets overseas turned *Larkswood* down because it's much too close to the bone to even bear thinking about.

But here's the point. Let's cut to the chase now. Listen up.

I began to receive emails from strangers in the middle of the night.

"I simply loved it," people told me. "I couldn't put it down. It's the best novel I've read in years. My mother lay dying in hospital. I had to sit by her bedside for two days. *Larkswood* kept me going. *I hope there will be a sequel. You can't just leave me like this. I'm longing for more.*"

Delighted, thrilled, astonished, deeply touched, I thanked everyone who wrote to me. I said I was thinking about a sequel. But every time I did, my heart quailed. I turned on

the relentless WHAT IF tap. DRIP, DRIP, DRIP …
EXTERMINATE … YOU'RE NOT UP TO IT …
WHAT IF DRIP.

What if the sequel flopped like bunny's ears? What if all
my loyal fans turned against me? What if they started to
mutter over their cornflakes, "This isn't *nearly* as good as the
first one. And it's *taken* her long enough … Let's give it to
Auntie Maud. She'll read *anything*."

The truth was: I still couldn't bring myself to re-read
Larkswood, let alone jump aboard another coracle in the
raging seas. But the fan mails kept on coming – and kept
me going.

Two years ago, I put on my wellingtons and sou'wester. I
did three months' solid research into the Second World War.
By the end of the third month I was drowning again, this
time in black depression. The stories of how fighter pilots
lost their young lives were so heart-breaking I couldn't take
them any more. I called a halt and wrote *Beatrice and
Alexander* instead.

And then Covid-19 blew the world apart.

Left in limbo, between novels, like a restless out-of-work
actor, I read other people's stories by the bucket load,
stomped around Blenheim's wondrous gardens, worried
from dawn to dusk about the people I love, and fed the Cat.

And in the enforced idleness, I began to *think and feel* my way
into a sequel. Not by doing more research. I wasn't allowed to
travel anywhere, the Woodstock Bookshop had closed, so had
all the libraries in Oxford together with the Bodleian.

A new title, *Flight of the Lark*, began zinging in my head.

The May Day singing in the centre of Oxford didn't
happen, but something else did. A gentle warming of the
sun and a lengthening of days. Walkers in Blenheim, who'd

remained mute as stones for weeks, started to say "Good morning". One of them stopped to talk to me: standing rivers apart, of course, and shouting above the noise of the honking geese. Martin Johnson asked me what I did. I said I was thinking about writing a sequel.

There! Those terrifying words had been unlocked. They'd sprung out of my bag. They could not be squashed back in.

On Tuesday 12 May 2020, Rachel Phipps of the Woodstock Bookshop arrived with the first book I'd bought all year. My next-door neighbour, Dan Ardizzone, talked to me one evening as I was watering my front garden about his marvellous Montessori School in Oxford. Life, miraculous friendly life, seemed to breathe again. We were conquering that vicious mountain peak. Hope danced in the air. Health partnered her.

I created a new file. Finally, *Flight of the Lark*, hello, what took you so long? I wrote a beginning and then deleted it. I wrote three more opening scenes and chucked them out. Blenheim's lake was being drained. I stared at its beachy edges. People dry up as well as things, I told myself. Maybe I should go home and bottle jam.

And then a miraculous moment happened. In every novelist's life there are, if they are lucky, maybe three.

It was Sunday 17 May 2020. Eleven in the morning. Woodstock was utterly silent. There were no people in the street. No humming car engines. No coachloads of visitors. No singing of hymns. And not a single chiming church bell.

I washed my hands again in the guest bathroom that overlooks the road. And, as I did so, I heard that still small voice in my head saying four little words:

"Hello, Mister Billy, sir."

It was Akbar speaking to me from Calcutta.

Flight of the Lark was born.

All aboard the Good Ship *Flight of the Lark*, then. All aboard. Five days later, it was 22 May 2020. I was already on page 14 and Chapter 4.

So: to all of you who took the time and trouble to write to me over the past seven years, loving *Larkswood* and asking for more, I say a very special "Thank you" in return.

You fanned the dying embers.

And now I light the fire.

For Winston

Frontispiece poem to Flight of the Lark

Nobody said it was easy, being the man that he was –
The wars and the women he fancied were never
straightforward because
He wanted to prove he was worthy,
he needed to say to the world
That in spite of those dangerous battles
He was bloody well going to be heard.

He had money and privileged backing
as long as he toed the right line
He had jackets and gloves at the ready,
or a glittering sword just in time
But then in the background was Mummy
who never quite loved him enough
Who often knew nothing about him
While Daddy was off with his snuff …

Nobody said, "Take it easy! It will all be all right
on the night!"
The advisors who clustered around him were keen to
encourage him. "Fight!"
So he ate and he drank and he worried.
He made big decisions. He spoke
In the voice that is now so familiar
To rally our country. No joke

That we died in our hundreds of thousands
We starved and we sweated for him
We turned on the wireless and nodded.
We scraped and we saved. We stayed slim
We slept with his voice in our eardrums
We rose every crack of the dawn
We fought for our Winston and then some
And now we are glad he was born.

The Eye of the Beholder

The look, tone and content of the best websites race to keep up with our changing times. Technology develops daily. Fashions sweep the board and wither away in weeks. But the basic rules of taking a brilliant photograph, designing a secret garden, maintaining a decent complexion and presenting your own image to the public world remain under one single word:

Grooming.

To produce an image that looks as good as the front cover of this Memoir is the result of many pairs of extraordinary eyes using their individual expertise. I shall be 82 in October. This photograph is not of a beautiful woman, but of an author who works meticulously around the clock at everything she does, says and writes.

I'm wearing an old T-shirt and a pair of even older jeans, but turquoise is the colour I cannot live without. My special trainers are made by Vionic: without them I can barely walk an inch without screaming in agony. My daily diet and lifestyle were mapped out for me fourteen years ago by The Food Doctor, Ian Marber. Five very small but very regular

protein-based meals every day, no alcohol, chocolate in tiny quantities and keep mobile. Work *with* your body and listen to it.

The older you get, the more closely you must listen. Don't bake your skin in the sun and only drink water if it's been filtered or boiled. But drink it, every hour, on the hour, in small quantities.

Above all: don't burn the candle at both ends and expect to live to tell your tale. Sleep matters.

My Undying Gratitude Goes To

Chris Challis Photographer, whose patient and visionary work makes the ordinary look luminous, who can see the shape and colours of the human being against the shades and nuances of landscape, and who can put them together to create an image that will survive the cruel test of time

Dominic Hare, Blenheim's Chief Executive, under whose leadership the Palace and Estate in all its rainbow-faceted expansions is making a real difference to thousands of local inhabitants, who has brilliantly negotiated the pandemic, and who is planting more than trees for our children's future

Heather Carter, outstanding Director of Operations at Blenheim Palace, for giving Chris and me the freedom to roam in Blenheim's gardens, for being the first woman to hold this prestigious post, and for remaining slim, glamorous, sympathetic, practical and human under challenging conditions

Avtar Ghataura, for hopping into a Blenheim Buggy at a moment's notice and chugging us around five miles of dampening pathways, waiting with never a hint of grumble while we danced in and out of the fields under a windy sky, hung on to gate posts, bridges and tree trunks, and generally disturbed the peace

All the Searcy's Staff in The Orangery, that most beautiful of Palace Rooms, for giving us a much-needed lunch just as the rain began to show her colours, for cooking fish to perfection and inventing puddings that melt on the tongue and steady the heart for yet another day slaving over Chapter Six

All the Blenheim Gardeners who know exactly how much to cut and prune, and when to leave everything else alone, for handling complicated, noisy machinery with tact and discretion, and for somehow ensuring that, miraculously, there are no nasty pot-holes and the paths are always safe

Nevrus of Woodstock for cutting my hair, and *Laura* for disappearing into her cupboard and mixing secret brews to create colours of any and every description in the blink of an eye

Judy Bendall, brilliant and tireless Manager of Blenheim's wonderful Shop, for my Hat and Scarf

Jaeger @ Marks & Spencer Online for my linen coat and *Hermes* who delivered it in person

Estée Lauder for their make-up, and getting it through the delivery lanes in spite of Brexit

L'Oreal Revitalift for feeding an elderly skin in exactly the right quantities

Simple Cleansing and Toning Lotions for doing exactly what it says on the bottles, and

Chanel for their Verde Pastello nail polish which dries in less than an impatient minute.

And Finally

To Team Mendes, without whom I should have disappeared to the seaside years ago:

Steve Cole, brilliant children's science-fiction author, and my first and only real Editor

Paul Downes, Creative Director of GD Associates, website and cover designer

Darren Millward, Director of JDPrint Solutions, printer of everything I need

Andrew Chapman, Director of Prepare to Publish, typesetter and publishing consultant

Colin Paice, Director of Paice Solutions, IT Consultancy and essential problem solver, and

Antonia Keaney, Blenheim Palace's distinguished author, historian and video creator.

Not Only But Also Farewell

For Rod Craig

I love the hours of twilight as the skies begin to fade
The swirl of cloud, the streaks of sun,
the patterns and the shade
The timing of the sunset, the deepening of the gloom
The sleepiness that stills my heart –
the propping of my broom.

I love the creep of dawning as the light
seeps through the pane
To warm the frost of eventide and bring a hint of rain –
The singing of the early bird, Cat scratching at the door
The cup of tea that stirs my heart before
my pen needs more.

I've never loved the noonday sun,
its blaze of burning heat:
It slows me down, it makes me pale. Its suffocating beat
Turns morning into afternoon. I'm glad to see it swim.
Mad dogs of an Englishman stew in its deadly grin.

I love the hour of teatime when the lemon drizzle cake
Slides down a treat to waistline sit. Forgotten how to bake?
Come! Sit with me till sunset. Talk as the day's light falls
Let's love the hours of twilight when my nightingale calls.

Valerie Mendes
10 September 2021

Lightning Source UK Ltd.
Milton Keynes UK
UKHW011405071021
391809UK00009B/235

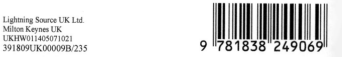